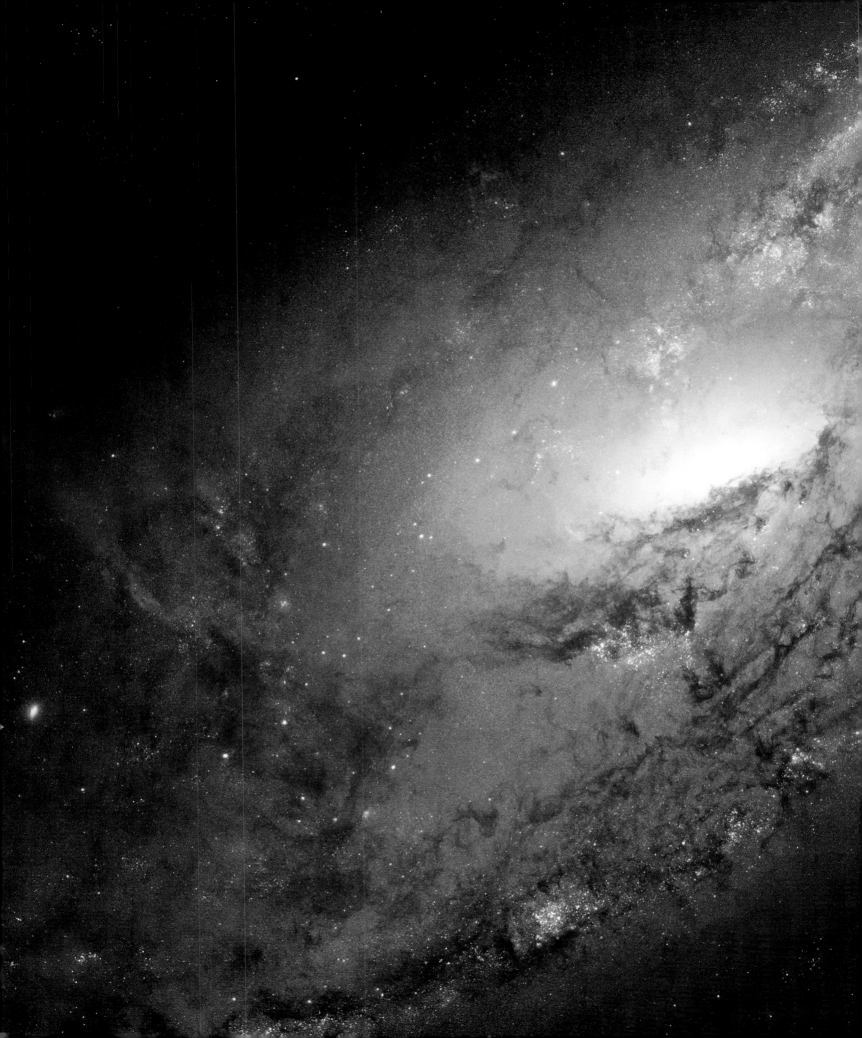

THE
HUBBLE
COSMOS

25 YEARS OF
NEW VISTAS IN SPACE

DAVID H. DEVORKIN AND ROBERT W. SMITH

IN ASSOCIATION WITH THE SMITHSONIAN
NATIONAL AIR AND SPACE MUSEUM

FOREWORD BY ROBERT P. KIRSHNER,
CLOWES PROFESSOR OF SCIENCE, HARVARD UNIVERSITY

NATIONAL GEOGRAPHIC

WASHINGTON, D.C.

Preceding pages: A composite image of M106, a spiral galaxy in Canes Venatici, made with images taken by successive instruments on Hubble combined with ground-based images

These pages: A star cluster in Scorpius. Hubble resolved the brightest stars, showing that they are among the most massive stars known.

CONTENTS

PART 01

LAUNCH AND AFTERMATH
MOMENTS 01–04

PART 02

REVIVAL AND REDEMPTION
MOMENTS 05–09

PART 03

REACHING DEEPER INTO THE RED
MOMENTS 10–12

PART 04

BIG NEW EYE
MOMENTS 13–18

PART 05

ULTIMA THULE
MOMENTS 19–25

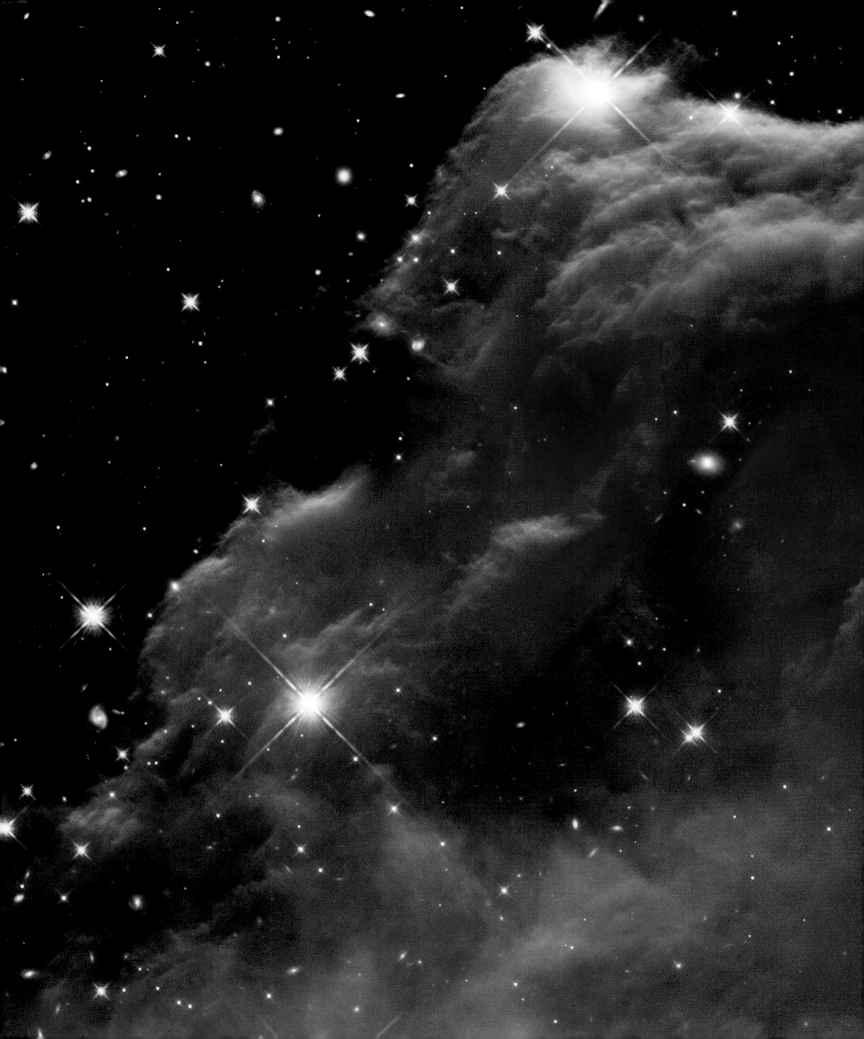

HORSEHEAD NEBULA (DETAIL)

OBJECT: DARK NEBULA
LOCATION: NEAR ALNITAK IN ORION'S BELT
DISTANCE: 1,400 LIGHT-YEARS
OBSERVED: OCTOBER 22, 2012–NOVEMBER 7, 2012

A composite image from exposures with the Wide Field Camera 3 and ground-based telescopes. These infrared images penetrate the cloud, revealing its structure but weakening its classic iconic shape. It is part of the much larger Orion molecular cloud complex.

M82 (THE CIGAR GALAXY)

OBJECT: STARBURST GALAXY
LOCATION: URSA MAJOR
DISTANCE: 12 MILLION LIGHT-YEARS
OBSERVED: MARCH 27–29, 2006

The Advanced Camera for Surveys/Wide Field Channel was employed to produce this four-color composite image of an unusual galaxy where stars are forming at rates far greater than in the Milky Way. NASA selected it to celebrate Hubble's 16th birthday in 2006.

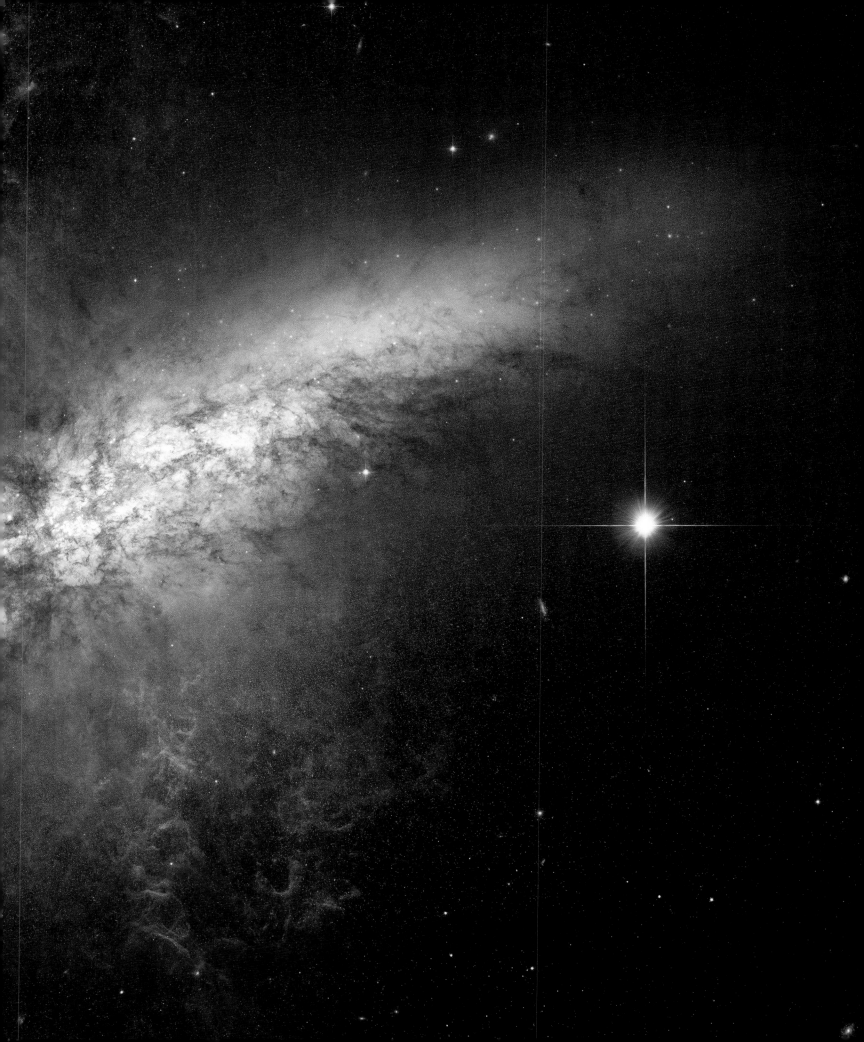

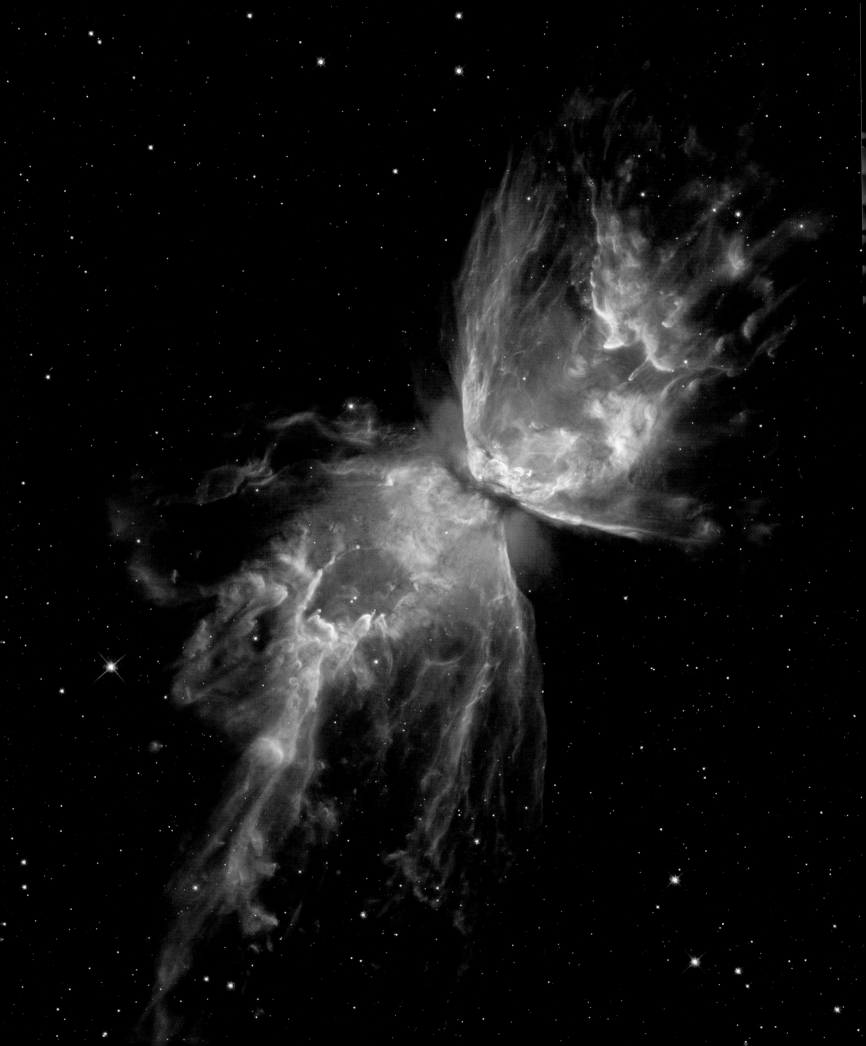

FOREWORD

To make progress in astronomy, build better instruments. This plan worked well for Galileo in 1610, and it has worked for my generation, too. For those of us growing up in the 1950s, Caltech's 200-inch telescope at Palomar Mountain shone as the pinnacle of scientific excellence. And, when I was eight years old, we went out in our backyard on an October night to see Sputnik orbiting over Massachusetts. I had no idea that these events had anything to do with each other, or with me. But that slightly ominous Soviet satellite helped spur investment in science in the United States, and I surfed that wave as a science nerd in high school and undergrad at Harvard. Then, as a graduate student at Caltech in 1972, I felt I had entered a cathedral when I used the Palomar 200-inch to observe a nearby supernova explosion. My thesis adviser, Bev Oke, kept going off to meetings at NASA about a big telescope in space. This became the Hubble Space Telescope.

During the lull in space shuttle launches after the 1986 *Challenger* disaster, while Hubble was being stored in Sunnyvale, California, there was a worldwide competition to decide what would be observed, and who was going to do it. As it turned out, I was awarded time to study supernovae with Hubble. I remember the frisson of excitement in opening the envelope with my first data tape from Hubble in 1990, sent second-day air from Baltimore. It had images of supernova 1987A that showed it was surrounded by a ring of gas, totally invisible from the ground—a key clue to the history of the exploding star.

During my lifetime, we've soared past the 200-inch (5-meter) telescope at Palomar to build 6-, 8-, and 10-meter telescopes on the ground, and we're headed for 30-meter telescopes—more than 98 feet. But Hubble has a mirror that's only 94.5 inches (2.4 meters) across. So why is it so special? Because the Hubble Space Telescope operates above our atmosphere. Like Sputnik, Hubble was launched by a powerful rocket into a low-Earth orbit only a few hundred miles up, but well above our atmosphere. And that represented a huge step forward in astronomical observations.

Our planet's air forms an opaque blanket that distorts our ground-based view of the heavens. The atmosphere screens out ultraviolet light. Worse, it glows in infrared light like a Times Square jumbotron. It even distorts visible light: Blobs of hot and cold air make images of space seen from Earth wobble and smear. The Hubble Space Telescope avoids all these burdens. Launched on the space shuttle to an orbit 350 miles above Earth, Hubble transmits images with a sharpness of vision that is limited only by the laws of physics and the wavelength of light. It is ten times better than looking up through the wiggly air.

The pictures in this book sizzle your retina, but you need deeper parts of your brain to understand what they mean. I hope it will ignite your curiosity about other planets that might harbor life; how stars form, live, and die; what galaxies are; and how invisible dark matter and dark energy rule the fate of the universe. These are astonishing ideas, but we need evidence to know which ideas are correct. The Hubble Space Telescope provides that evidence and opens the path for human imagination to explore the universe.

—Robert P. Kirshner, *Clowes Professor of Science, Harvard University*

A superhot dying star located just west of the Scorpion's stinger is creating the Butterfly Nebula by expelling enriched gas and dust into space. NASA chose the image as an example of the refurbished Hubble on September 9, 2009.

MOMENTS TO REMEMBER

ROBERT W. SMITH

The Hubble Space Telescope is a remarkable machine. But that was not a generally held opinion on June 27, 1990, a dismal day in the telescope's history. Just over two months earlier, Hubble had been lofted into space aboard the space shuttle *Discovery*. But the dream of observing the heavens with unprecedented clarity had already turned sour.

On the morning of June 27, I joined a crowded meeting of leading astronomers and NASA managers associated with the project. The attendees knew from earlier meetings or the rumor mill that there was a serious problem. The word was out: Hubble could not focus images nearly as well as expected. It suffered from spherical aberration.

On the afternoon of the same day, I watched a group of ashen-faced NASA managers, scientists, and engineers face puzzled and sometimes astonished questioners at a hastily called press conference. Surely Hubble was as perfect a telescope as could be? Hadn't NASA and astronomers proclaimed as much? Well, they had, but Hubble was far from as perfect as a telescope could be.

The news was now very public. "Spherical aberration" was splashed on newspaper front pages and discussed by TV anchors. A media frenzy had erupted. The telescope's patrons on Capitol Hill were dismayed and angry. One senator termed Hubble a "technoturkey." There were editorial cartoons showing the telescope as a flying lemon or being given an eye test by astronauts in space.

But even during the morning meeting on June 27, and especially in the follow-up discussions the next day, the mood was not one of devastation. Rather, there was already a determination in the air to figure out what had gone wrong and to fix things. Hubble might be down, but it was not out.

Three and a half years later, I attended another memorable news conference, this time to celebrate an impressively successful repair mission to Hubble by shuttle astronauts. Senator Barbara Mikulski, from Maryland, was one of the participants. She happily waved before-repair and after-repair star images taken by Hubble. The difference in the two images was striking, as was the mood in the room compared with the June 27, 1990, press conference. The trouble with Hubble, Mikulski proudly announced, was over.

As more astronomical results from Hubble began to flow in, the telescope was transformed from a national and international embarrassment to a symbol of technological and scientific prowess. It had certainly become one of the most significant machines ever devised for science, if not the most significant.

Hubble's results also repaired and radically remade its relationship with the general public. Not only was Hubble enabling astronomers to write streams of scientific papers, but also its images were regularly paraded and trumpeted on TV news broadcasts, in newspapers and news magazines, on T-shirts and coffee mugs, and in time on websites and social media, as these became more common. An image that became known as the Pillars of Creation proved to be especially powerful and an extraordinary game changer. It displayed a region of star formation

Wide Field Camera 3 (WFC3) infrared exposures of the so-called Monkey Head Nebula. The tortured shapes are caused by intense ultraviolet light from nearby hot blue stars. This image was part of a 24th-anniversary press release in 2014.

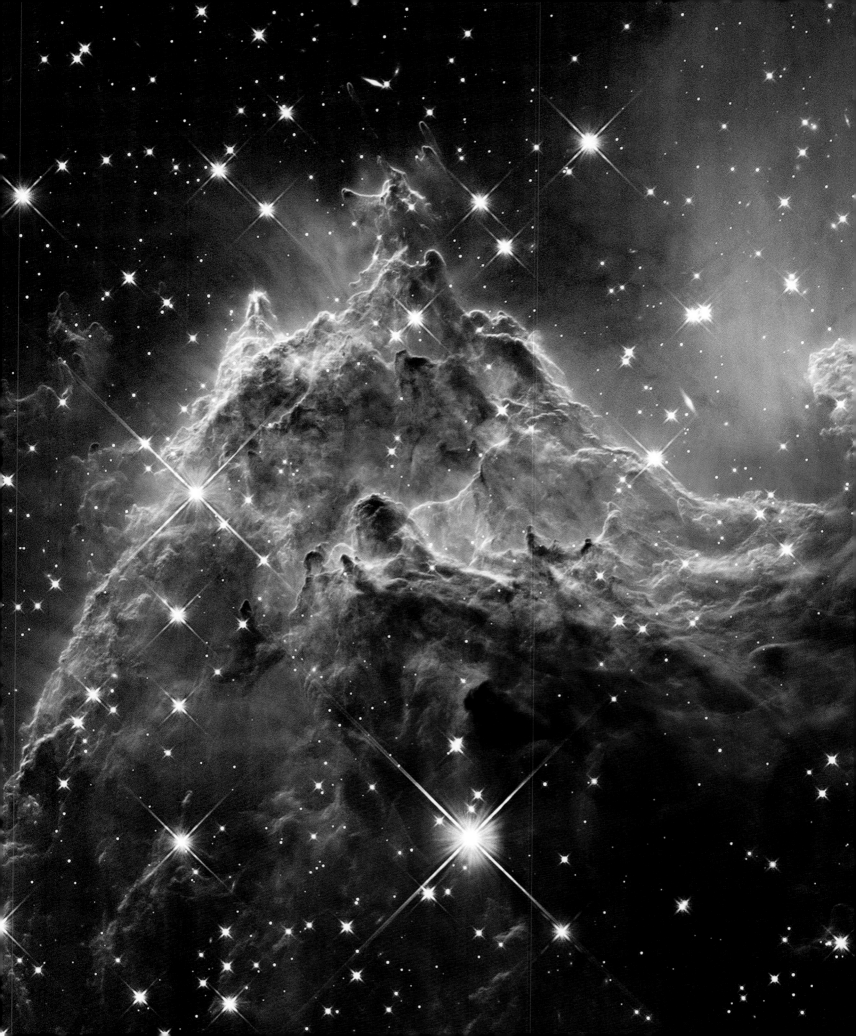

The core of Omega Centauri, a globular cluster, reveals a variety of stars in different stages of life, from late life (orange and red), to the enigmatic "blue stragglers," old stars that somehow have become rejuvenated through collisions.

some 7,000 light-years distant. As we explain, the first headlines in 1995 were ecstatic. The response of even professional publications was "giddy." As one art historian has put it, the Pillars of Creation "resonated across religion and popular science." In time, Hubble would itself become a celebrity, lauded in popular culture with its own enthusiastic fan base.

When in 2004, NASA Administrator Sean O'Keefe canceled what was planned to be the final servicing mission to Hubble, he provoked a storm of protest. The opponents included irate "Hubble huggers," fans of the telescope who were appalled that Hubble was to meet what they saw as an absurdly premature end at NASA's hands.

The servicing mission was reinstated and a shuttle flew to Hubble one final time in 2009. The astronauts arrived not a moment too soon. Hubble was in a very hobbled state. The repairs and updates breathed new life into the telescope, so that it is still a highly productive and state-of-the-art observatory that far more astronomers want to employ than there is observing time available.

The way those astronomers who did secure observing time on Hubble went about their business went beyond what had been anticipated when Hubble turned to the heavens in 1990. In traditional astronomy, researchers worked alone or in small groups. This was very much how Edwin Hubble, after whom the Hubble Space Telescope is named, pursued astronomy at the Mount Wilson Observatory in California in the early 20th century. His most famous collaboration was with just one other colleague, Milton Humason. The pair of them, as we present here, provided the evidence for the expanding universe, one of the great finds of 20th-century astronomy. The accurate measurement of the rate of that expansion has also been one of the

key goals of astronomers for many decades. Two teams of astronomers exploited Hubble to make this determination. The emphasis here is on teams—the team that produced what other astronomers regarded as the most credible result was made up in 2001 of 28 members from 23 institutions.

We will also examine a find as spectacular as the expanding universe, the discovery that the expansion is speeding up, that it is accelerating. This defied what astronomers had regarded as common sense. It was as unexpected as if someone on the surface of Earth lobbed a ball into the air and the ball, instead of arching back to the ground under the pull of gravity, shot upward at an increasing speed. Observations with Hubble played a crucial role in confirming the idea of an accelerating universe. Again, the astronomers who pursued these observations worked in sizable teams.

Just as Hubble's astronomers have often worked together in teams, so Hubble itself has often been employed as part of a joint attack with other telescopes—sometimes with other telescopes in space, sometimes with telescopes on the ground, and sometimes with both—on particular astronomical problems. In 1995, fragments of comet P/Shoemaker-Levy 9 hurtled into Jupiter. Hubble was watching, along with many ground-based telescopes. Another of Hubble's most stunning images—the Hubble Deep Field—revealed thousands of very distant galaxies. Once this image was published, tens of other telescopes were trained on this region of the sky as astronomers eagerly pressed to tease out its secrets. Hubble has also served as a "scout" for the New Horizons spacecraft that is speeding toward Pluto, hunting for additional moons and rings in order to prevent New Horizons plowing into them.

The most famous telescope ever built, a celebrity, a tool to remake the astronomical community, the most influential mediator ever between astronomers and the general public, a provider of data for the writing of thousands of scientific papers and often astonishing scientific findings, Hubble has been on an amazing 25-year journey. Who, on the afternoon of June 27, 1990, would have thought it all possible? The 25 Moments that follow trace the operational life of the Hubble Space Telescope. We offer them as signposts that indeed answer this question and point to the enduring significance of Hubble in our quest to learn about the universe.

EDITOR'S NOTE

In this book, we celebrate the Hubble Space Telescope story in 25 "Moments"— key turning points, accomplishments, and contributions, roughly chronological, all summing up a magnificent story about the telescope that has changed forever our picture of the universe we live in. Mixed among the moments, we share the "Hubble All-Stars"— National Geographic's selection of the telescope's most spectacular images. For ease of understanding, we include a list of acronyms and abbreviations on page 214.

STAR CLUSTER IN THE TARANTULA NEBULA

OBJECT: **STAR-FORMING REGION**
LOCATION: **LARGE MAGELLANIC CLOUD IN DORADO**
DISTANCE: **160,000 LIGHT-YEARS**
OBSERVED: **OCTOBER 20–27, 2009**

Composite Wide Field Camera 3 image, a snapshot in cosmic time.
The stars visible are a few million years old and will last a few more million.

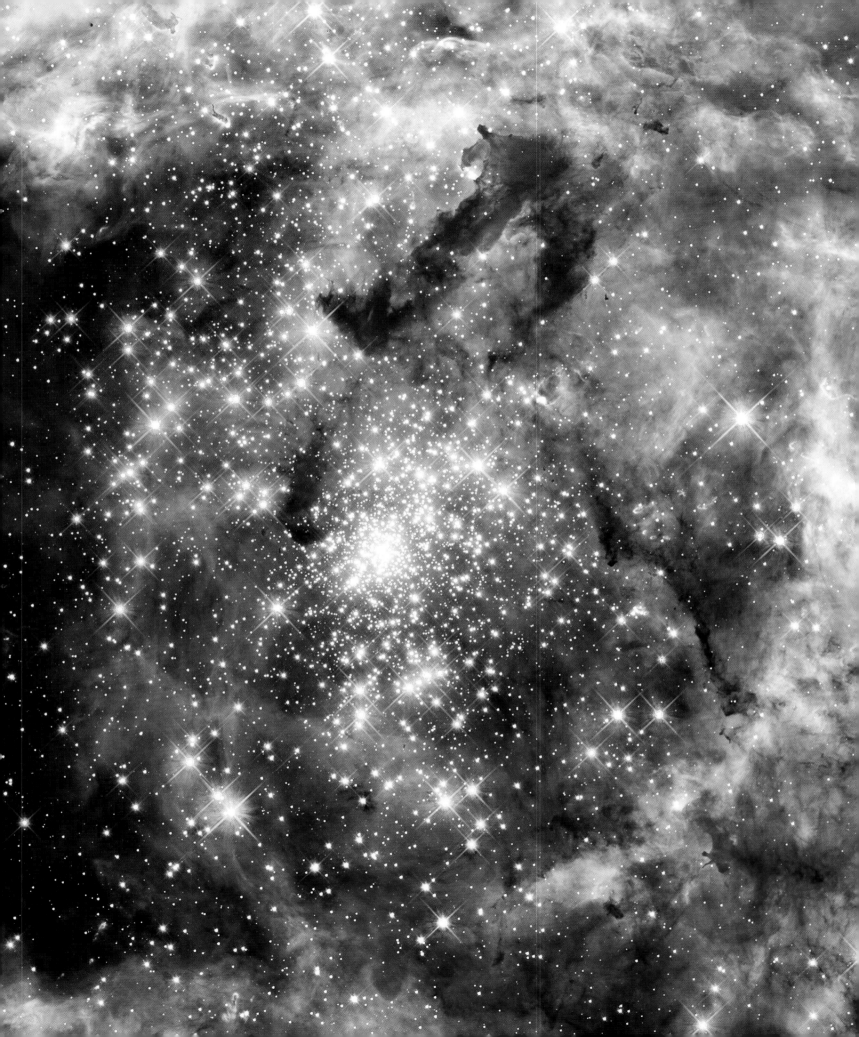

MACS J0416.1-2403

OBJECT: GALAXY CLUSTER AND GRAVITATIONALLY LENSED IMAGES
LOCATION: ERIDANUS
DISTANCE: APPROXIMATELY 4 BILLION LIGHT-YEARS
OBSERVED: JULY–SEPTEMBER 2012

Cluster of galaxies imaged by the ACS, WFC3, and a computed "mass map"
revealing the distribution of dark (or invisible) matter. The MAssive Cluster
Survey (MACS) is a program based at the University of Hawaii.

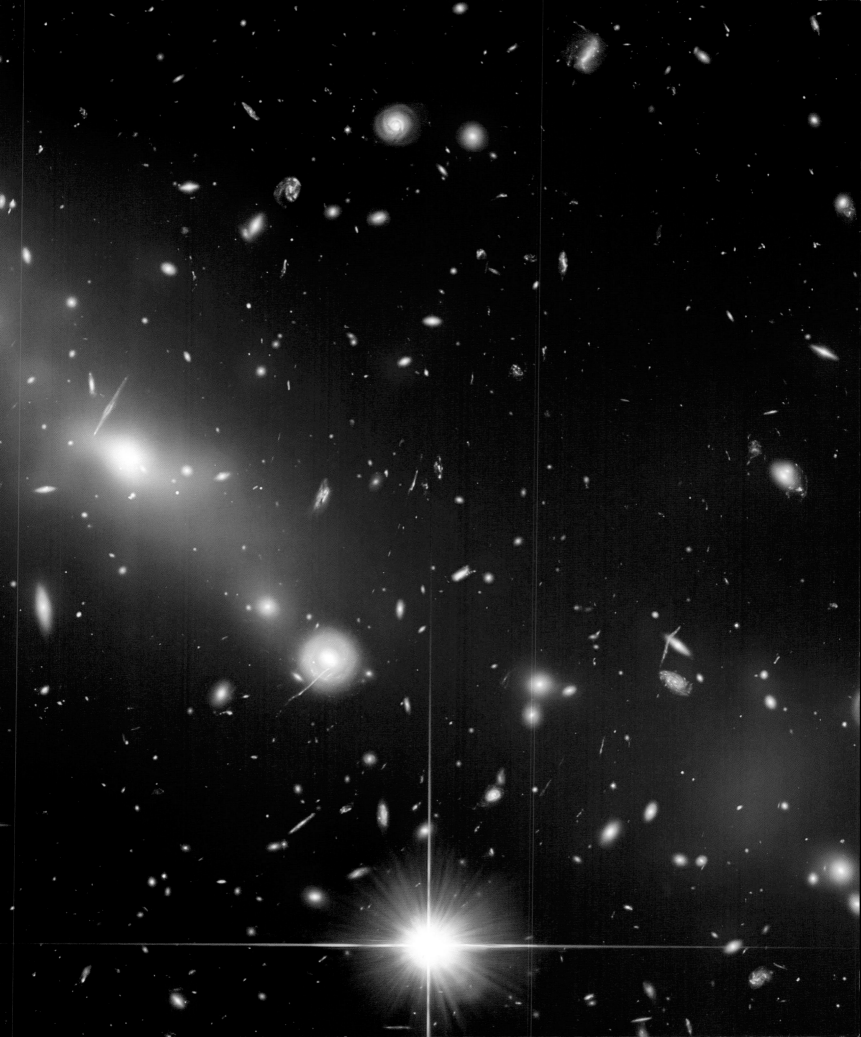

PART | 01

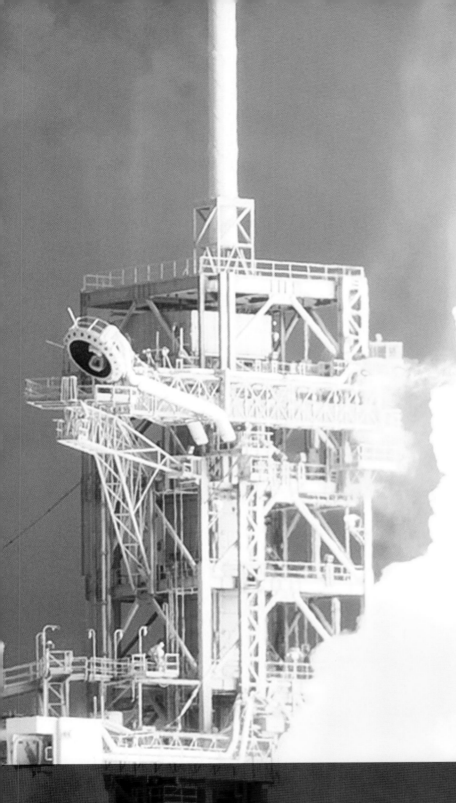

LAUNCH AND AFTERMATH

A TELESCOPE POISED ABOVE EARTH'S ATMOSPHERE
PROMISES NEW VIEWS OF THE UNIVERSE.

UP, UP, AND AWAY!

AFTER DECADES OF PLANNING,
HUBBLE TAKES FLIGHT.

ON APRIL 24, 1990, a crowd of spectators anxiously waited. From the busy viewing area of the Kennedy Space Center in Florida, they could see the squat form of the space shuttle *Discovery* pointing to the heavens from launch complex 39B. Stowed in the shuttle's payload bay was the Hubble Space Telescope—an instrument its builders believed to be the most complex and formidable optical telescope ever constructed. After a brief hold in the countdown at T minus

31 seconds, at 8:33 a.m. eastern daylight time, *Discovery's* engines ignited, and the shuttle rose slowly from the launch-pad on a growing pillar of billowing smoke and flames before it raced skyward.

AN EYE IN THE SKY

Among the crowd was Lyman Spitzer, Jr., a 75-year-old astronomer. For Spitzer, this day was the culmination of a long journey. In 1946, he had authored a report, "Astronomical Advantages of an Extra-terrestrial Observatory," which explained how lifting telescopes above the obscuring layers of Earth's atmosphere could deliver enormously exciting scientific returns across a range of astronomical areas. Spitzer believed it also had the potential "to uncover new phenomena not yet imagined, and perhaps modify profoundly our basic concepts of space and time." This grand vision drove Spitzer's efforts for decades to turn his dream into reality.

Preceding pages: Smoke billows around a launch complex at the Kennedy Space Center in Florida, as it did when the space shuttle *Discovery* soared skyward, carrying the Hubble Space Telescope on its long-awaited journey into space.

Born in 1914 in Toledo, Ohio, Spitzer was one of the leading scientists of his generation with a well-developed fondness for science fiction. When he completed his doctorate at Princeton in 1938, the idea of a large telescope in space was very much in the realm of imagination. But the strikingly rapid developments in rocketry during World War II deeply impressed him and, as he later recalled, "made it all seem possible." Spitzer's 1946 report was an outgrowth of this belief.

For most of the late 1940s and 1950s, astronomers were little interested in building space telescopes, however. An extraordinary amount of money would be needed, to say nothing of the enormous and novel technical challenges to be overcome to transform the idea of a space telescope into a working reality. During this period, Spitzer made little headway with his astronomer colleagues. As he later remembered, they "were all quite startled to have a serious astronomer talking about what one could do" with large telescopes in space.

The launch of the first Sputnik in October 1957, however, transformed matters radically. For those in the know, the

After decades of work by thousands of people across the United States and Europe, Hubble, carrying the hopes and dreams of astronomers, was launched into orbit by the space shuttle *Discovery* on April 24, 1990.

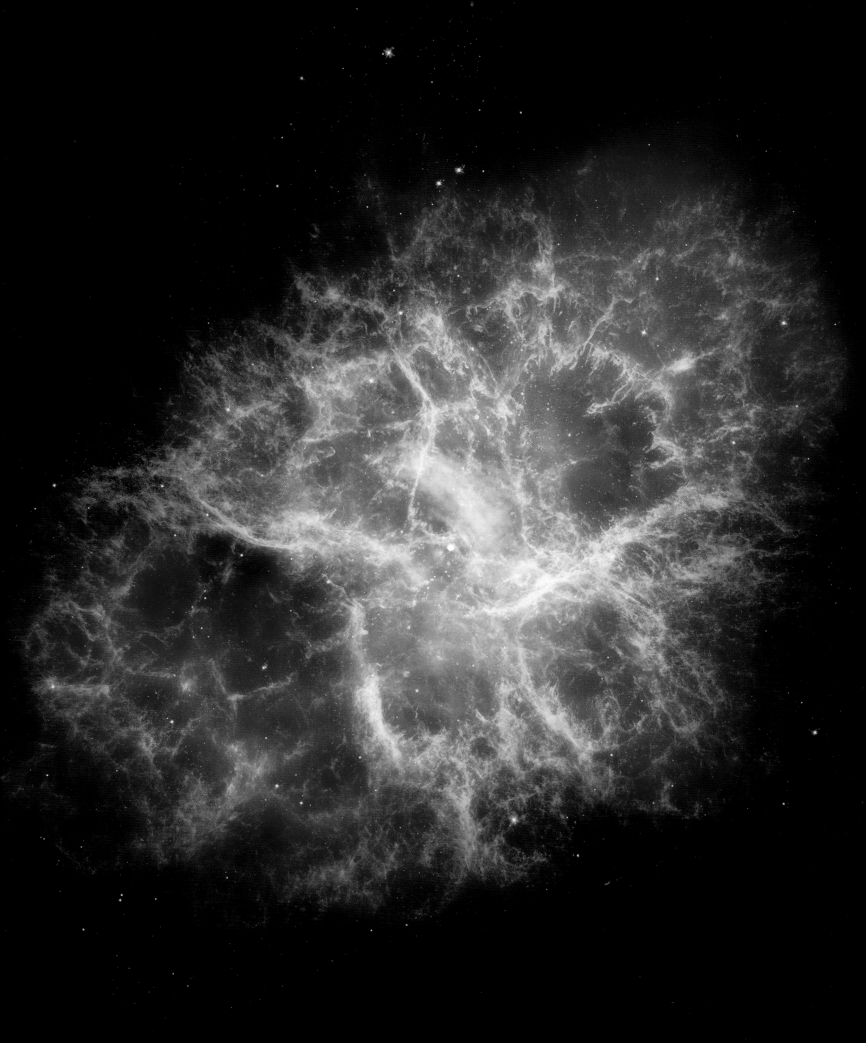

building of spy satellites to fly over the Soviet Union was already an important element of the Cold War. But as the United States set about trying to best the Soviet Union in what would come to be termed the "space race," a new government agency was formed in 1958—the National Aeronautics and Space Administration. While NASA's early years were dominated by competition with the Soviet Union and feats in human spaceflight, the new space agency also pursued a wide range of scientific projects. These included a number to do with astronomy from above Earth's atmosphere via rockets and satellites.

Spitzer's grand plans for a large space telescope were no longer in the realm of science fiction. They had also become even more ambitious. In 1962, for example, he delivered a lecture to the third International Space Sciences Symposium and examined the sorts of astronomical questions that a space telescope could tackle. The "ultimate" telescope of this sort, he reckoned, would be one with a primary mirror 400 inches in diameter.

With the urging of Spitzer and a group of like-minded enthusiasts, planning for a big space telescope picked up some steam in the late 1960s. A space telescope with a 400-inch mirror was never in the cards, however. The challenges were reckoned to be daunting even for a telescope with the selected size of 120 inches.

In fact, even for much smaller orbiting telescopes, the learning curve for astronomers and engineers was very steep. The program of Orbiting Astronomical Observatories, for example, saw a mix of failures and successes. The first of these observatories was launched in 1966, but lasted in orbit only a few days before a catastrophic failure occurred. (Most likely the batteries overheated.) Orbiting Astronomical Observatory-3, on the other hand—later to be named Copernicus—carried an ultraviolet telescope with a primary mirror 32 inches in diameter and returned scientific data for 9 years.

The Crab Nebula is a rapidly expanding envelope from a star that was recorded by many cultures as a nova in 1054. This is a composite image built up from data from the three Great Observatories: Hubble, Chandra, and Spitzer. See also page 34.

HST FACT

Lyman Spitzer finally got a telescope named after him in December 2003, when NASA launched the Spitzer Space Telescope, devoted to infrared astronomy.

BUILDING THE DREAM

By the early 1970s, with the support of NASA, hundreds of astronomers and engineers at numerous companies, government labs, and universities across the United States and Europe were tackling the problems associated with the design and operation of a "Large Space Telescope"—renamed the Hubble Space Telescope in 1982 in honor of American astronomer Edwin Hubble. In 1974, however, these plans ran into stiff opposition in the U.S. Congress, as a number of members were very concerned by the likely cost and were not convinced of the worth of such a telescope. In the face of this threat, astronomers embarked on a series of political campaigns. Spitzer and his colleague John Bahcall played especially important roles between 1974 and 1977 in leading a vigorous drive by astronomers to win congressional approval for Hubble. Industry representatives were also extremely active. Without the advocacy efforts of many people, Hubble might never have gotten off the drawing board.

By 1977, Congress had granted approval to start the detailed design and construction of Hubble. NASA had also secured by this date the agreement of the White House and Congress that the space agency would work jointly with the European Space Agency, headquartered in Paris, France.

Some thought had been given earlier to basing a large telescope on the moon, but these schemes had faded even before the end of the Apollo program in 1972, as there was no likelihood that astronauts would be returning to the moon any time soon. Hubble would instead be launched into orbit around Earth by the space shuttle. The space shuttle was NASA's key program. And what was the point of building it if there were no suitable payloads for it to carry to space? Advocates for Hubble pointed to the advantages of the use of the shuttle, and advocates of building the shuttle emphasized how useful it would be for payloads like Hubble.

Unlike any astronomical space telescope before or since, a crucial feature of Hubble's design was that it was planned from the very start to be serviceable. Every few years, astronauts would visit Hubble to update and repair equipment to ensure it would have a much longer and more productive

lifetime than the typical scientific spacecraft. New and more advanced scientific instruments could be periodically exchanged for older and less capable devices. Every so often—perhaps every five years—the shuttle could even collect Hubble from its orbital perch, stow it in the shuttle's payload bay, and return it to Earth for more serious upgrades. With the enhancements completed, Hubble would be returned to space. Much of Hubble was therefore designed to be readily replaceable in orbit. All of the scientific instruments, for example, were designed to fit inside roughly phone-booth-size modules that could be both removed from and inserted into Hubble quite easily (though no operations in space are that easy!). Hubble would also be a completely automated observatory. It would circle hundreds of miles above Earth, but commands would need to be sent to it regularly from the ground.

INNER WORKINGS

The heart of Hubble would be a 94.5-inch primary mirror. This reduction from the originally planned 120-inch mirror was made because a smaller mirror was reckoned to save money and make the task of building it easier. The primary mirror's job would be to collect and direct light from astronomical objects onto a much smaller secondary mirror. From the secondary mirror, the light would be reflected through a hole in the center of the primary mirror to a battery of six scientific instruments for analysis. Technically, no photographs would be taken aboard the Hubble itself. Rather, each of the scientific instruments exploited electronic detectors to catch and record the light that reached the telescope so that the information gathered could be radioed back to Earth. The instrument expected to be the workhorse of Hubble was the Wide Field Planetary Camera (WFPC), conceived and built by a team led by Jim Westphal of the California Institute of Technology that included James Gunn, William Baum, Sandra Faber, and many others. At the camera's core were two sets of four electronic detectors, called CCDs (charge-coupled devices), novel technology at the time, but versions of the CCDs would soon be extremely common, first in video cameras and then in mobile phones.

Construction of Hubble began in 1978. It involved a massive industrial, technical, and scientific effort and the labor of thousands of people. The engineering and managerial challenges were forbidding, as getting Hubble to meet all its various performance requirements pressed the state of the art in many areas. The various components of Hubble were nevertheless starting to be shipped for assembly and testing to the Lockheed Missiles and Space Company in Sunnyvale, California, by 1984. Indeed, Hubble's route to space lay through Sunnyvale, as the entire telescope would be put together there before being shipped to Florida's Kennedy Space Center. Designing and

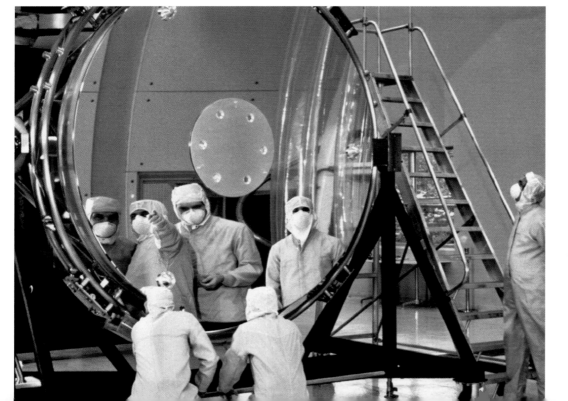

The heart of the Hubble Space Telescope is its primary mirror. Measuring 94.5 inches in diameter, it works in combination with Hubble's secondary mirror to direct light to the telescope's set of scientific instruments.

A TELESCOPE BY ANY OTHER NAME . . .

The Hubble Space Telescope was known by a variety of names before it was finally named after astronomer Edwin P. Hubble. In the late 1950s, plans were aired for a Large Orbital Telescope that might be serviced and maintained by a nearby space station. In 1965, Boeing completed a feasibility study of a Manned Orbiting Telescope, underlining that it would be regularly visited by astronauts—a bold new idea, since 1965 had seen the very first space walk by a U.S. astronaut, Ed White, who had clambered out of his Gemini spacecraft while it orbited Earth.

The advocates of a large telescope in space, however, were anxious to keep the support of those astronomers interested in placing such a telescope on the moon. For a time, then, the chosen name was the Large Space Telescope, which carried no implications about location. Some astronomers especially liked this name as they took the initials LST to stand for "Lyman Spitzer Telescope," so closely was Spitzer associated with the plans to put a big optical telescope into space. But in the throes of the battles with Congress over funding that ran from 1974 to 1977, the word "Large" was dropped from the name, as NASA officials worried that it expressed an unwanted air of extravagance. Thus, the Large Space Telescope became the Space Telescope.

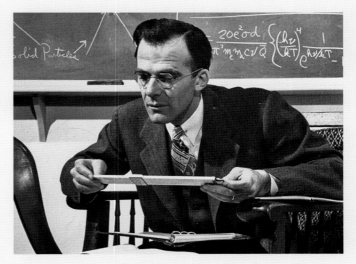

Lyman Spitzer's enthusiastic advocacy of space telescopes led to Hubble's success. An astronomer and plasma physicist, Spitzer was one of the nation's leading scientists for half a century.

At last, in 1982, the decision was made to change the name to honor one of the leading American astronomers of the first half of the 20th century, Edwin P. Hubble. Hubble had made his reputation observing the most distant objects in the universe, and the Hubble Space Telescope was expected to make its main scientific contributions by doing that too.

building individual components for Hubble was one thing, but getting all the parts to function together harmoniously was a very different matter. Matters did not always run smoothly, but by early 1986, Hubble was slated to be launched into space later in the year.

However, the Hubble team faced a devastating setback on January 28, 1986. That morning the space shuttle *Challenger* was destroyed 73 seconds after lifting off from the Kennedy Space Center. All lives were lost. As the nation mourned their deaths, investigators from inside and outside NASA set about determining what had gone wrong and how such a disaster might be avoided in the future. For the time being, the shuttle fleet was grounded, and Hubble's flight into space postponed.

HUBBLE HOME AT LAST

Four years later, in April 1990, the shuttles were flying again. Hubble was at the Kennedy Space Center being readied for its launch aboard *Discovery*. The first launch attempt on April 10 was aborted, but two weeks later, with its crew of five astronauts as well as the space telescope, *Discovery* reached its planned orbit of 380 miles above Earth. The next day, April 25, Hubble was gently swung out of the cargo bay and deposited into space by the shuttle's robotic arm.

After a journey of more than two million miles and 80 orbits, *Discovery* returned to Earth four days later. The big question now: How well, after billions of dollars had been spent on it and thousands of people had labored over it, would Hubble perform?

ARP 240 NGC 5257
AND NGC 5258

OBJECT: INTERACTING SPIRAL GALAXIES
LOCATION: VIRGO
DISTANCE: 300 MILLION LIGHT-YEARS
OBSERVED: DECEMBER 30, 2001

A pair of interacting spiral galaxies shows tidal disruption in faint tendrils acting as a bridge between them in this image, released on the mission's 18th anniversary in 2008. The images with diffraction spikes are stars in our galaxy.

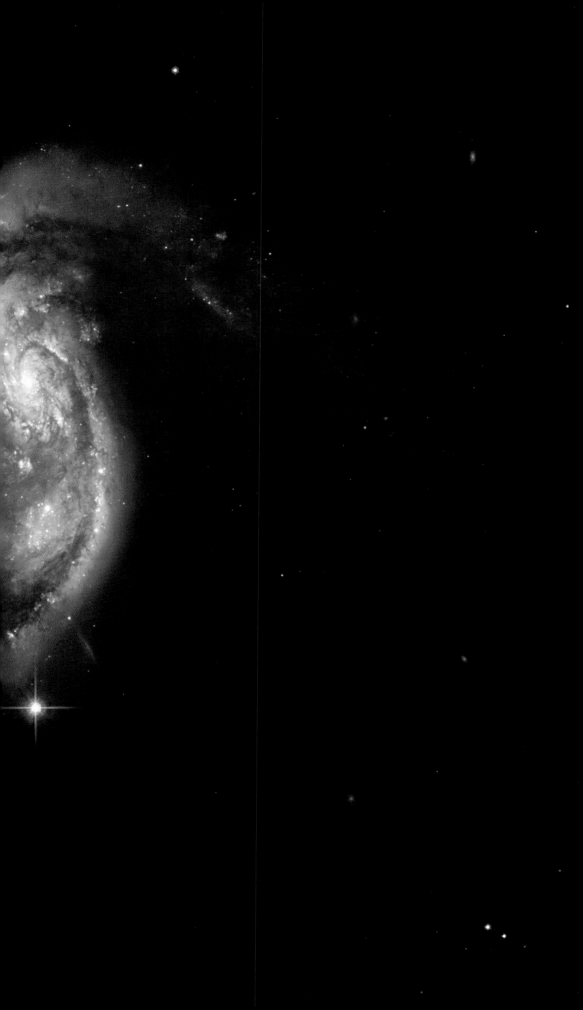

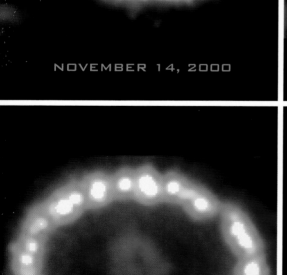

SEPTEMBER 24, 1994

FEBRUARY 6, 1998

NOVEMBER 14, 2000

MARCH 23, 2001

DECEMBER 6, 2006

JUNE 13, 2011

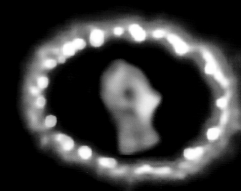

Su
ov
Th
of
ov
th
sta

ON THE MORNING OF FEBRUARY 23 OR 24, 1987, depending upon where on Earth you were located, news arrived that something truly stupendous had taken place somewhere in the Large Magellanic Cloud, a companion galaxy to the Milky Way galaxy, some 160,000 years ago. That news was undetectable to all but three very special energy detectors on Earth. The bulk of the vast stream of particles signaling the event, elusive neutrinos, passed right through us

on Earth without our feeling anything. Nineteen of them were caught in deep pools of water, near Kamioka, Japan, under Lake Erie, and in Europe. But no one knew this for weeks.

On the same day, a few hours later, a new star appeared in the Large Magellanic Cloud, and it was soon found by astronomers observing on a high mountain in the Chilean Alps. It could just be seen with the naked eye, which meant it was something really big. These astronomers instantly sent out the word: They alerted a clearinghouse for short-lived phenomena centered at the Smithsonian Astrophysical Observatory in Cambridge, Massachusetts; they sent out electronic mail alerts and telegrams, telling astronomers where to look. Within hours, the world's telescopes (those in the Southern Hemisphere at least, and those in space) were looking at the brightest supernova in the past 400 years.

Unfortunately, Hubble was not one of them—not yet. In the long run, though, Hubble would become a key player.

EYES ON THE SKY

Those telescopes that were in space and on the ground in 1987 did a great job, but they were stretched to their limits.

Within hours, the International Ultraviolet Explorer, or IUE, in geosynchronous orbit 22,500 miles above the Atlantic Ocean, was turned to the star by astronomers at Goddard Space Flight Center in Greenbelt, Maryland. They first saw it electronically as a bright point of light, but that was only to set it on the telescope's spectrographs, to sift the light into spectra to determine what was actually happening. Within the first eight hours, the astronomers confirmed that the supernova was truly in the Large Magellanic Cloud. Simultaneously, observations from observatories in Chile showed that it was indeed an explosion, with a debris cloud expanding at 11,000 miles a second on the first day, slowing to 9,300 miles a second on the second day.

The light spectrum of the explosion changed constantly. Some of the changes matched theoretical predictions, but many others caused astronomers to frown. Why was the ultraviolet light not increasing as much as the visible light? And why was the object not symmetrical? The irregularity of the fuzzy pixelated image, pushing the limit of resolution for the 18-inch IUE mirror and its electronic detectors, made astronomers wonder: Just what had blown up? For some time they

MOMENT
02

REQUIEM FOR
A MASSIVE STAR

HUBBLE JOINS THE WORLD'S TELESCOPE TEAM
AND HELPS EXPLAIN A STARRY EXPLOSION.

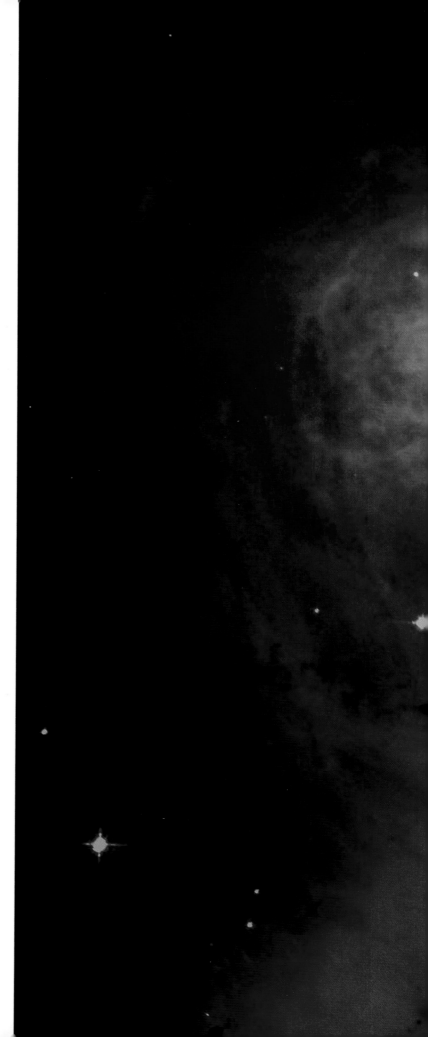

went back and forth between the images and the spectra, unraveling the scene. The supernova was very close to the position of a blue supergiant star that had been faithfully recorded in the past, and that star had a faint companion. Which star had exploded? And when all the gas and dust cleared, what would be left? A rapidly rotating neutron star called a pulsar, or even a black hole? These questions kept x-ray and radio astronomers at their helms.

OBSERVATIONS OUTRUN THEORY

The Goddard astronomers presented their puzzling findings at a hastily called meeting, which included astronomers from the nearby Space Telescope Science Institute (STScI) in Baltimore, the operations center for the planned Hubble Space Telescope. Although Hubble was still years from flight, astronomers there were already at work, devising new, highly powerful image-processing techniques. They applied their new computer codes to the data coming in from the IUE, and lo and behold! They found a third star. After a month of wrangling the data, they determined that a blue supergiant had exploded. This surprised everybody: Until then, supernovae were believed to originate from red supergiants, vastly bloated dying stars like Betelgeuse, and not blue giants, like Sirius. More questions arose.

The IUE, along with x-ray satellites in orbit and telescopes on the ground, monitored the fading light from the supernova as constantly as possible, while theorists scrutinized its behavior, fitting the observations to then held ideas about what happens when stars explode. This revolutionary astronomical phenomenon, named SN 1987A, was mentioned more than 3,000 times in the astronomical literature in the next three years. Observations continued, and SN 1987A kept expanding rapidly, still about 6,500 miles a second. At that rate, a pulse could travel from Earth to the sun in just under four hours.

Astronomers kept watching, hoping to see some structure that made sense. The IUE and ground-based instruments

An optical (Hubble) and x-ray (Chandra) image of the heart of the Crab Nebula mapping out motions in the medium surrounding the central star, a rapidly rotating neutron star called a pulsar. In time, when the gas and dust clear, SN 1987A may reveal a similar object in its core.

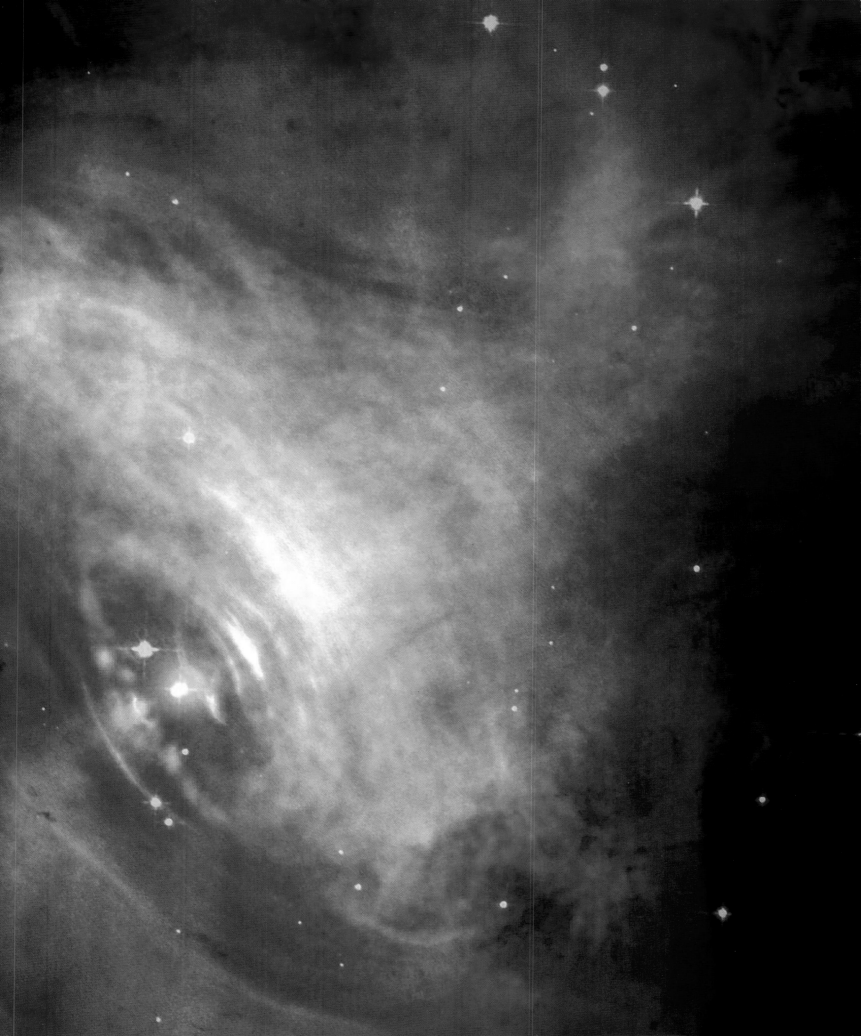

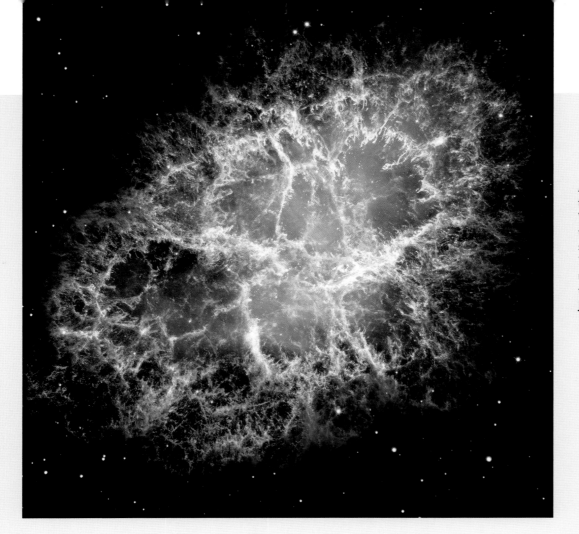

A Crab Nebula mosaic from 24 exposures with the WFPC2. The Crab Nebula, the remnant of a massive star that exploded some 7,500 years ago, was first recorded in the constellation Taurus by Chinese and Japanese astronomers in 1054 (see also page 24).

MAKING "SUPERNOVA" A HOUSEHOLD WORD

Since the late 1930s, astronomers have known that there are, roughly speaking, two classes of novae, or "new stars"—ordinary novae and supernovae. Ordinary novae, we know today, come mainly from stars interacting in orbit around one another, close enough so that mass from one gets gravitationally ripped from it and falls onto the surface of the other star, usually a white dwarf—an extremely dense, "old" star near the end of its life. The infalling matter heats the surface of the white dwarf enough to cause hydrogen to fuse into helium, a nuclear reaction that vastly brightens the surface of the star.

Supernovae, however, come in two basic types, depending upon how they change in brightness over time. Type I is similar to the binary accretion mechanism for novae, but at a larger scale. The binary accretion mechanism involves a system of two stars where material from one star falls on the other through tidal interaction—the star getting bombarded eventually blows up. Type II supernovae (the type for SN 1987A), on the other hand, are very massive stars that have exhausted all known forms of nuclear fusion in their cores. They've consumed available hydrogen, helium, and their nuclear by-products, carbon,

oxygen, nitrogen, and now are faced with trying to consume iron. Iron fusion, however, requires energy. It does not produce energy. So the star finds itself a vastly expanded mass with nothing to support it. Inner portions rapidly collapse and heat up, compressing matter in the very center into the most dense and impenetrable state of matter known to science: neutrons. The rest of the infalling material, the bulk of the star, hits this wall and is repelled so violently that it is blasted out into space, creating an explosion that can match the combined energy emitted by an entire galaxy.

The bright star observed and recorded in 1054 by the Chinese and Japanese, and evidently seen by many who looked at the sky, because it became at least four times brighter than Venus, is today linked to what we call the Crab Nebula, in the constellation Taurus. The Crab—so-called because when William Parsons, third Earl of Rosse, first glimpsed it and drew it in the 1840s, it had tendrils making it look like a crab—is some 6,500 light-years away, expanding at more than 600 miles a second. There is a pulsar at its heart. In another 1,000 years, SN 1987A might look something like this.

soon found evidence of a tiny shell around the star. But its structure and its luminous properties were getting harder and harder to discern as its fading light combined with nearby stars. The existence of faint rings thought to be light echoes were finally substantiated.

WARNING: SUPERNOVA EXPLOSION AHEAD

Enter the Hubble Space Telescope. Harvard astronomer Robert Kirshner, who had worked closely with Goddard astronomers peering at SN 1987A, kept his sights on the object once he joined the Hubble team. They started working on the star in August 1990, and within six days the Space Telescope Science Institute issued a press release that included a colorized raw image. Despite an optical flaw in the main mirror, the press release stated, the Hubble Space Telescope had "resolved [in] unprecedented detail" this "mysterious elliptical ring of material around the remnants of Supernova 1987A."

The press release described the ring itself as the superheated remains of the outer part of the star that was now some 1.3 light-years across. By this stage, theory had caught up to the observations, and theorists had managed to create models whereby blue giant stars could indeed blow up as well as models to make red supergiants contract into hot blue stars before they blow up. So for a moment, once again, some astronomers wondered if this meant that Sirius, the Dog Star in our winter sky and only eight light-years away, might explode. Various stories from ancient times had indeed described it as a red star. Should we worry?

Hubble's Faint Object Camera (FOC), provided by the European Space Agency, continued to monitor the supernova, and by the end of 1990 it found that the supernova was ejecting material in clumps, not in a uniform stream. Carefully measuring its size, speed, and inclination, astronomers also realized that this ejected material came from the equator of the star several thousand years before the actual explosion itself. It was not a remnant of the supernova, but a burp signaling a supernova would be coming.

HST FACT

When supernova 1987A exploded, 50 trillion neutrinos are estimated to have passed through everyone on Earth.

It was a warning, coming from far off in the universe, that a supernova was about to explode. The ability to predict short-lived violent events in nature can be important for survival, not to mention act as a tool for learning about what makes things tick. Astronomers would love to know ahead of time that a star was about to explode into a supernova. All sorts of telescopes (optical, radio, infrared, x-ray, gamma ray) would be turned to it and then watch it go through the complexity of trying to blow itself up, sometimes succeeding, as in a supernova.

But what if that supernova happened to take place in a star close to us, like Sirius or Betelgeuse? Is such a thing possible, and when—and then what would happen? Present opinion is that we have nothing to worry about because there is no star close enough (less than about 75 light-years) to bother us, but do we know everything there is to know about the mechanisms promoting a supernova? As Nobel laureate Charles Townes reminded us, in a 2014 University of California press release reporting evidence that the red supergiant star Betelgeuse is shrinking: "Whenever you look at things with more precision, you are going to find some surprises and uncover very fundamental and important new things." So the motto is: Be prepared. And Hubble helps us be prepared.

JELLY BEANS IN THE SKY

Meanwhile, astronomers now understand exploding stars more fully, thanks to the Hubble Space Telescope. "The Hubble observations have helped us rewrite the textbooks on exploding stars," said Kirshner in 2007. "We found that the actual world is more complicated and interesting than anyone dared to imagine." Indeed, the closer astronomers look, and the longer they look as changes take place, the more complex become the supernovae in our universe. "We thought the explosions were spherical and we didn't think much about the gas a star would exhale in the thousands of years before it exploded," said Kirshner. "The actual shreds of the star in SN 1987A are elongated—more like a jelly bean than a gumball—and the fastest-moving debris is slamming into the gas that was already out there from previous millennia. Who would have guessed?"

NGC 346

OBJECT: STAR CLUSTER, BRIGHT NEBULAE, DARK FILAMENTARY NEBULAE
LOCATION: SMALL MAGELLANIC CLOUD IN TUCANA
DISTANCE: 210,000 LIGHT-YEARS
OBSERVED: JULY 2004

Star cluster embedded in a large star-forming region of gas and dust in the Small Magellanic Cloud. The image was made from data taken with the ACS.

HH 901/902

OBJECT: **STAR-FORMING REGION**
LOCATION: **CARINA**
DISTANCE: **7,500 LIGHT-YEARS**
OBSERVED: **FEBRUARY 1–2, 2010**

Composite image derived from ultraviolet and visible data from the WFC3
of a star-forming pillar in the Carina region. Within the nebula are active
Herbig-Haro (HH) protostars, whose jets are barely visible here.

Supermassive black holes reside at the hearts of galaxies. They pull material from the rest of the galaxy onto a swirling disk of gas and dust. As shown in this artist's impression, they can also fire out jets of energetic particles.

THE SPACESHIP U.S.S. *PALOMINO* is near the end of a long journey exploring space. Events take a totally unexpected turn, however, when the crew chances upon a black hole near to which, in apparent defiance of the laws of nature, is another spaceship that should long ago have been ripped to shreds by the huge gravitational attraction of the black hole. What's going on? So begins the Disney movie *The Black Hole*, released just in time for Christmas audiences in 1979.

SEEING WHAT CANNOT BE SEEN

ASTRONOMERS NOW HAVE THE TOOLS TO TURN BLACK HOLES FROM THEORY TO OBSERVABLE FACT.

The basic concept of a black hole—a volume of space where the gravity is so powerful that nothing, not even light, can escape from it—had already left the pages of abstruse physics journals and become a staple of science fiction stories. Black holes entered more fully into popular culture and everyday language a decade later, given a big push by Stephen Hawking's best-selling book *A Brief History of Time*, a work that transformed Hawking into a scientific icon. Two decades later, Hubble played a key role in demonstrating that supermassive black holes are everywhere in the universe.

A MATTER OF GRAVITY

The original scientific celebrity, Isaac Newton, also thought deeply about the workings of gravity. The first scientist to be given a state funeral, Newton's abilities implied to his contemporaries that he was scarcely human. As one poet of the time put it: "Nature and Nature's laws lay hid in night: God said, 'Let Newton be!' and all was light." Newton made his biggest splash with the publication in 1687 of his book *Mathematical Principles of Natural Philosophy*. Here, among other things, he explained the operations of "universal gravitation" as a force that acts between each and every body in the universe. He thereby provided a remarkably successful account of the motions of bodies within the solar system. Based on Newton's theory of universal gravitation, spacecraft have been guided to all of the planets.

Newton also wrote a popular account of some of his theories. In so doing, he invited his readers to consider the firing of a cannon from a mountaintop. Depending on the speed of the cannonball, it would reach different distances from the mountain before hitting the ground. To calculate that distance, Newton pointed out, he had to take account of the curvature of Earth. Moreover, if the cannonball was fired from the cannon with just the right speed, the downward motion of the cannonball would match exactly the Earth's curvature, and so the falling away of the surface of the Earth matched the falling of the cannonball. In these circumstances, the cannonball would never hit the ground. We would say the cannonball was sent into orbit. Today, this sort of orbital motion is thoroughly familiar from satellites like Hubble that circle a few hundred miles above Earth at about 18,000 miles an hour.

If we press this idea a bit further and consider a rocket blasting off from Earth, we can ask how fast it would need to

SYNERGY AMONG TELESCOPES TO FIND BLACK HOLES

Astronomers had used observations from space to identify a candidate black hole long before Hubble was launched. The candidate was Cygnus X-1, the brightest x-ray source located in the constellation Cygnus (the Swan). Cygnus X-1 was found in 1964, using instruments aboard a rocket. Later, the x-ray observatory Uhuru continued the study. Launched into orbit from a platform off the coast of Kenya in 1970, the space telescope was named Uhuru, the Swahili word for "freedom," because the launch took place on Kenyan Independence Day.

Uhuru's position in orbit gave astronomers the freedom to study in the x-ray spectrum without interference from Earth's atmosphere, which blocks x-rays. Satellites and rockets are therefore essential in the study of black holes such as Cygnus X-1, which is believed to be the result of a binary system—two stars in orbit around each other, one a supergiant star and the other a black hole. Material blown from the star forms what is called an accretion disk, a swirling disk of gas, around the black hole. Friction heats up the disk so that it gets intensely hot and x-rays are emitted. Hubble's instruments are sensitive to optical light as well as some ultraviolet and some infrared radiation, but they are unable to see x-rays. X-ray telescopes work on quite different principles from optical telescopes, as x-rays possess so much energy, they will simply pass through a regular telescope mirror. Accretion disks also emit gamma rays. As for x-rays, the only ways to study gamma rays directly from objects in the cosmos is to fly instruments above Earth's atmosphere or infer their existence from ground-based optical detectors that sense the high-energy interactions of gamma rays with atoms in Earth's atmosphere.

Uhuru blazed the trail for later x-ray observatories, the most sophisticated of which to date is the Chandra X-ray Observatory, launched in 1999 and named for the astrophysicist and co-winner of the 1983 Nobel Prize in physics, Subrahmanyan Chandrasekhar. Hubble has often worked in tandem with the Chandra X-Ray Observatory, as we will see in later Moments.

be moving for it to escape from Earth and break free of its gravity. The answer is about 7 miles a second, or nearly 25,000 miles an hour—and so we can say that the "escape speed" is 25,000 miles an hour.

Some decades after Newton's death, instead of examining the pull of gravity on a cannonball, astronomer John Michell pondered the attraction of light by gravity. Light, Michell knew, travels enormously faster than a cannonball (at about 186,000 miles a second). He wondered what the escape speed would be from the sun and worked out that it would be about 500 times smaller than the velocity of light. Michell went on to argue that a star with a radius about 500 times larger than the sun, if it had the same density as the sun, would trap all the light that it emits, or as he put it, "all light emitted from such a body would be made to return towards it, by its own proper gravity." Michell's argument can be criticized on the grounds of modern physics, but the crucial point is that he grasped that if an object's escape velocity is greater than the velocity of light, it will be invisible, since no light can reach an observer positioned outside of it. Michell had described what we now call a "black hole."

DETECTING THE INVISIBLE PERTURBER

Invisible, yes, but Michell then suggested it was still possible to detect such a black hole. If other objects—stars, say—that we *can* see are in motion around the black hole, then "we might still perhaps from the motions of these revolving bodies infer the existence of the central ones with some degree of probability, as this might afford a clue to the apparent irregularities of the revolving bodies, which would not be easily explicable on any other hypothesis."

When early in the 20th century Albert Einstein developed general relativity, a theory of gravitation whose basis was radically different from Newton's, it, too, implied the existence of black holes. But for decades, such an idea was widely taken to be a mathematical curiosity rather than a likely physical reality. This attitude started to shift in the 1960s, as astronomers became increasingly interested in the fate of stars. Some astronomers now argued that it would be possible for a star much more massive than the sun to explode as an enormously violent supernova, its core imploding in on itself to form a black hole.

SUPERMASSIVE BLACK HOLES?

By the time of Hubble's launch in 1990, there was very strong evidence for the existence of such black holes. And there were clear pointers that another and strikingly different type of black hole exists as well, a supermassive black hole. These monsters were suspected to lurk in the centers of galaxies and to range in mass from about a million times the mass of the sun up to a few billion suns.

The case for supermassive black holes was compelling but not conclusive, and so Hubble joined the hunt. A prime suspect for a supermassive black hole was the core of a giant elliptically shaped galaxy known as M87 (number 87 in the famous catalog of fuzzy objects in the night sky compiled by 18th-century comet hunter Charles Messier).

M87 is just one of many galaxies in the relatively nearby Virgo cluster of galaxies (relatively nearby, that is, by cosmic standards, as it is more than 50 million light-years distant) and contains around 2 trillion stars. It had long been regarded as odd because a strange jet of material appeared to be linked to M87's bright central region. In 1994, when the center of M87 was examined by a team of astronomers using Hubble's Wide Field Planetary Camera (WFPC), they found, as one of them explained, "a striking departure from what the normal core of a giant elliptical galaxy would look like." In fact, the changes in brightness near the center suggested to them that a supermassive black hole a staggering 2.6 billion times more massive than the sun was buried deep within M87. But as one astronomer said: "It looks like a 'duck,' but we haven't heard it 'quack' yet." In other words, the evidence was still not conclusive.

When astronomers aimed Hubble's Wide Field Planetary Camera 2 (WFPC2) at the heart of M87, lead investigators Holland Ford and Richard Harms were astounded to see a gaseous disk at the center. There was also a clear pattern to the disk, a spiral. As Ford noted, it's "just totally unexpected to see the spiral-like structure in the center of an elliptical galaxy." They concentrated on trying to measure the speeds of the gas as it whirled around extremely close to the center of M87. In effect, Ford and Harms were testing what Michell proposed some 200 years earlier, that a black hole might divulge its presence by the

The repaired Hubble observed the heart of the giant elliptical galaxy M87. Astronomers detected new details of the gigantic jet apparently emanating from that center, but most importantly interpreted their results as conclusive evidence of a supermassive black hole.

effects it would have on the motions of shining bodies in motion around the black hole.

THE DUCK QUACKS

Determining the speed of the gas meant exploiting one of Hubble's spectrographs, the Faint Object Spectrograph (FOS), the performance of which had been improved by the installation of the Corrective Optics Space Telescope Axial Replacement (COSTAR) in the repair mission of late 1993 (see Moment 04, page 45). When the FOS team got the results, "Everyone in the room," Holland Ford would recall, "knew we had seen the incontrovertible gravitational signature of a black hole at M87's heart. We left the room that day hardly touching the ground, knowing that we had experienced one of those rare moments when a beautiful result leaps out of the data." The duck had well and truly quacked—and told of a black hole at the center of M87, with a mass more than two billion times the mass of the sun.

Astronomers would go on to use Hubble to explore the centers of many galaxies in the chase for other supermassive black holes. This cosmic census enabled astronomers to conclude that supermassive black holes are in fact so common that most if not all large galaxies harbor one.

HST FACT

For Earth to be turned into a black hole, it would have to be compressed to the size of a grape.

M104, SOMBRERO GALAXY

OBJECT: SPIRAL GALAXY, SEEN EDGE-ON
LOCATION: VIRGO
DISTANCE: 28 MILLION LIGHT-YEARS
OBSERVED: MAY–JUNE 2003

This mosaic of ACS images shows the famous edge-on spiral, which covers an
area of the sky roughly one-fifth the diameter of the full moon. Released by NASA
to commemorate the fifth anniversary of the Hubble Heritage Team.

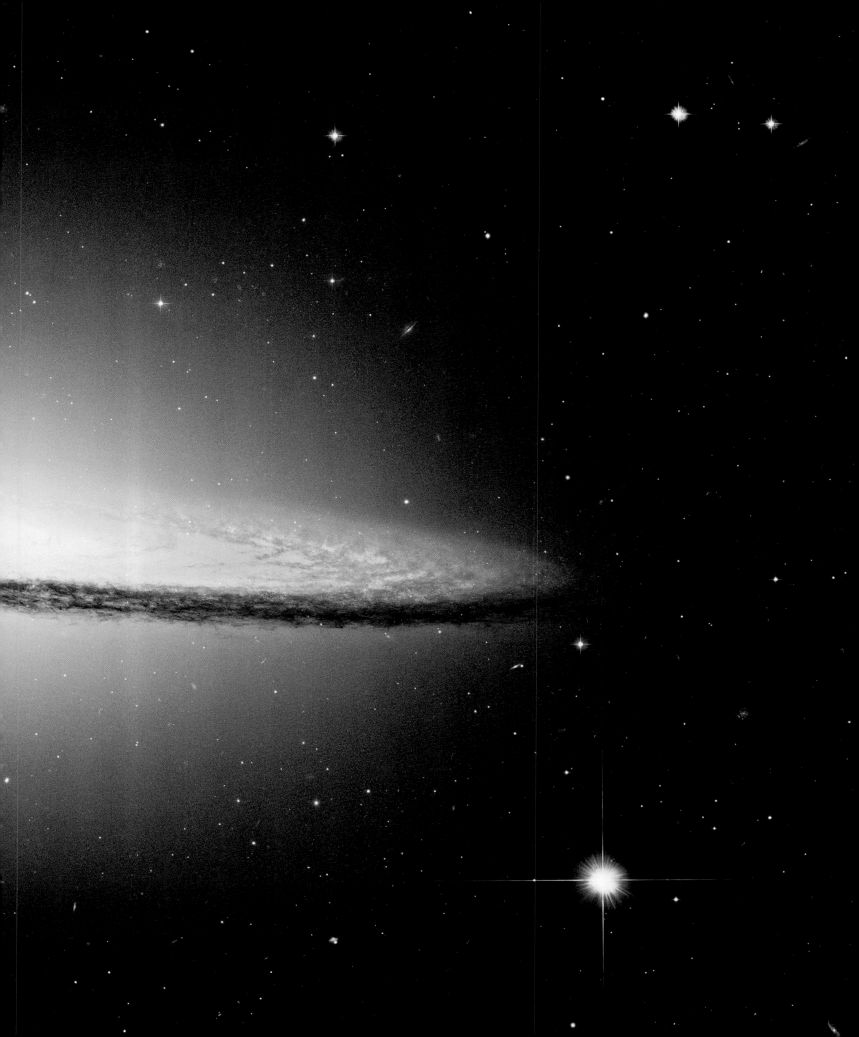

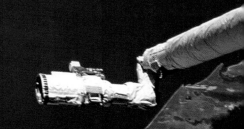

Hubble viewed from the space shuttle *Endeavour* during the first servicing mission in 1993. The shuttle's Remote Manipulator System arm appears in the lower right of the shot. It was used to capture and bring Hubble into *Endeavour*'s payload bay.

THE BIG FIX

HOW ONE TINY FLAW CAN DISTORT
A VIEW OF THE UNIVERSE—AND
WHAT NASA DID ABOUT IT.

WHEN THE HUBBLE SPACE TELESCOPE was launched in April 1990, images coming back did not live up to expectations. A diagnosis was reached in two months' time: The primary mirror had a major flaw, called spherical aberration, which meant that not all light from a star of interest could be drawn into a single sharp focus. • When the flaw was announced, the media had a field day. Fuzzy images, waste of money, government agency ineptitude: "Hubble Trouble"

became a catchword. Even now, cartoons refer to the momentous failure. The National Geographic Channel featured the debacle in a *Naked Science* episode.

Engineers and scientists were dumbfounded. How could such a thing have happened? Reams of harsh editorials and recriminations circulated. But NASA faced an even more enormous challenge than simply repairing the agency's image: The telescope had been in orbit for only two months, and now NASA had to figure out how to fix it.

Hubble was the first major satellite designed to be fixable in orbit. It was designed to orbit low enough to be reached by the space shuttle, and its instruments and components were built to be handled by astronauts floating in space and wearing protective garb with gloves akin to hockey mitts. So the fix would come via a servicing mission, but would it be an on-the-spot repair or would the shuttle retrieve Hubble and bring it back to Earth? There was a perfectly acceptable backup mirror, manufactured by Kodak and in storage at the prime contractor for the mirror, Perkin-Elmer, in Danbury, Connecticut. But, when fixed, would Hubble ever fly again? Even with the flawed mirror, Hubble was making some wonderful discoveries.

NASA astronomer Steve Maran, then press officer for the American Astronomical Society, summed it up in 1991: "We are getting great science from the Space Telescope despite its problems." But, he quickly added, "Unfortunately, we are not getting all of the science we paid for."

The NASA decision was to fix Hubble in orbit. This avoided another costly launch mission, and it was a scenario that would demonstrate that humans could perform complex and demanding tasks in orbit, which was a key element in the agency's ongoing mission to promote the human occupation of space. NASA had elected to contain costs by relaxing some of the technical requirements for how components were to fit together and work in orbit. It did so knowing that the telescope could be fixed in space. But could it really be fixed? Hubble's life was on the line, as was NASA's reputation.

PLANNING THE FIX

The fix required two major replacements. The mirror was far too large and too difficult to handle. The tactic would be to install corrective optics into the telescope that would counter the big mirror's flaw. Astronomers and engineers at the Space

HOW DO YOU TRAIN FOR OUTER SPACE? DIVE IN

The *Endeavour* astronauts were far from alone when they were floating in space performing "extravehicular activities," known in NASA as EVAs. Connected by electronic umbilicals was an army of ground controllers as well as their onboard fellow astronauts operating the space shuttle's remote manipulator arm. The necessity of performing EVAs was in itself a compelling argument for those advocating human spaceflight, but they were also some of the most demanding challenges facing the astronaut corps. Training to perform EVA maneuvers safely and effectively was far from straightforward. Many volumes have been written on the activity and the experience, showing it to be anything but a clinical exercise. Being physically alone in a confining space suit can promote definite psychological issues. By the time of the servicing missions to Hubble, with accumulated experience, most of the kinks were ironed out. Even so, the demands were proportionately greater. Testing and training were essential. There were many elaborate steps in the process, from virtual reality sessions, to long and exhausting forays in the Johnson Space Center's Weightless Environment

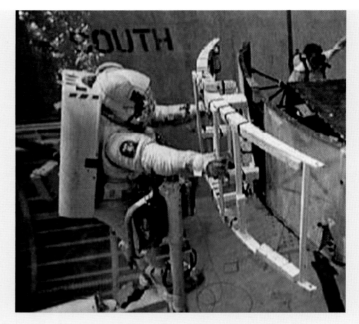

Training in a water tank at Johnson Space Center in Texas was key to preparing the astronauts for servicing Hubble. The buoyancy of the water simulates the weightlessness of space.

Training Facility, a deep pool containing full-scale mock-ups of all the devices that the astronauts would have to manage during the mission. They rehearsed for the repair missions aided by scuba-equipped divers.

Telescope Science Institute and at the Ball Aerospace Corporation in Boulder, Colorado, created a small forest of tiny mirrors on movable stalks anchored to a column. A set of electronic commands would tell the column to deploy and unfold the stalks, much like an articulated shower head, placing the mirrors precisely within the primary mirror's optical path.

A different solution was needed for the Wide Field Planetary Camera (WFPC), however, since the light field required at the very center of Hubble's field of view was just too large. This was not a new problem, however. Even before the *Challenger* accident, NASA and its team at California's Jet Propulsion Laboratory (JPL) had been planning to replace the original camera. This was the first time that a civilian astronomical satellite had been equipped with charge-coupled devices (CCDs), the revolutionary digital imaging technology now found in cell phones and cameras but rarely in use then. As John Trauger, lead scientist at JPL for the replacement,

WFPC2, recalled, "There were surprises." For example, the first set of CCDs had to be flushed periodically with strong ultraviolet light to wipe them clean and restore sensitivity, but new CCDs were designed that did not have to be flushed.

A LOT TO PROVE

The flawed mirror was discovered within weeks of the launch, but the servicing mission was not scheduled until December 1993, nearly three years away: a painfully long wait for astronomers, to say nothing of an impatient public and a skeptical Congress. But NASA, the Space Telescope Science Institute, and their host of contractors put together a longer to-do list. The solar arrays provided plenty of power, but when the telescope moved from direct sunlight to the darkness and bitter cold of Earth's shadow every 96 minutes, the panels quivered. Though a tiny wobble, this bothered the stability of the telescope as it was taking long exposures of the deep sky.

As a NASA website poignantly recalls, the first servicing mission in December 1993 "had a lot to prove and a lot to do." Between December 4, when they docked with Hubble, to December 9, when they released it, space shuttle *Endeavour*'s astronauts accomplished a record number of five space walks, performed by Thomas D. Akers, Jeffrey A. Hoffman, Story Musgrave, and Kathryn C. Thornton, from among the crew of seven. None was a rookie; each had flown from three to five times. They had spent countless hours training—in virtual reality, in water tanks, with a replica of Hubble in the National Air and Space Museum, and in their minds. Now they would do it for real, in teams of two, five times.

As they approached Hubble in orbit, matching speed and direction, Hoffman was the first to find it with binoculars and noticed that the solar panels were just not right. Ground commands had been sent to stow Hubble into safe mode—to batten down the hatches, as it were—so it could be safely grappled remotely and brought to the payload bay. During the first space walk, on flight day 4, the repair crew replaced some gyroscopes and rolled up the solar panels. The second space walk, on flight day 5, saw the solar panels replaced. Flight day 6 was the third space walk, devoted to replacing WFPC with the new camera, delicately maneuvered by Hoffman and Musgrave in a dance that took more than six hours. On the fourth walk, on flight day 7, Thornton and Akers removed one of the original axial instruments and installed COSTAR with flawless choreography. A fifth and final walk corrected solar array issues and upgraded electrical connections for the Goddard High Resolution Spectrograph.

There were, to be sure, some tense moments throughout the flight: sticky bolts, noisy electronics, and a faulty motorized deployment system that had to be manually overridden to place the new solar panels in their proper position. But all critical components passed what NASA calls "aliveness" tests, and the telescope was deemed healthy. The telescope was gently maneuvered away from the shuttle using the remote manipulator arm, and *Endeavour* said goodbye to Hubble.

The astronauts had done their jobs. Now it was up to the scientists and engineers to see what Hubble's new, improved optics might show them.

HST FACT

COSTAR returned to Earth in 2009, when the fourth Hubble servicing mission made it obsolete. Along with the WFPC2, it's now displayed in the National Air and Space Museum.

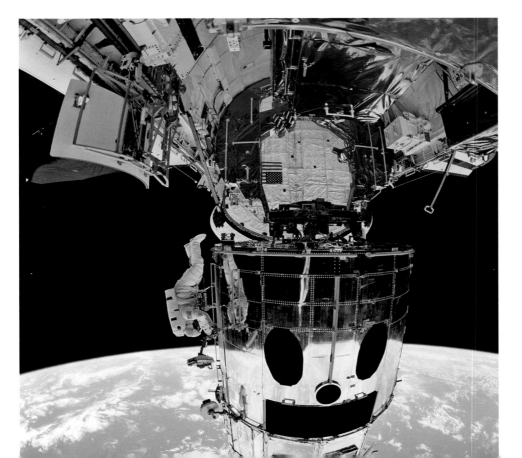

At work in the payload bay of *Endeavour*, astronaut Jeff Hoffman prepares to install the Wide Field Planetary Camera 2 during the third of the five sets of space walks by crew members to upgrade and repair Hubble in 1993.

PART | 02

REVIVAL AND REDEMPTION

HUBBLE'S VISION IS CORRECTED, AND THE NEW IMAGES
DEMONSTRATE THE TELESCOPE'S FULL POWERS.

The space shuttle *Endeavour* touches down at the Kennedy Space Center on December 13, 1993, after a nearly 11-day mission. The astronauts' success in replacing and upgrading various components was a key turning point in the history of Hubble.

THE END OF HUBBLE TROUBLE

THE REPAIRED TELESCOPE IMAGED STARS AND GALAXIES IN UNPRECEDENTED DETAIL.

A S ANXIOUS AS ASTRONOMERS were to see if Hubble's vision had improved, they were not able to immediately acquire astronomical images. In addition to various engineering checks and adjustments, the electronic detectors of the Wide Field Planetary Camera 2 (WFPC2) needed to cool down to the temperature at which they operated most effectively. • Everything went very smoothly and there were no engineering hitches. By the early hours of December 18, 1993, there

were around two dozen astronomers, technicians, and NASA officials crammed in a small room in the basement of the Space Telescope Science Institute. They were eagerly awaiting the arrival of the first image from the fixed Hubble: a bright star designated as AGK+81°266.

When, at around 1 a.m., the image of AGK+81°266 appeared on a monitor screen, the tension melted away into relief and delight. The image was greeted by shouts and cheers. On the screen was a neat, tight, and well-focused star image. No longer was the bright core of the image surrounded by the weird haloes, tendrils, and tentacles that had marred the earlier images. Minor focusing and alignment adjustments were still needed, but the strong sense in the room was that Hubble had been fixed. Now the astronomers were ready to obtain images of a range of astronomical objects.

Staff at the Space Telescope Science Institute had been debating what the repaired Hubble would look at first. One way or another, they wanted to tell the world as quickly

as possible what the new WFPC2 and the original Faint Object Camera (FOC), now aided by COSTAR, could do. Naturally, the choices should best reveal how Hubble's eyesight was improved. They decided to image single stars in external galaxies; search for minute details in the ring structure of supernova 1987A; and probe deep into the Orion Nebula, searching for stars and planetary systems in formation as well as stars at the brink of destruction.

The most compelling early image was perhaps the one secured on New Year's Eve of the spiral galaxy M100. Sharper and more distinct than the image of M100 taken when Hubble was still hobbled by spherical aberration, this image allowed astronomers to trace, for the first time, the path of the galaxy's spiral arms into the most central regions. The WFPC2 had delivered an exciting New Year's Eve gift and the promise of many more such gifts to come.

CHAMPAGNE TIME

In Houston, astronaut Jeff Hoffman and his wife had hosted a New Year's Eve party. As Hoffman was clearing up at the end of the party, his phone rang. It was an astronomer friend at

Preceding pages: A detail of the Orion Nebula showing the delicate bow shock LL Orionis, caused by radiation from stars outside the frame, upper left

the Space Telescope Science Institute who had seen the M100 image. Hoffman's friend asked, "Do you have any champagne in the refrigerator?" "And yeah," Hoffman recalled, "we had a bottle left over, and he said, 'Go pour yourself a glass and we're going to drink a toast because, I'm not really supposed to tell anybody, but we got the first pictures back from Hubble, and it worked. It's perfect.'" As one NASA official emphasized shortly after, with the image of M100 "even skeptics were convinced we were on the road to total success."

The FOC, provided by the European Space Agency, joined the action in early January. Its observations were in part tests of COSTAR, the Corrective Optics Space Telescope Axial Replacement that had been installed by the astronauts to correct spherical aberration for three scientific instruments, one of them being the FOC.

The FOC began by observing Melnick 34, a bright star in a star-forming region in the nearby galaxy, the Large Magellanic Cloud. Once again, rather than the blurry images seen before

HOW SENATOR MIKULSKI LEARNED TO LOVE HUBBLE

G rowing up in Baltimore, Barbara Mikulski wanted to be a scientist—an ambition, she has recalled, fueled by a movie about Marie Curie, the first woman to win a Nobel Prize. In college, she turned instead to social work, but she never lost her love for science. For the astronomers engaged with the Hubble Space Telescope, this was very fortunate, as Mikulski has been by far the single most important politician in the telescope's history, and her support was crucial at several points.

A member of Congress for more than three decades, Mikulski first served in the House of Representatives from 1976 to 1986, before entering the Senate. By 2013, she had risen to the lofty position of chairwoman of the Senate Appropriations Committee, the first woman to hold the post. As one of her colleagues put it in a *New York Times* profile that year, "She is tough, she is determined, she is prepared. She is also accommodating. But once she gets to a place, she is a bulldozer you can't move."

Mikulski has been a booster for her home state, Maryland. And Maryland is home to both the Goddard Space Flight Center, the NASA center charged with management of the Hubble program, and the Space Telescope Science Institute in Baltimore, the scientific nerve center for Hubble. But she had been exasperated by a string of NASA problems in 1990, including Hubble's spherical aberration. Thus, her pronouncement at a January 1994 news conference that the Hubble trouble was over was therefore especially telling. After the flaw with Hubble's mirror had been discovered, Mikulski pressed to ensure that NASA had adequate funds for the repair mission and beyond. What was the sense of putting

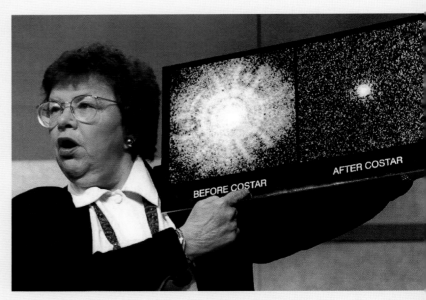

Senator Barbara Mikulski was very critical in 1990 of Hubble's spherical aberration. In a January 1994 news conference, however, she declared that the trouble with Hubble was over.

all the effort into fixing Hubble only to cut back on its observing programs, she asked, arguing for Congress to provide "the resources then to take advantage of the restoration of its original capability."

In 2012, in recognition of her support of space astronomy, the data archive at the Space Telescope Science Institute was named the Barbara A. Mikulski Archive for Space Telescopes. That same year, a newly discovered supernova was named Supernova Mikulski.

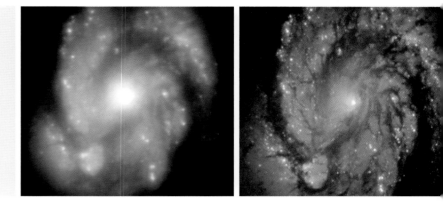

Spiral galaxy M100 before (near right) and after the first servicing mission in 1993 (far right). Cepheid variable stars that were detected in the galaxy with Hubble's corrected vision enabled astronomers to greatly refine their distance to the galaxy.

the fix, the renovated camera system now provided a clearly focused image. COSTAR, too, it seemed, was working well.

TECHNOTURKEY NO MORE

After the huge embarrassment of spherical aberration, NASA held information on Hubble's post-repair performance very tightly indeed. Finally, a news conference was called for on Thursday, January 13, at the Goddard Space Flight Center. Hubble's flaw had sparked a media frenzy, and now the announcement of a new stage in the Hubble story also drew a large crowd of media representatives.

One of the presenters at the news conference was Senator Barbara Mikulski. Some three and a half years earlier, angered by a string of NASA problems, including that of Hubble's mirror, she had complained, "How long do we put up with these technoturkeys?" Now she held up photographs of two star images, one taken before the fix and one taken after. The big difference was clear even to an untrained eye. "The trouble with Hubble is over," she proclaimed.

The news conferences were fashioned as celebrations of the repaired and upgraded Hubble. In June 1990, Hubble program scientist Edward Weiler had been one of the panel members who had had the gut-wrenching job of announcing that the telescope's optics were flawed. Now, in January 1994, he was able to report that Hubble had been "fixed beyond our wildest expectations." The engineer who had led the COSTAR team extolled Hubble's vision to be "as perfect as engineers can achieve and as physical laws will allow."

HST FACT

Corrected, the Hubble was so powerful it could detect a firefly at a distance equivalent to that between Washington, D.C., and Tokyo.

The day after the Goddard news conference, a variety of new images from Hubble were presented at a meeting of the American Astronomical Society. As the magazine *Science* reported, the "nearly 2,000 astronomers who turned out for the society's largest meeting yet provided plenty of 'oohs' and 'aahs' for every new image." Another report noted that "enthusiastic applause" greeted the images.

Astronomers used the improved images to show that Hubble was performing even better than expected. Robert Jedrzejewski, an astronomer from the Space Telescope Science Institute, for example, showed an image of a giant ball of stars, the globular cluster 47 Tucanae, some 17,000 light-years distant from Earth, taken just a few days before. An image of the same object taken before the repair mission had been hazy, speckled with fuzzy blobs. Now those specks showed up as individual stars. Most important, white dwarf stars were now detectable within the globular cluster. Dense burned-out cores of stars that have collapsed, these so-called white dwarf stars had been predicted to exist in globular clusters but had never been detected there. "We knew white dwarfs must exist there but had just not been able to see them before," said Jedrzejewski.

An orchestrated barrage of images was released to the public on January 13 and 14, 1994, marking a new stage in Hubble's history. Now astronomers could turn to the exciting prospect of exploring the universe with a fully functioning Hubble Space Telescope.

30 DORADUS, OR THE TARANTULA NEBULA

OBJECT: EMISSION NEBULA AND MASSIVE STARS
LOCATION: LARGE MAGELLANIC CLOUD IN DORADO
DISTANCE: 160,000 LIGHT-YEARS
OBSERVED: OCTOBER 2011, JANUARY 2006

Central portion of huge star-forming region in the Large Magellanic Cloud seen in a composite of many Hubble observations plus data from a telescope in Chile.

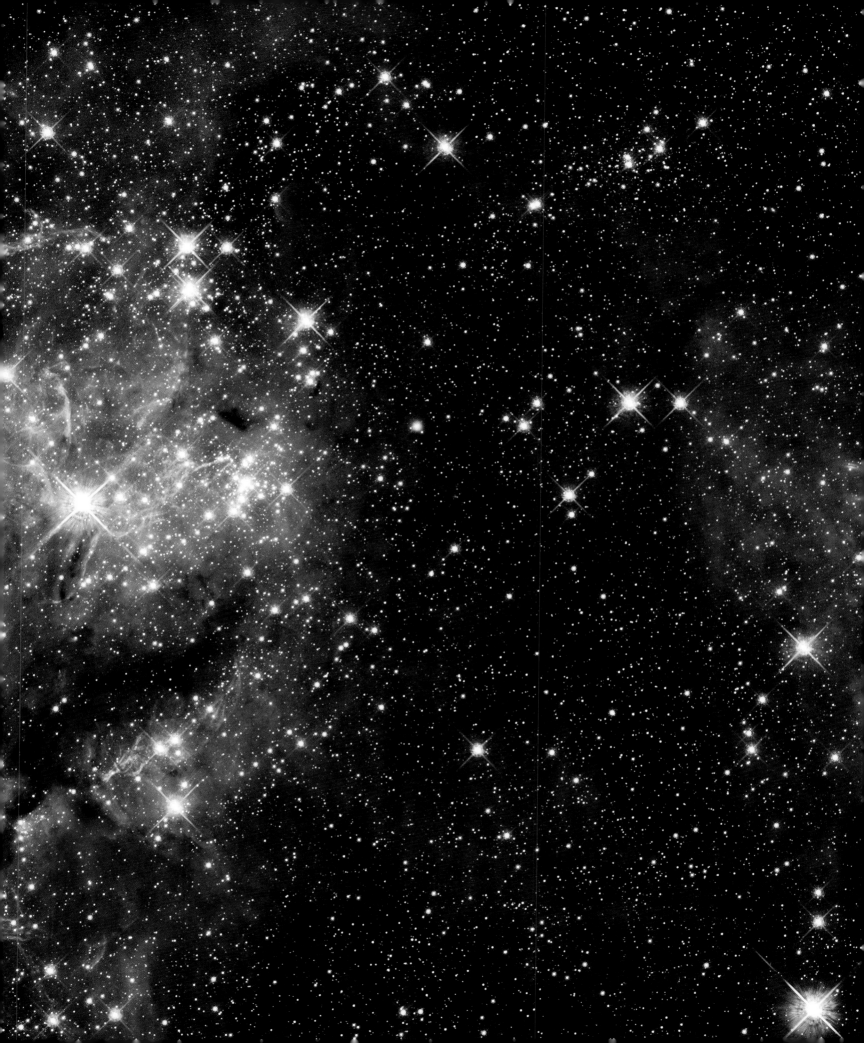

Hubble was trained on Jupiter to observe the effects of the fragments of comet P/Shoemaker-Levy 9 smashing into the planet. In this composite image, from data taken with the WFPC2 through three filters, eight impact sites are visible as dark markings

THE SPACE TELESCOPE SCIENCE Institute was an extremely busy place on the evening of July 16, 1994, and the Hubble Space Telescope took center stage. Visiting astronomers, institute staff, television cameras, and crowds of reporters—all were there to witness what Hubble could reveal of the "solar system event of the century." A comet was about to conclude its four-billion-year journey in a string of stupendous collisions with Jupiter that would go on for five days and more.

A SQUASHED COMET

It had all started a year earlier, when Caltech and Palomar Observatory astronomer Carolyn Shoemaker was hunting for asteroids and comets using a special instrument called a stereomicroscope, which compares images taken at different times. A highly skilled comet hunter, she was taken aback when she detected a bizarre object that she at first identified as a "squashed comet." Another astronomer, using a different telescope, reported that it "is indeed a unique object, different from any cometary form I have yet witnessed." Comets often display a head and a tail, but this remarkable comet exhibited not one head and one tail, but several of them.

The newly discovered comet was named P/Shoemaker-Levy 9, as it was the ninth short-period comet—a comet that orbits in less than 200 years—discovered by Carolyn and Eugene Shoemaker and David Levy. Hubble was first aimed toward it on July 1, 1993, in tandem with telescopes on the ground. Now, after the successful December 1993 repair mission had turned Hubble into a more powerful telescope, further (and sharper) images of the comet came back in January 1994. They disclosed

that the squashed comet was in fact composed of at least 21 cometary fragments now stretching over a distance of 700,000 miles. The 11 largest fragments were reckoned to range in size roughly between 1.25 and 2.5 miles wide.

The vast majority of comets in our solar system—and there are trillions of them—spend their time far beyond Neptune. But occasionally one of these gigantic dirty snowballs is driven into the inner reaches of the solar system. After that, they may be ejected from the solar system never to return; or they may fall into the sun; or they may be pulled by the gravitational action of Jupiter, the most massive of the planets, into orbits relatively close to the sun. Comet Halley, perhaps the best known of all comets, is the prime example of this sort of comet. But most comets that swing into the inner reaches of the solar system will be driven out again into orbits that have periods of hundreds of thousands or even millions of years.

Comet P/Shoemaker-Levy 9 (abbreviated to SL-9) was extremely unusual in that it had swept in from the far reaches of the solar system but was now in orbit around Jupiter. Comet SL-9 had also flown so close to Jupiter in 1992 that the

COSMIC COLLISIONS

WITH HUBBLE, ASTRONOMERS TAKE A RINGSIDE SEAT AS FRAGMENTS OF A COMET PLUNGE INTO THE GIANT PLANET JUPITER.

HUBBLE HOMES IN ON EUROPA

Fifth planet from the sun and one of the five planets visible to the naked eye on Earth, Jupiter has been known and recognized throughout all of recorded history. It holds a special place in that history, however, starting with Galileo. On September 25, 1608, members of the provincial government of Zeeland (a province in the southwest of the Dutch Republic) wrote a letter to their representative to the national government in The Hague. There was, they reported, a spectaclemaker in the capital of Zeeland, Middleburg, who had fashioned a "certain device by means of which all things at a very great distance can be seen as if they were nearby."

So began the age of the telescope, for this would be the name given to the device in time. By August 1609, Galileo, an obscure mathematics professor at the University of Padua, had constructed a telescope for himself. Galileo initially focused on the moon, but in January 1610, he began to examine Jupiter. More massive than all the other planets put together and so big that some 1,300 Earths could fit inside it, Jupiter is a gas giant—a planet made more of gases such as hydrogen and helium than of rock. The most famous of its atmospheric features, a gigantic storm known as the Great Red Spot, has typically been so big that if Earth and Mars were placed side by side they would just about cover it. In the late 19th century, it was even larger at more than 25,000 miles across. The Hubble Space Telescope has been used to monitor both the Great Red Spot and the banded appearance of Jupiter's upper atmosphere.

In his own observations, Galileo discovered the planet's four brightest moons, including Ganymede, the largest, with a diameter about half the size of Earth's. The Great Red Spot, however, eluded Galileo—an indication of how far our observational abilities have come in these 400 years, to the extent that today Hubble can chronicle the consequences of the impacts of comet P/Shoemaker-Levy 9 on Jupiter. Further, in 2013 Hubble was used to explore Europa, one of the four moons discovered by Galileo. To Galileo, Europa had been just a point of light. But Hubble has found evidence of geysers of water near this moon's south pole, making it of special interest to astrobiologists seeking planetary objects where life could or might once have formed and survived.

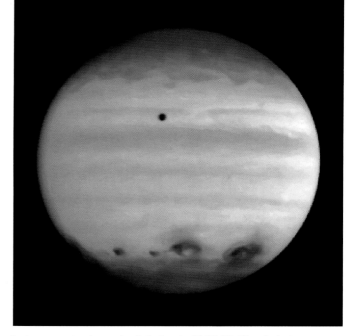

Jupiter seen in ultraviolet light by the WFPC2. The dark dot just above center is Jupiter's moon Io. The other dark markings are the result of the impacts of cometary fragments.

enormous but unequal forces exerted by the planet on the comet's near and far sides had ripped it into the chunks that Carolyn Shoemaker and her comet-hunting colleagues had found in 1993. Calculations of the orbit predicted that these chunks would not just sweep close to Jupiter in the future but actually smash into the planet in July 1994.

COSMIC COLLISIONS

Collisions are very common occurrences in the solar system. Anyone on Earth, looking up at a clear night sky from a location far from city lights, will not have to wait long to observe a shooting star or meteor. These flashes of light are the result of a piece of rock typically about the size of a grain of sand traveling some ten times faster than a rifle bullet and burning up in the Earth's atmosphere. Each year, about 10,000 tons of cosmic debris meet such a fiery end.

But, on occasion, some of the material speeding into the atmosphere makes it to the surface of the Earth as a meteorite. And (thankfully) only on rare occasions do large pieces of rock from space, as well as comets and asteroids, survive the journey through the atmosphere to smash into the Earth or explode above its surface, with potentially devastating consequences. A cataclysm of this sort is widely reckoned to have led to the extinction of the dinosaurs about 65 million years ago. The enormous submerged Chicxulub Crater at the tip of Mexico's Yucatán Peninsula is a candidate for the crater resulting from this catastrophe. A far better preserved crater from a cosmic

collision is the Barringer Crater in Winslow, Arizona. This is about a mile wide and nearly 600 feet deep. It is the product of the impact some 50,000 years ago of a meteor perhaps 100 feet in diameter traveling at more than 12 miles a second.

Astronomers had advance warning of comet SL-9's date with its own destruction, and so they could plan accordingly. This made it an extraordinary and exceptionally rare event. As luck had it, the collisions of the comet's various pieces would occur on the far side of Jupiter as viewed from Earth. But Jupiter spins more rapidly than Earth, taking ten hours to turn once on its axis. Astronomers would therefore have to wait only a short time after the actual impacts before they could observe the consequences.

FIZZLE OR FEAST?

But what *were* the likely consequences? There were two major uncertainties about the cometary fragments. First, how big were they, and, second, what was their composition? If the chunks disintegrated rapidly into thousands of minor fragments, there might be no explosions of the sort to produce consequences visible from Hubble. Similarly, if the fragments were too solid, they might tunnel so far down into Jupiter's atmosphere that the results of their explosions would also be invisible to Hubble. There was, then, no firm guarantee of Hubble capturing dramatic events in the atmosphere of Jupiter.

Comet P/Shoemaker-Levy 9 was torn into fragments in 1992 by Jupiter's powerful gravitational attraction. Astronomers tracked these fragments—some of which are seen here in a combination of images—well before they collided with the giant planet in 1994.

HST FACT

The explosive effect of all comet P/Shoemaker-Levy 9's impacts on Jupiter is reckoned to have been equivalent to about 300 billion tons of TNT.

No wonder the mood at the Space Telescope Science Institute on July 16, 1994, was a mixture of excitement and tension. Astronomers hoped for the best and a spectacular visual show, but they also feared the worst in the form of a cosmic fizzle.

They need not have worried. Hubble's Wide Field Planetary Camera 2 secured an image of Jupiter about 90 minutes after the first large fragment, fragment A, hurtled into the planet's atmosphere at a speed some 60 times faster than a typical rifle bullet, that is, 6 times faster than an earthly intruder, the difference being due to Jupiter's huge gravitational field. After being downloaded from the orbiting spacecraft, the image popped onto a monitor at the institute. Most of the upper part of the screen was filled by Jupiter. And there, scarring the planet's surface, was the blemish left by fragment A. Astronomer Heidi Hammel had a ringside seat: "In my dreams we couldn't have gotten any better!" The view of the impact site delighted the watching astronomers. More fragments of comet SL-9 continued to slam into Jupiter for the next 5.5 days, and astronomers around the world avidly observed the effects with a variety of telescopes.

The fate of comet SL-9, and especially Hubble's observations of its spectacular demise, made the public aware as never before of the destructive powers of a big object slamming into Earth. In 1998, two blockbuster movies—*Armageddon* and *Deep Impact*—dramatized the threat posed by large bodies hurtling on collision courses toward Earth. Hubble had helped heighten Hollywood's awareness too. As the website *Armageddononline.org* pronounced in April 2010: "The Hubble Space Telescope has revolutionized the way humanity views the universe."

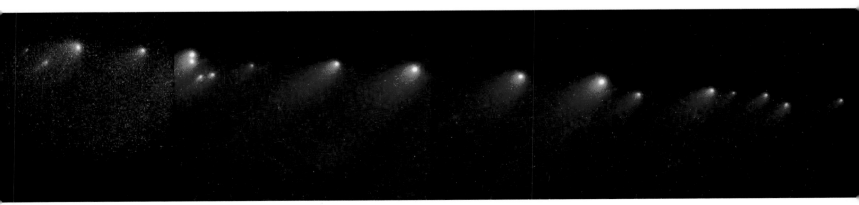

ABELL 901/902

OBJECT: SUPERCLUSTER OF GALAXIES
LOCATION: LEO
DISTANCE: MORE THAN 2 BILLION LIGHT-YEARS
OBSERVED: JUNE–JULY 2005

An ACS wide-field composite mosaic of Abell 901/902, a supercluster of galaxies.
Purple haze, or dark matter, calculated from the gravitationally lensed images
and added to this one shows a distribution different from the optical galaxies.
Stars with diffraction spikes are in the foreground.

NGC 6217

OBJECT: **BARRED SPIRAL GALAXY**
LOCATION: **URSA MINOR**
DISTANCE: **60 MILLION LIGHT-YEARS**
OBSERVED: **JUNE 13 AND JULY 8, 2009**

A composite image of barred spiral galaxy NGC 6217, 60 million light-years distant from the revived ACS after the final servicing mission in 2009. The image was composed for testing and calibrating the revived camera.

Central feature of M16, the Eagle Nebula, dubbed the Pillars of Creation. Oriented to optimize the format of the WFPC2 CCD geometry. Radiation from nearby hot stars sculpts gas and dust into columns that contain stars in the process of formation.

SHAPING THE IMAGINATION

MORE THAN ANY OTHER, THE IMAGE OF ONE NEBULA BRINGS HUBBLE HIGH ACCLAIM.

IN 2009, THE ASSOCIATED PRESS looked back on Hubble's history in an essay with the pointed title "From Cosmic Joke to Historic Eye in Space." A 1995 image had "forever restored the telescope's tarnished early reputation," read the article, referring to the image of the Eagle Nebula. "It was stunning, with beautiful colors and dramatic clouds where stars formed. NASA called it the 'Pillars of Creation.'" • From the media's point of view, the image was transformative

in the history of the Hubble Space Telescope. It helped to change popular views of what's out there in this universe of ours as well. And it brought back into the popular vocabulary a phrase that has a history as well as a mixed cluster of associations.

WHAT'S IN A NAME?

Today, if you do an Internet search for the phrase "Pillars of Creation," you'll get a wide variety of results. At the top will be a Wikipedia listing on the Eagle Nebula, known also as M16. You'll also find the phrase in the seventh book by popular fantasy novelist Terry Goodkind in his *Sword of Truth* series. Iconoclastic electronic and metal bands from Chicago, Las Vegas, and London are using the name, and songs with that title can be found easily on YouTube.

And it's not just the name of this Hubble telescope image that has spread wide throughout today's culture. The image itself adorned a U.S. postage stamp issue. Publications, print and online, from *Scientific American* to the *Huffington Post,* have used it on their covers and in their pages. The website *Space .com* now considers it a "classic image."

The ubiquity of the Pillars of Creation—both phrase and image—is a recent phenomenon, though, that can be traced to the release date for the image from the Hubble—an image so eerily beautiful, NASA decided it warranted a televised news conference in November 1995.

M16 can be found in the constellation Serpens (Serpent), in the northern sky. At its heart, a spectacular array of dark fingers reaches for a collection of brilliant blue stars. The fingertips seem to glow at their tips. M16 found its way into Charles Messier's 18th-century catalog in part because its many odd structures and complexities made it an attractive target for ambitious astronomers seeking new nebulous objects in the sky, like faint comets—a major occupation at that time.

Messier's list helped avoid confusion and speed discovery and fame among these observers. When wide-field photography became possible in astronomy with large portrait lenses and sensitive photographic emulsions, these nebulae became better known and described, and many tens of thousands were discovered. Today, M16's fingers can be readily imaged with high-end amateur equipment—with a good bit of care and preparation, of course.

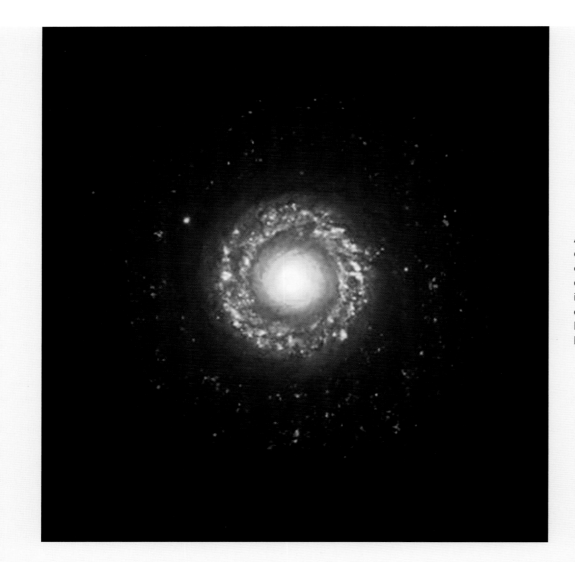

Astronomer Arthur Hoag called attention to this object in 1950. Now classed as a ring galaxy, it was formed through the collision of two galaxies. It helped to inspire the Hubble Heritage Project.

THE BIRTH OF THE HUBBLE HERITAGE TEAM

Just like the dog that catches the car it's chasing, in the wake of the wild popularity of the Pillars of Creation, the question within NASA and the Space Telescope Science Institute became, "What now?" It was something of a wake-up call that convinced purists within the community that pretty pictures have punch. Fortunately, the institute reacted positively, in 1997, establishing a team of creative astronomers and artists to use the opportunity to educate and inspire. It all started when four institute astronomers proposed to Director Robert Williams that a small portion of the director's "discretionary time" on Hubble be devoted to building larger field images of some of the most dramatic objects examined thus far. They would scan the existing scientific database for potentially impressive scenes. Extra observing time would be dedicated to reorient or reframe the scene, deepen it or widen it, or recast the scene using different filter combinations to heighten the contrast. Williams liked the idea, and thus began the Hubble Heritage Team.

Largely a volunteer effort, the team started issuing images and information about them in October 1998, choosing scenes of Saturn, a rich star cloud in Sagittarius, the Bubble Nebula, and a face-on tight spiral galaxy with an uncanny resemblance to a perfectly fried egg. After five years, issuing 65 images culled from the Hubble database of some 500,000 raw images secured during Hubble's lifetime, the team acquired several orbits of Hubble observing time with its new Advanced Camera for Surveys to produce a stunning mosaic of the Sombrero Galaxy (see pages 42–43).

To this day, the team works together to create spectacular Hubble imagery and make it available for people around the world to see.

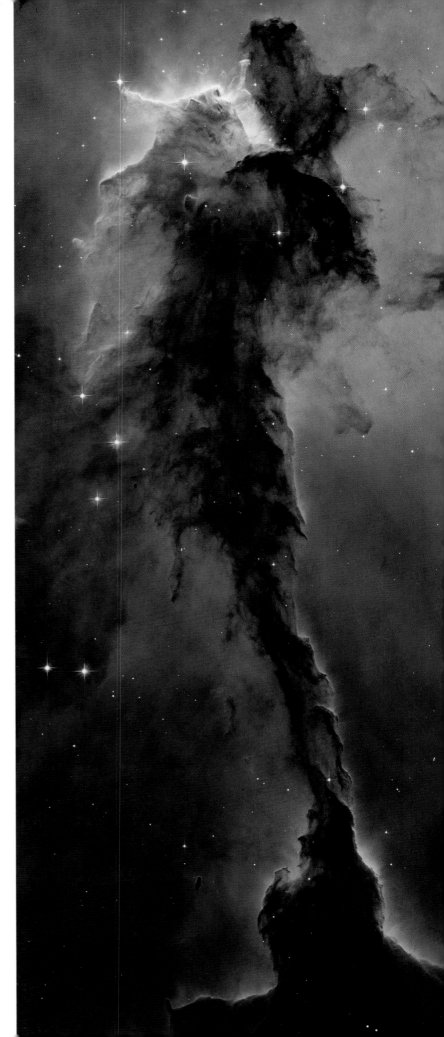

SELECTING THE TARGET

None of this had anything to do with how and why Hubble was originally directed to M16 for a series of exposures in April 1995. Jeff Hester and Paul Scowen, astronomers at Arizona State University, had proposed to image the object because they were very interested in the fine structure of nebulae where the tendrils of gas and dust were being intensely agitated by the flood of high-energy ultraviolet radiation from nearby hot stars. This process, dubbed photoevaporation, happens in regions where the illumination is so intense that the light disperses the gas and dust. Hester had long been interested in this phenomenon as it related to star destruction and star formation.

A member of the WFPC2 camera team, Hester was already producing images with the new camera in December 1993. For both Hester and Scowen, the Eagle was just another object on their bucket list, and it was business as usual. But after Scowen downloaded the data and processed them into new images of the Eagle Nebula, they both were transfixed. They programmed some 32 different exposures with precise combinations of four different filters. Hester got to work manipulating the exposure data, adjusting the hues. They chose colors based upon wavelength range so the image would reveal the composition and dynamics of the clouds. Overall, they wanted to create the perception of depth to focus attention on the photoevaporation mechanisms.

Clearly, Hester and Scowen knew they had a winner. During a meeting at the Space Telescope Science Institute (STScI) in Baltimore, Hester cornered NASA Associate Administrator Edward Weiler for a hushed conversation. Weiler recalls that when he saw what Hester pulled out, "I was stunned, and I blurted out, 'This will be the cover of every newspaper in the world when it is released!'" Ray Villard, public information officer for STScI, remembers that he was skeptical at first, but when Weiler showed him the image: "My jaw dropped and I must have looked at it for five minutes . . . The picture has a hypnotic effect." Once the final image was ready, Weiler and Villard arranged a press conference, complete with TV coverage.

An ACS image of a column of gas and dust in the Eagle Nebula released in recognition of Hubble's 15th anniversary in 2005. The column is some 9.5 light-years long, or more than twice the distance from the sun to our nearest star in space, Alpha Centauri.

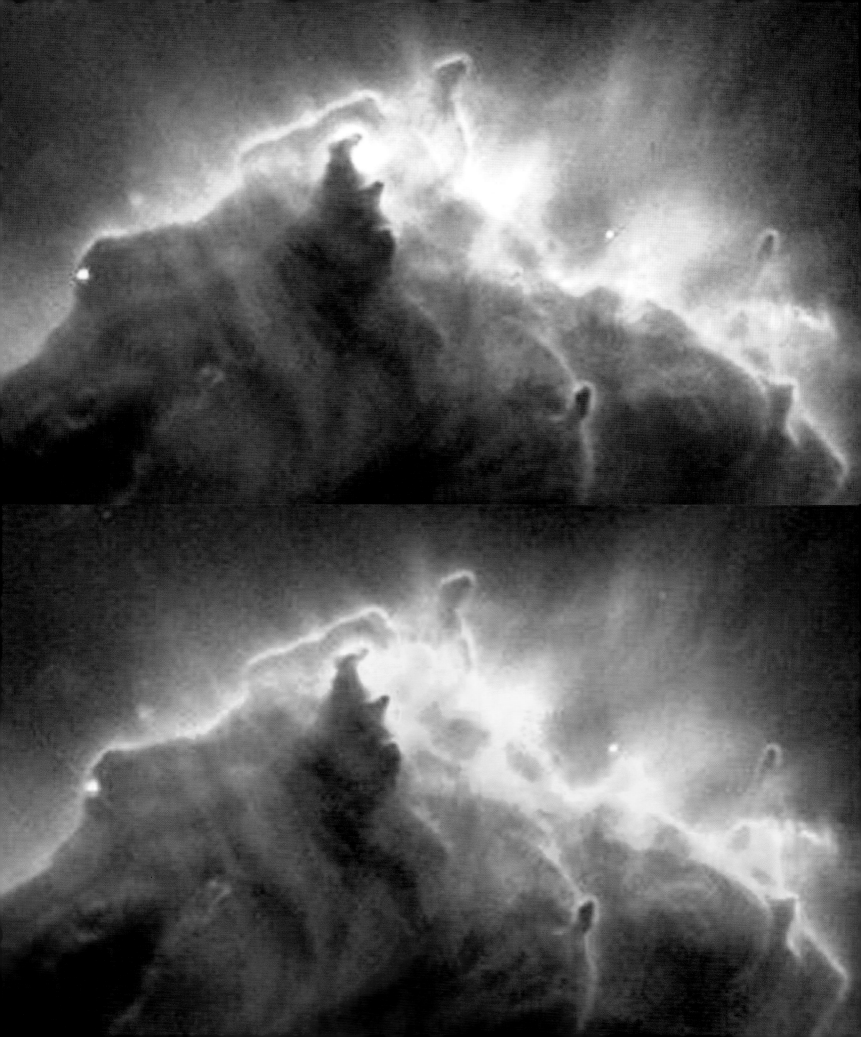

THE PRESS REACTS

Press reaction was instantaneous. The first headlines were ecstatic. "A Stunning View Inside an Incubator for Stars," read the headline for John Noble Wilford's account in the *New York Times.* "Hubble Sends Images of Unborn Stars: 7,000 light-years away, a Window Opens on Stellar Formation—HOW A STAR IS BORN," read the lead for Kathy Sawyer's story in the *Washington Post.* Professional publications were likewise giddy: "Hubble Finds EGGs in an Eagle's Nest," declared the newsletter for the American Geophysical Union, playing off what astronomers were calling evaporating gaseous globules (EGGs) as the spawning grounds for new stars. Soon there were even spiritual reactions, as Joel Achenbach reflected for the *Washington Post* in an essay titled "A Beautiful Illusion: It Looks Like Heaven."

Art historian Elizabeth Kessler at Stanford University has closely analyzed the choices Hester made in producing the image that came to be known as the Pillars of Creation. She concludes overall that more than most astronomers before him, he paid attention to the aesthetic appeal of his images and for this reason, his work "appeals not only to the senses but also to reason." And, in fact, the image did serve the advancement of science. A final research report by Hester, Scowen, and more than 20 colleagues, published in the June 1996 *Astronomical Journal,* included high-resolution black-and-white negative images of the scene in the light of hydrogen, sulfur, and oxygen, as well as a high-contrast image filtered to reveal about 70 tiny evaporating globules that could be the nest eggs, or protomaterial, for new stars. The journal also went to the effort to reproduce the full-color rendition, something common now but rarely seen even in professional journals of that day.

A VISUAL AMBASSADOR

As Kessler observes, the image of the Eagle Nebula, promoted via NASA's pillars metaphor, "resonated across religion and popular science." It "combined aesthetics and science more

HST FACT

Astronomers on the Hubble Heritage Team cull material from the data that had been collected to answer scientific questions. They also compete for observing time to augment these data.

effectively and dramatically than any previous Hubble image." A few years after the image's release, journalists like the *Post's* Achenbach were still beguiled by the vision it held. He went to a meeting of the American Astronomical Society in Toronto in 1997 hoping to obtain insight. Astronomers who knew the image as it had appeared in earlier renditions made comments that helped him appreciate why it was framed as he had it, with the fingers pointing up as pillars, and not drooping down, as larger field images of the Eagle would show it. The astronomers clearly admired "the technical virtuosity" that went into the image, and Achenbach went away just as deeply moved as before.

Indeed, the legacy of Hester's original image, as rendered time and again in the popular media, has changed how we look and think about the universe around us. The overall experience has also left a mark on Hester. On his website today, he recalls the years he spent on the camera team, trying to assure the world that Hubble was successful: "With the eyes and weight of the world on us, we had the task of making sure that it worked."

SCIENCE AND RELIGION MEET

In calling the Hubble's spectacular new image of the Eagle Nebula the Pillars of Creation, NASA scientists were tapping a rich symbolic tradition with centuries of meaning, bringing it into the modern age. As much as we associate pillars with the classical temples of Greece and Rome, the concept of the pillars of creation—the very foundations that hold up the world and all that is in it—reverberates significantly in the Christian tradition.

When William Jennings Bryan published *The World's Famous Orations* in 1906, he included an 1857 sermon by London pastor Charles Haddon Spurgeon titled "The Condescension of Christ." In it, Spurgeon uses the phrase to convey not only the physical world but also the force that keeps it all together, emanating from the divine. "And now wonder, ye angels," Spurgeon says of the birth of Christ, "the Infinite has become an infant; he, upon whose shoulders the universe doth hang, hangs at his mother's breast; he who created all things, and bears up the pillars of creation."

WFPC2 images (composites with and without tinting) of EGGs (evaporating gaseous globules) in the crown of one of the "pillars" in the Eagle Nebula, or M16. The tiny protrusions at the top of the EGG are about the size of our entire solar system.

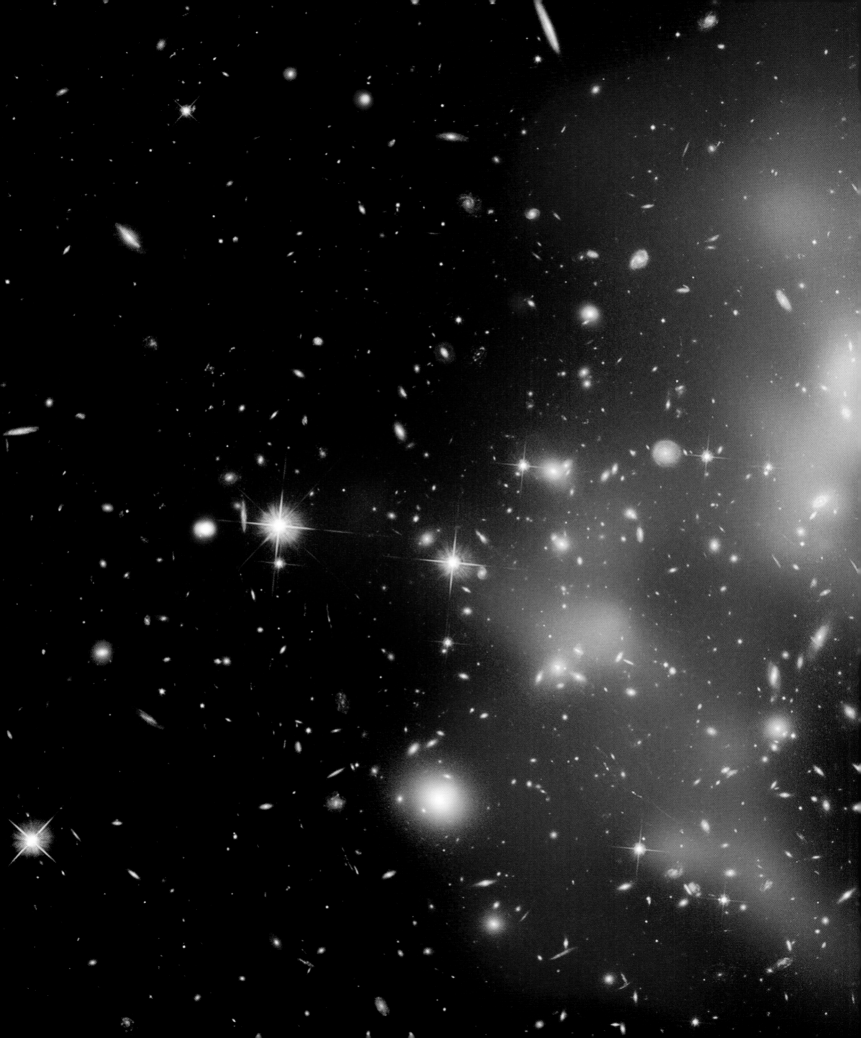

MACS J0717.5+3745

OBJECT: FOUR GALAXY CLUSTERS COLLIDING
LOCATION: AURIGA
DISTANCE: 5.4 BILLION LIGHT-YEARS
OBSERVED: JANUARY 24–FEBRUARY 9, 2005 (ACS/WFC);
JANUARY 10, 2003 (CHANDRA ACIS)

A composite image based upon data from several exposures with the ACS, combined with x-ray data from the ACIS instrument on the Chandra X-ray Observatory. The Chandra data are represented by the blue and violet hues.

Produced by combining 342 separate exposures secured over a ten-day period in late 1995, the Hubble Deep Field drew huge public and scientific interest. The great majority of objects visible in this image are far-off galaxies. Images with diffraction spikes are stars in our galaxy.

DEEP IN SPACE, BACK IN TIME

THE HUBBLE DEEP FIELD IMAGE REACHES BACK TOWARD THE ORIGIN OF GALAXIES.

HOW FAR CAN WE SEE with Hubble, and what will we find at the farthest limits of its vision? With those questions in mind, in late 1995, astronomers directed Hubble to an obscure part of the sky. • The result was a startling image. Called the Hubble Deep Field, it revealed more than 2,000 galaxies, the great majority of them billions of light-years away. The picture raises profound questions about our place in the cosmos and the nature of the universe itself.

Consider the view of Earth hanging against the blackness of space, as seen in 1968 from the Apollo 8 spacecraft as it journeyed to the moon. Or the "pale blue dot," as Carl Sagan called it: the faraway Earth as pictured by the Voyager 1 spacecraft as it sped out of the solar system. "Look again at that dot," said Sagan. "That's here. That's home. That's us. On it everyone you love, everyone you know, everyone you ever heard of, every human being who ever was, lived out their lives." The vision changed our sense of the universe and ourselves within it.

For Robert Williams, director of the Space Telescope Science Institute and the person most responsible for the revolutionary image, the Hubble Deep Field posed equally weighty issues. "The variety of galaxies we see is amazing. In time these Hubble data could turn out to be the double helix of galaxy formation," said Williams. "As the images have come up on our screens, we have not been able to keep from wondering if we might somehow be seeing our own origins in all of this."

INTO THE DEEP

Why was the Hubble Deep Field image so important? Why did it make such a stir? And why, for that matter, was it called a *Deep* Field? To start to answer these questions, let's transport ourselves to the cliffs on a stretch of desolate and rough Scottish coast known as Siccar Point in the early afternoon of one sunny June day in 1788. From our vantage point, we can spy a small boat making its way through the waves toward the beach below us. On board are several farmhands and three gentlemen of science from Edinburgh, including James Hutton, a prominent geologist who reckoned the Earth was vastly older than generally believed at the time.

The history of the Earth was, for Hutton, without "vestige of a beginning or prospect of an end"—an idea much at odds with the conventional understanding of God's creation at the time. As one of his traveling companions that day later remembered about viewing the Siccar Point rock formations, "We felt ourselves necessarily carried back to the time when the schistus [a type of rock] on which we stood was yet at the bottom of the sea . . . The mind seemed to grow giddy by looking so far into the abyss of time." They were experiencing "deep time," a concept Hutton was key in establishing: the idea that the history of Earth has to be counted not in thousands but in billions of years.

INFORMATION TOO IMPORTANT TO KEEP QUIET

To earn observing time with Hubble, astronomers have to submit proposals explaining what they plan to do with the telescope and why their proposed research is significant. Many proposals are rejected. A small fraction of Hubble's observing time is counted as Director's Discretionary Time, so that if something unexpected turns up in the skies, Hubble can be trained on it at short notice. In 1994, for example, Director's Discretionary Time was used to observe comet P/Shoemaker-Levy 9's encounter with Jupiter.

In 1995, it was used for the Hubble Deep Field observations, a planned endeavor. Even so, pursuit of the Deep Field carried risks. If the result had been an uninteresting collection of galaxies, the person who would have borne the brunt of the criticism for wasting valuable Hubble observing time would have been Robert Williams, director of the Space Telescope Science Institute. Williams had taken on the job just before the repair mission to Hubble in December 1993.

Even though Hubble data were usually held back for a year for confirmation, Williams decided to release the Hubble Deep Field immediately so the astronomical community could set to work on it right away. One astronomer likened the resultant outpouring of data to "drinking from a fire hose."

Instead of criticism, with the final image widely regarded as a scientific and public relations triumph, Williams earned plaudits from astronomers and a request from aides of Vice President Al Gore for a copy of a poster that displayed the Hubble Deep Field.

Simultaneously, Hutton's contemporary, astronomer William Herschel, was exploring "deep space." In a time when most astronomers focused only on our solar system, Herschel envisaged a universe of galaxies beyond our own Milky Way. The great Andromeda Nebula was, Herschel estimated, so distant that its light journeys for some 2 million years to reach Earth, a number that struck his fellow scientists as astonishingly high. Even then it was understood that we may sense things happening after they've happened, the delay directly related to how fast the information travels to our senses. We see the lightning flash before we hear its associated clap of thunder because light travels so much faster than sound. There is a relationship between the delay, the relative speeds of the light and sound signals, and the distance to the event. In other words, delay time and distance are related.

Light from this book you are now reading will reach your eye in a tiny fraction of a second. Sunlight takes a bit over 8 minutes to journey to us, while light from the surface of Jupiter typically arrives in about 43 minutes. The light from the star nearest to the sun has a journey time to us of just over 4 years. Our telescopes see M87, the giant elliptical galaxy at the heart of which is a supermassive black hole (see Moment 03, pages 38–39), as it was roughly 50 million years ago. This is because the light from it has taken that long to reach Earth. Telescopes like Hubble are therefore time machines that transport us back to earlier times. The more distant the object Hubble scrutinizes, the longer the light has taken to reach us, and so the earlier into the history of the universe we have delved. By peering deep into space, astronomers are also traveling deep into time.

DEEP INTO SPACE
MEANS BACK INTO TIME

Astronomers today, unlike Hutton and his traveling colleagues, are very much used to "looking so far into the abyss of time." They do it on a daily basis and have sought endlessly to reach farther and farther back into that abyss by improving observing tools and techniques. As Edwin Hubble himself put it in 1936, "Eventually we reach the dim boundary—the utmost limits of our telescopes. There, we measure shadows, and we search among ghostly errors of measurement for landmarks that are scarcely more substantial. The search will continue." The Hubble Deep Field image project was intended to survey what lay at the Hubble Space Telescope's "utmost limits."

When Hubble was launched in 1990, some astronomers had harbored doubts about how much better than ground-based telescopes its vision would prove for studies of far-off galaxies. One group of astronomers calculated Hubble would possess a quite limited performance edge over telescopes on the ground. But following the servicing mission in 1993 that

corrected its spherical aberration, images from Hubble of distant galaxies told another and more optimistic story. These images disclosed many of the remotest galaxies to be quite unlike the spiral and elliptically shaped galaxies with which astronomers were very familiar, which are observed in profusion in our own local region of the universe. These results were sufficiently promising that they inspired Williams to hunt for galaxies at the very edge of the visible universe. The aim was to accumulate the light from extremely distant and faint galaxies with the Wide Field Planetary Camera 2 (WFPC2) by combining many single images into one grand image of the farthest depths of space ever pictured.

A SHOT IN THE DARK

The Hubble Deep Field was literally a shot in the dark. Astronomers picked a region of the sky for its relative

emptiness and apparent lack of nearby objects. Bright stars would saturate the camera's electronic detectors and spoil the view of more distant, dimmer objects. The target area also needed to be far from the Milky Way, a crowded part of the sky rich in stars, nebulae, and clouds of gas. Nor did it make sense to pick an area of sky containing known and already cataloged clusters of galaxies. Astronomers also wanted the target area to lie within one of Hubble's continuous viewing zones—narrow rings around the north and south celestial poles that can be examined even in the daylight part of its orbit around Earth without any interference from either Earth or the sun.

Hubble started its sequence of Deep Field exposures on December 18, 1995, with the WFPC2 trained on a small part

Scottish geologist James Hutton interpreted the rock formations at Siccar Point in Scotland in terms of deep time—the notion that Earth's history has to be reckoned in terms of vast stretches of time.

of the sky near the Big Dipper for some 150 orbits over a total of ten days. All told, the result was the equivalent of an exposure of nearly 100 hours. What the image showed was an astounding array of objects and dots of light, almost all galaxies, the majority of them four billion times fainter than can be detected by the unaided human eye. Astronomers estimated the most distant were more than ten billion light-years away, perhaps viewed as they were only a billion years after the big bang. It was a history-making composite image. Earlier observations of extremely distant galaxies from ground-based telescopes had reached as deeply as Hubble, but they had lacked the sharpness of the Hubble image, and they packed nothing like the same punch.

FIND THE MEANING IN THE DEEP FIELD

Astronomers often turn to geological or archaeological analogies to explain the significance of the Deep Field, conjuring up the sense of traveling very far into the past. The original press release called it "the deepest archaeological dig astronomers have ever done" in pursuit of the history of galaxies. It's like a core sample drilled from deep underground that provides a record from different stages of Earth's history.

But in an archaeological dig, Williams pointed out, artifacts are located in different layers of material (like at Scotland's Siccar Point) that give clues to dating those artifacts. With the Hubble Deep Field, it was as if all the layers of material had been removed so that all the artifacts (the galaxies) had collapsed into a single layer in the line of sight. The image was so deep, it did not have an informing depth of field. Younger galaxies appeared to be mixed with older ones. Faint galaxies might be very distant or they might be relatively nearby galaxies that just did not shine brightly. An image of deep space had been generated, but to construct the time line of those things found at the far limits of Hubble's vision, astronomers needed now to determine the distances to as many of those galaxies as possible using redshifts. The Hubble Deep Field offered a vast wealth of information—and unanswered questions.

In 1968, Apollo 8's crew became the first people to journey to the moon. During one of the orbits of the moon, astronaut William Anders looked back to Earth and snapped one of the most famous photographs ever, Earthrise.

M83, THE SOUTHERN PINWHEEL GALAXY

OBJECT: BARRED SPIRAL GALAXY
LOCATION: HYDRA
DISTANCE: 15 MILLION LIGHT-YEARS
OBSERVED: AUGUST 19–26, 2009

Detail of the core of the barred spiral galaxy M83. Regions of active star formation, brilliant star clusters, and both red and blue supergiant stars stand out.

STEPHAN'S QUINTET

OBJECT: INTERACTING GALAXY GROUP
LOCATION: PEGASUS
DISTANCE: 290 MILLION LIGHT-YEARS. THE UPPER LEFT GALAXY IS A FOREGROUND OBJECT AT 40 MILLION LIGHT-YEARS.
OBSERVED: JULY–AUGUST 2009

Grouping first described by Marseilles astronomer M. E. Stephan in 1877 as "four small nebulae." Hubble observed the cluster to refine knowledge of the extant tidal interactions.

HOW OLD IS THE UNIVERSE?

HUBBLE HELPS TO GAUGE THE SIZE AND AGE OF THE UNIVERSE.

HOW OLD IS THE UNIVERSE? Does it have an age? Talking about the age of the universe implies a beginning, and how can there be a beginning to *everything*? Philosophical questions aside, astronomers are today comfortable with the notion of the age of the universe—and the Hubble Space Telescope has made a major contribution to the quest to pin down that age. In fact, the great majority of astronomers now believe the universe is about 13.7 billion years old—a figure

striking in its specificity, especially when considering that estimates in 1990 ranged from 10 to 20 billion years old.

So how does Hubble help determine the age of the universe? From the start, one of the telescope's key projects was to measure the so-called Hubble constant. Named (like the telescope) for the great astronomer, Edwin Hubble, the Hubble constant puts a value to the rate of expansion of the universe. It does so by relating a galaxy's distance from Earth to the rate at which it is observed to be moving away from Earth, measured by observing shifts in the light spectra it emits.

The vast majority of galaxies are receding from our galaxy, which implies that the universe is expanding. The expanding nature of the universe, confirmed around 1930, was one of the great scientific discoveries of the 20th century. It produced a shift in our conception of the universe as revolutionary as the Copernican revolution centuries earlier, when the Earth was moved from its immobile place at the center of the cosmos and put in motion around the sun.

To get a better grasp of these ideas, imagine the history of the universe as a movie, and then hit rewind. Run cosmic history backward, and we would travel to a time when all the

material in the universe was packed together much more closely than now. Nearly all astronomers now believe that the universe began in an infinitely dense state. Its expansion began with a "big bang," and it has been expanding ever since. Therefore, the age of the universe would be reckoned as the time since the big bang.

It's important, however, to avoid thinking of the expansion in terms of material hurled outward into a preexisting space from a central point in the manner of, say, a bomb exploding in a room and shrapnel flying out into all parts of the room. The universe is nothing like a room: There is nothing to expand *into*. It is more helpful to think of the space between the galaxies as being stretched. It's this stretching that carries the galaxies farther away from each other. The galaxies don't travel *through* space, but they do, as space itself stretches, travel with it over time.

THE HUBBLE CONSTANT

Determining that there is such a thing as the Hubble constant is a first step, but astronomers knew that determining the constant's value would be exceptionally hard in practice. Enter

In addition to beautiful young star clusters like NGC 346, the Small Magellanic Cloud contains many Cepheid variable stars. It was the site used by Henrietta Leavitt to establish the critical period/luminosity relation for Cepheids.

Edwin Hubble spent his career exploring the universe beyond our own galactic system. His achievements led to the Hubble Space Telescope's being named in his honor.

HONORED WITH A TELESCOPE NAMESAKE

Edwin Hubble made his first great discovery in 1924 when, with the aid of the 100-inch telescope at the Mount Wilson Observatory in California, he clinched the case for the existence of galaxies beyond our own Milky Way. In that year, he stumbled across a Cepheid variable star in the Andromeda Nebula (we now call it the Andromeda galaxy). By observing the Cepheid's variations in brightness, he was able to roughly estimate its distance to be 900,000 light-years. Less than its present value, but far beyond the boundaries of our own Milky Way system. This opened the way for astronomers to accept that the universe contains many galaxies.

In the late 1920s, Hubble worked with Milton Humason. Together, they tried to answer the question of whether or not the redshifts of the galaxies (measured by Humason) correlated in some way with their distances from Earth (measured by Hubble). They found that a straightforward relationship existed: Double the distance to a galaxy, and the redshift will be doubled; increase the distance fourfold and the redshift will be increased fourfold too; and so on. In time, this relationship became known as Hubble's law, and the constant that relates velocity and distance is known as the Hubble constant—though Hubble himself (unlike nearly all other astronomers) was never convinced the redshifts were really velocities.

the Key Project Team on the Hubble constant, led by Wendy Freedman of the Pasadena-based Observatories of the Carnegie Institution of Washington. This group of astronomers had been selected in 1986, so the astronomers were ready to begin observations as soon as Hubble launched.

There are two parts to determining the Hubble constant: measuring the velocities of receding galaxies and measuring the distances to those galaxies. Velocity is determined by measuring a galaxy's so-called redshift. If a light source, say a galaxy, is moving with respect to an observer, then its speed can be reckoned by measuring how much the galaxy's spectral lines shift toward the red or the blue end of the spectrum. These spectral lines are produced when atoms in a gas absorb or emit light. Within the full rainbow of color spectra, dark lines indicate a hot, dense object with a cooler gaseous envelope, while bright lines in the absence of the rainbow indicate a purely gaseous object, hot but low in density. A blueshift, or move toward the blue, means the object is moving toward us; a redshift, or move toward the redder end, reveals the object is traveling away. Provided a galaxy is not too dim, determining its redshift is a relatively straightforward operation.

UNDULATING LIGHTS

The Hubble constant expresses the relationship between velocity and distance, and so the second part of determining the constant involves calculating the distances to galaxies. For this, astronomers must choose from a variety of complicated methods. As Freedman has pointed out, "Each has its advantages, but none is perfect."

The most important method requires observation of Cepheid variable stars, so called because the first was identified within the constellation Cepheus. Cepheids display extremely regular undulations: patterns of dips and increases in brightness that distinguish them from other stars. They are also 1,000 to 100,000 times brighter than the sun, and so Hubble can detect them even in galaxies 100 million light-years away.

Distances to most objects in the universe are challenging to measure accurately, but Cepheids can reveal their distances to us in the length of their light variations. Cepheids were crucial to Edwin Hubble's demonstration in the mid-1920s that there are indeed galaxies beyond our Milky Way system (see sidebar, page 80). He, and later astronomers too, relied on the remarkable property of the Cepheid stars first noticed

Two images of the spiral galaxy NGC 5584: In the image on the right, Cepheids with periods shorter than 30 days are marked with green circles; for periods of 30 to 60 days, with blue circles; and for longer than 60 days, with red circles.

early in the 20th century by Henrietta Swan Leavitt, an astronomer at the Harvard College Observatory in Cambridge, Massachusetts. By examining a field of Cepheid-type variables in the Small Magellanic Cloud (and hence effectively at the same distance from Earth), Leavitt established that the time between the successive peaks in brightness for the Cepheids was related to their luminosity (intrinsic brightness): the longer the time between peaks, the brighter the Cepheid. To reckon the distance to a Cepheid, an astronomer needs to measure the time between peaks of maximum brightness and the apparent luminosity of the Cepheid, and then compare the calibrated actual luminosity with apparent luminosity.

But astronomers wanted to stretch our knowledge of the universe beyond the distance to visible Cepheids, and they exploited the Hubble Space Telescope in that quest. Conflicting methods of determining distances led to values for the Hubble constant between 50 and 100 kilometers a second per megaparsec (one parsec is equal to 3.26 light-years, so a megaparsec is equal to 3.26 million light-years)—values so disparate that they indicated the universe could be anywhere from 10 to 20 billion years old: not a satisfactory answer.

AGE CRISIS AVERTED

The new and improved Hubble Space Telescope allowed Freedman's team to discern Cepheids at great distances, and calibrate them against other methods of determining distances,

HST FACT

The Andromeda galaxy is one of few that are not receding from us but moving toward us. About 2.5 million light-years from the Milky Way, the two will collide head-on in about four billion years.

like supernovae. The team's preliminary result, announced in 1994, implied an age of the universe of between 8 and 12 billion years. Many astronomers considered this an uncomfortably short period of time and began talking of an "age crisis" in astronomy, cosmology, and astrophysics. Some stars in the Milky Way as well as stars in the globular clusters that orbit the Milky Way had been calculated to be older than 12 billion years. But how could stars in the universe be older than the universe itself? "We live in a special time," commented one astronomer. "After millennia of not knowing the size and age of our universe, we soon will. We also live in a time of crisis, for we may be forced to accept something new about the ages of the stars or the nature of the universe."

Freedman's team continued their studies, aided by Hubble's resolving power and ability to detect Cepheids among crowds of stars in far-off galaxies. By 1999, the 27 astronomers on Freedman's team announced their more certain determination that the Hubble constant equaled 70 kilometers a second per megaparsec, plus or minus 7—a calculation founded on some 800 Cepheids in 18 galaxies. With Hubble, astronomers located many more Cepheids, and so the work stretched on into the future. The new value of the Hubble constant did quell one debate, however: It implied that the universe was between 12 and 15 billion years old—a finding more in keeping with astronomers' calculations for the ages of stars. The age crisis was a crisis no more. Hubble had delivered.

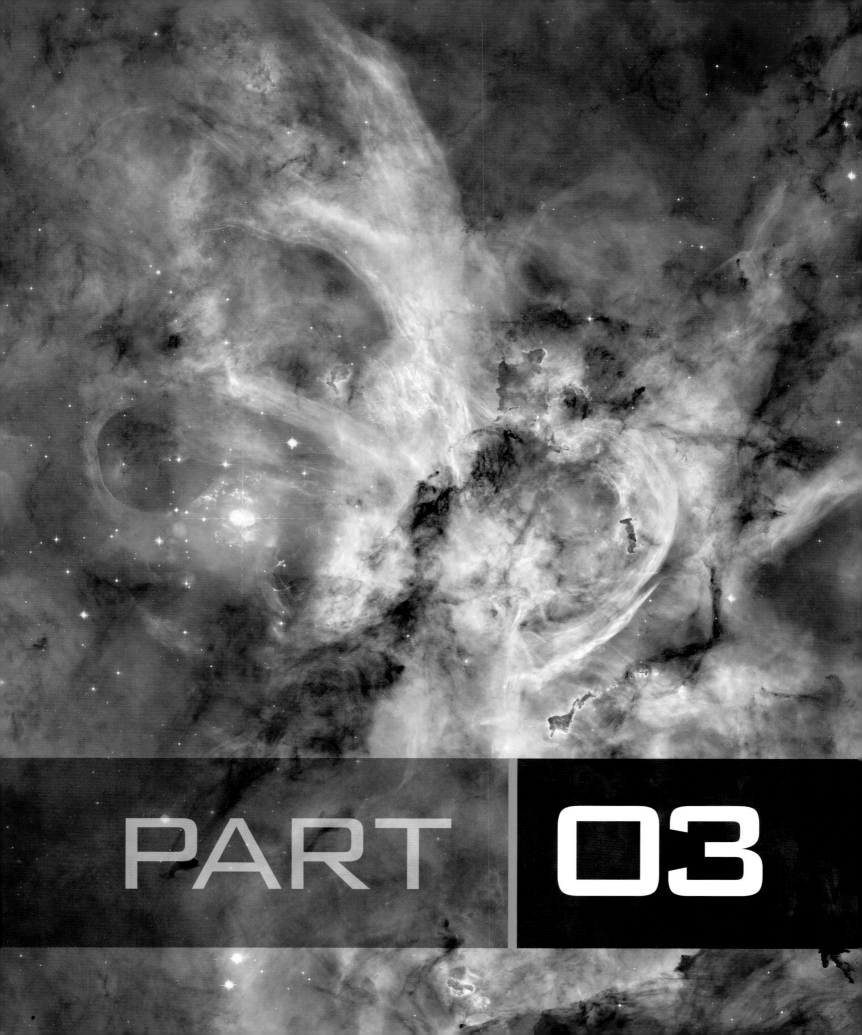

PART 03

REACHING DEEPER INTO THE RED

IMPROVED EYES ON HUBBLE REVEAL STARS IN FORMATION AND CLARIFY DETAIL ON PLANETARY SURFACES.

T HE SECOND SERVICING MISSION to Hubble in February 1997 installed a new camera in one of the telescope's axial instrument bays called NICMOS (Near Infrared Camera and Multi-Object Spectrometer). NICMOS extended Hubble's eyes deeper into the infrared, that part of the spectrum of light energy we can't see with our eyes but can feel with our skin as heat. NICMOS has three cameras and all sorts of attachments to sense either narrow or broad bands of the spectrum.

It can also sift the light bands themselves into a spectrum, block central portions to reveal faint outer details in objects, and even sense if the light is polarized or aligned in ways that reveal the presence of magnetic fields. It is an army unto itself, or at the least a brigade. And it does all this with the ultrahigh spatial resolution of the corrected Hubble optical system.

NICMOS

NICMOS was optimized to see cool objects, not only in temperature but also on the light spectrum: objects that are extremely interesting to astronomers who want to understand how galaxies formed in the early universe, or how stars and planetary systems form out of the cool, vast clouds of gas and dust in space that shroud and nourish them. To sense cool objects, however, Hubble's eyes themselves have to be cooled to temperatures well below that of the objects they want to

Preceding pages: The Carina Nebula complex, a vast star-forming region in the core of our Milky Way spiral arm. Composite portrait incorporating high-resolution Hubble data and the high-contrast abilities of the Blanco telescope highlights star-forming processes. Observed December 2001, March 2003, and March–July 2005.

study. So NICMOS sits in a refrigerator called a "dewar" that uses solid nitrogen as a deep coolant, or "cryogen." The detectors sit in a series of three nested cylindrical capsules that look like a set of progressively larger propane tanks. At launch, the middle tank carried 240 pounds of solid nitrogen coolant in a matrix of aluminum foam. The coolant was pumped in as a liquid, and then cold helium gas was circulated through pipes in the chamber to freeze the nitrogen completely to about 40 kelvins (40 degrees above absolute zero). Under operating conditions, the coolant was expected to last about four years. In actual fact, various problems reduced it to only two years, after which NICMOS was taken offline pending the next servicing mission, when it would be reinvigorated by an active closed-circuit cooling system.

Within its first year, NICMOS observed faint galaxies in the Hubble Deep Field (see Moment 08, pages 70–71). It also peered into the dense center of our Milky Way galaxy, and searched for and studied detailed structures of the disks of gas and dust that surround many nearby stars. Among the first users, a team of UCLA and Caltech astronomers proposed to look at a rather puzzling object in the direction of the

MOMENT
10

MAMMOTH STARS

THE HUBBLE SPACE TELESCOPE
PEERS DEEP INTO GALAXY CENTERS
AND FINDS NEW SURPRISES.

Very hot Wolf-Rayet stars in the
Carina Nebula complex are energetic
enough to rapidly evaporate dense
dust and gas clouds where stars are
still trying to form. The provocative
"finger" seen in the image on pages
182–183 points directly to these stars.

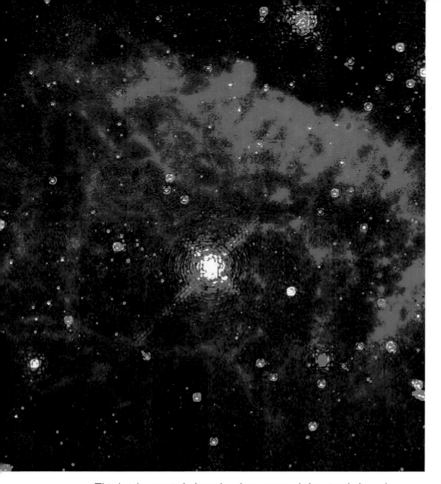

This bright star is believed to have created the pistol-shaped nebula above it from eruptions that took place some 4,000 to 6,000 years ago as the massive star shed its outer layers.

constellation Sagittarius (Archer) and near the center of our galaxy: the Pistol star.

THE CENTER OF THE MILKY WAY

Just as the real action takes place downtown in the city center, so astronomers are especially interested in what happens in the center of our Milky Way galaxy. Since June 1994, the UCLA astronomers had been engaged in an observing program at California's Lick Observatory using the 120-inch Shane reflecting telescope with a special near-infrared detector they had built. Their goal was "to assess the ubiquity of young, hot, and luminous stars near the Galactic center." Ubiquitous or not, observing from Earth at an altitude of some 4,300 feet, and so miles under our own atmosphere, they could just barely penetrate the obscuring dust and gas in this very murky part of the galaxy. But the astronomers penetrated it enough to realize that there were, indeed, some really interesting stars lurking there. One deserved closer attention. It was located very close to a pistol-shaped nebula, and quite possibly was creating it by the flood of ionizing photons it was emitting. It may have looked cool, but it was

acting as if it was very hot and massive. Because of this possible link, the reddish star was dubbed "the pistol." Don F. Figer, one of the UCLA astronomers, had explored it for his Ph.D. thesis starting in 1993, and began to wonder if the nebula itself, rather than being just excited by the star, was actually created by explosions from that star in past time. This question became one of his UCLA team's goals for observing the star with Hubble's new NICMOS camera.

THE PISTOL STAR

What the scientists found was that the star was the source of a huge stellar wind of high-energy particles and radiation, billions of times stronger than the wind generated by our own sun. Only a supermassive star of extreme luminosity could produce the winds they were detecting. Making all the calculations, they found that the star was among the most massive yet detected, some 200 times the sun's mass when it was first formed—only 1 to 3 million years ago. Since that time, its eruptive bursts shed it of much of its mass, which is now partly in the form of the Pistol Nebula. And given its continuing eruptive nature, and its overall energy output, the star is not likely to last much longer, maybe becoming a supernova within a few million years.

If the Pistol star was not shrouded by the gas and dust in the direction of the center of the galaxy, it would be a star bright enough to be seen directly by eye from Earth. At 25,000 light-years distance, this makes it one really bright, massive star. It certainly is not a stable star; with the observations collected and analyzed, astronomers soon realized it violated every rule in the book for the way stars should behave. That's what made it so interesting.

SCOPING OUT STAR FORMATION

Actually, the Pistol star is part of a larger story about the Hubble Space Telescope and the history of how massive stars can become. Before astronomers enjoyed the superb resolving power of Hubble or the ingenious optical and imaging electronics revolution of recent years, there were some suggestions that stars thousands of times more massive than the sun might well exist. Theorists who built stars on computers could not create anything that massive that was remotely stable, but observations of incredibly active regions like what appeared to be a stellar knot, or tight cluster of stars, in the 30 Doradus

LOTS OF ACTIVITY, CENTER STAGE

How do we know our Milky Way has a center? Today, there is plenty of evidence, though in fact, we cannot actually "see" the center with our eyes because it is shrouded in countless masses of gas and dust. But as Andrea Ghez and her UCLA team have shown using the Keck Observatory telescopes, there is something huge lurking there. Something astronomers call a supermassive black hole. Everything else in the galaxy seems to move around this spot in space, but it took many years to realize this.

The fact that the Milky Way has a center at all was argued indirectly by astronomer Harlow Shapley, even before we knew that our galaxy was one of countless in the universe. Working at the Mount Wilson Observatory near Los Angeles throughout World War I, Shapley knew that clusters of stars called "globulars" were not evenly distributed throughout the sky. There were more than 80 of them, and they seemed to appear equally on both sides of the Milky Way. Far more, however, appeared in the direction of the constellations Scorpius and Sagittarius than appeared in other directions. But there were very few actually within the plane of the Milky Way itself.

In addition to the clusters' angular distribution, Shapley also had the means to determine their distances. These clusters contained Cepheid variable stars that varied in light very regularly and which Harvard astronomer Henrietta Swan Leavitt had shown just a few years earlier to be valuable distance indicators (see Moment 09, pages 80–81). Shapley applied this relationship, measured the periods of variation of light in these stars in globulars, and so determined their intrinsic brightnesses. Comparing that to their apparent brightnesses, he had a measure of distance based on the simple principle that the apparent brightness of an object is a product of two things: how bright it really is and how far away it is. So armed with distances and directions, he mapped out the full space distribution of the globulars and declared that their centroid, or geometrical center, lay in the direction of the constellation Sagittarius, in the heart of an unusually bright region of the Milky Way.

The distance Shapley inferred for the distance to the galactic center was so great he concluded that the Milky Way was the entire visible universe. Edwin Hubble did not agree with this, as we saw in Moment 09.

star-forming region in the Large Magellanic Cloud (popularly known as the Tarantula Nebula) behaved like a supermassive star, with characteristically huge stellar winds.

After Hubble was engaged in 1990, turning its Faint Object Camera to the object and still hampered by its imperfect mirror, the telescope helped to confirm that there was an entire cluster of violently hot stars involved. Indeed, the knot in 30 Doradus contained more than 60 very tightly packed stars. Ground-based observations had just shown some two dozen stars were involved, but Hubble's direct observations showed far more, and provided hints that some of these stars could be more than 100 times the mass of the sun. This gets us back to the Pistol star and the eponymous nebula of its own creation.

HST FACT

Harlow Shapley was the first astronomer to demonstrate that the sun and its attendant planets were not at or even near the center of the Milky Way.

Just as Hubble has been used to continue ever closer scrutiny of star-forming regions like 30 Doradus, it has helped to show that there are such stars at the center of our galaxy, and indeed, star formation occurs there too. This was something of a surprise to astronomers, who are now investigating what took place a few million years ago to stimulate a burst of star formation. No doubt among the many responsible factors may be the monster lurking at the very center of the galaxy: a gigantic supermassive black hole like those sensed in other galaxies (see Moment 03, pages 38–39). Hubble's observations were not alone in helping astronomers come to this realization, but they remain essential in enhancing our understanding of how, and where, stars are forming in the universe, and how the process of formation changes over time.

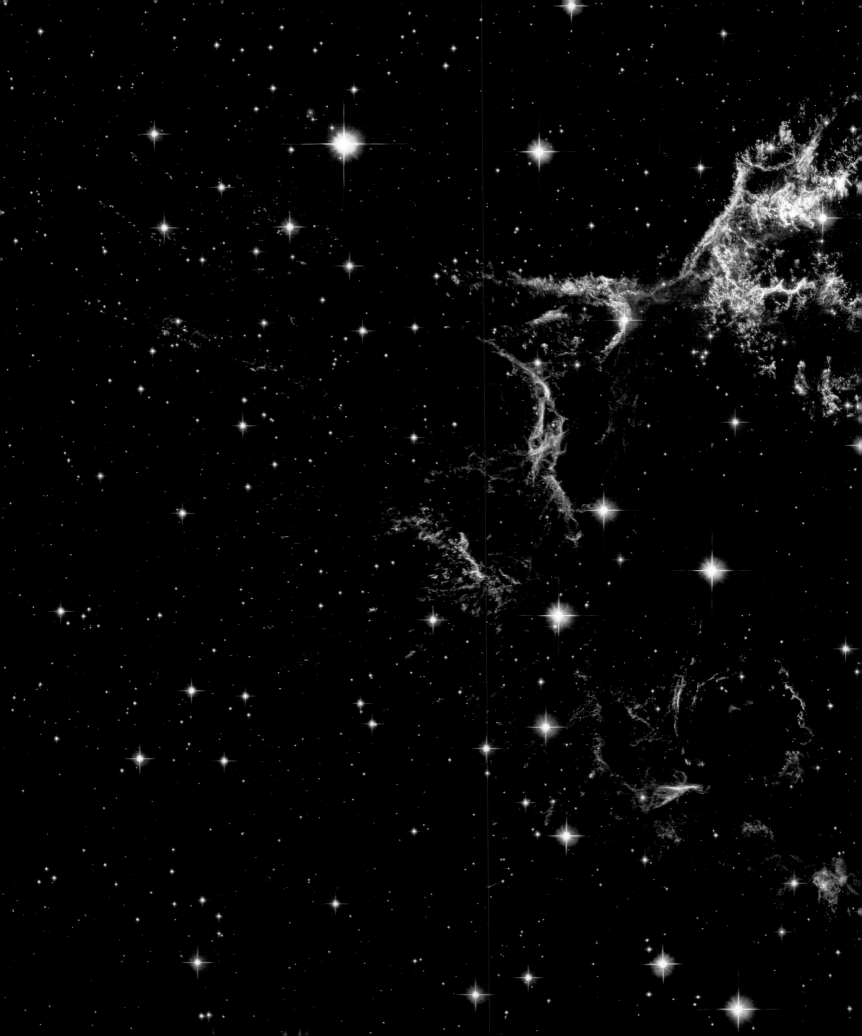

CASSIOPEIA A

OBJECT: SUPERNOVA REMNANT AND RADIO SOURCE
LOCATION: CASSIOPEIA
DISTANCE: 11,000 LIGHT-YEARS
OBSERVED: MARCH 2004, DECEMBER 2004

Composite mosaic image of the debris from a supernova explosion that was reconstructed from many exposures with the ACS. There is no definite historical record of the progenitor supernova, estimated to have occurred in the 1670s.

A collage of the Orion Nebula combining high-resolution ACS images with a wide-field view from the European Southern Observatory's 2.2-meter telescope at La Silla, Chile. A close view is on pages 48–49.

MAKING AND BREAKING PLANETS

HUBBLE SPOTS PIGS AND PROPLYDS,
SIGNS OF PLANETS FORMING.

O N A CLEAR WINTER NIGHT, the heavens are a wondrous sight, inspiring questions about where stars come from. Here and there among the stars, there are a few tiny, elusive clouds of light that our ancestors most assuredly noticed, and maybe wondered about, if not recorded. One of these fuzzy bits lies within the gentle arc of stars the Greeks called Andromeda, and the other rests within the sword scabbard of the mighty hunter, Orion. • Both of these luminous clouds,

then called nebulae, are now known to be places where stars are born and die. They and their kin attracted much attention after telescopes were improved and applied to closer scrutiny of the nature of objects in deep space. Andromeda eventually was found to be a galaxy, as large as the system of stars we live in, but vastly farther away than any star in our galaxy (see Moment 09, page 78). And Orion is a place where stars are being born before our eyes. Edwin Hubble was the astronomer who provided the first insight, with the Mount Wilson Observatory's 100-inch telescope. And his telescopic namesake, equal in size to Mount Wilson's but in orbit high above Earth, confirmed where stars are born, after it was directed to Orion by an astronomer who had been its project scientist for more than a decade.

SEARCHING FOR WHERE
STARS COME FROM

A well-established observational astrophysicist, C. Robert O'Dell specialized in studying how stars formed from gaseous nebulae. In the early 1970s, he accepted the demanding challenge of being project scientist for what was then called the

Large Space Telescope at NASA's Marshall Space Flight Center in Huntsville, Alabama, because he was intrigued by working with a space telescope. He came to believe that such a device provided the means to observe the heavens "vastly better than you can ever hope to do on the ground."

When the telescope went into operation, O'Dell knew what he wanted to do with it. He had been studying the Orion Nebula since the mid-1960s at the Yerkes Observatory in Wisconsin, peering deep into the nebula to determine what it was made of, learning how the gases and dust within it swirled to and fro, either to condense into stars, or to tear barely forming stars asunder.

As former project scientist in 1990, he was on the first team to use the Hubble Space Telescope. O'Dell now was armed with an instrument whose powers would have been like magic to his forebears. Soon after launch in April 1990, he planned to use the Goddard High Resolution Spectrograph on Hubble to examine the dynamics of gas and dust grains in interstellar clouds, searching for how the gases condense on the grains and, variously, if and how the grains were being destroyed by turbulence. He put together a team of

C. Robert O'Dell (near left), a former Space Telescope Project scientist, employed Hubble to probe the Great Nebula in Orion, cataloging a wide variety of shock phenomena (far left) and their influence on star formation—and destruction.

ORION NEBULA, CELEBRITY OF THE NIGHT SKY

The Orion Nebula was among the first objects to be examined by astronomers when they acquired new tools to explore the universe, and it continues to hold interest as our technologies advance. Detection of the great nebula itself is as old as the telescope. It was described as early as 1610 and the first published description dates from 1619. Charles Messier listed it as object #42 in his catalog in the 1770s. Astronomers William Herschel and William Parsons, third Earl of Rosse, spent many nights with their gigantic reflectors tracing its wisps, knots, and tendrils in the late 18th through the mid-19th centuries, looking for the subtlest of changes. It was among the first objects to which astronomer William Huggins turned his spectroscopically equipped telescope in 1865, confirming immediately that it indeed was a gaseous nebula, and not an assemblage of stars too faint and distant to be resolved. In the 1870s, before he became the founding director of the Lick Observatory, E. S. Holden spent much effort collecting all descriptions of the object, hoping to discern evolutionary change and learn, specifically, if and how stars were born out of those luminous mists.

In 1880, American astronomer Henry Draper was the first to actually photograph the heart of the Orion Nebula, and three years later, A. A. Common's wide-field photographs first recorded its extent. Since then, it has been the hottest target for telescopes coming online, as a litmus test of their worth and as a testimonial to the spirit of discovery: There's always more to be learned, and the Hubble Space Telescope has shown us even more about this famous fuzz in the sky.

astronomers to image the Orion Nebula. They chose to image sections of the nebula in highly selected spectral bands where sulfur, hydrogen, and oxygen are bright and would reveal the dynamics of the cloud. The fine structure in their first images of the nebula showed what could be tiny regions of turbulence and coalescence. Maybe they were protoplanetary disks, new-born planetary systems just forming around young stars.

OF PIGS AND PROPLYDS

Intense scrutiny of the field in the following months led O'Dell, with colleagues from Rice University and the Kitt Peak National Observatory, to announce in late 1992: "We have found numerous new compact sources (CSs) which may be keys to understanding the nature of star formation." These sources had been glimpsed by others, who called them compact partially ionized globules—or, using the unglamorous acronym, PIGs. Adding high-resolution radio telescope data and evidence from other optical searches over many wavelengths, including the infrared, O'Dell and his colleagues realized that the centers of these PIGs were most likely stars, "thus strengthening our arguments for these being protoplanetary disks." They coined a term for this newly discovered type of object: proplyd. The scientists found more than a dozen proplyds, and each typically appeared as a disk with a hole in the middle where the star was. Further, many of these tiny objects were irregular. Some even looked like comets with tails.

But the astronomers knew these were not comets. They might have looked small, but at a distance of some 1,500 light-years, they were 50 times larger than Earth's orbit

around the sun! O'Dell and his colleagues soon realized they were looking at vast shock fronts disturbing the medium around them, like the bow waves of a ship plowing through the sea, or a jet breaking the sound barrier. In these cases, though, it was the medium that was moving: Intense ultraviolet radiation from nearby hot stars at the heart of the Orion Nebula was boiling off material from the surface of the proplyd and then propelling it into the shape of a comet, constrained by the stellar "wind" of radiation and particles blowing out of the intensely hot stars.

As O'Dell and his colleagues well knew and stated in 1991: "Even given its impaired performance, [Hubble Space Telescope] allows us for the first time to visually explore the structure [of these objects] on size scales of 0.1 second of arc [some 50 times the size of the Earth's orbit at the distance of the nebula]." What would they see once Hubble's vision was fixed?

HST FACT

Use an ancient technique to see the Orion Nebula. Look at the three bright stars of Orion's belt, and you'll notice that your peripheral vision picks up a fuzzy cloud right below it.

LOOKING CLOSER

In December 1993 and January 1994, "immediately after the successful repair and refurbishment mission," as he later reported, O'Dell and his colleagues gained more telescope time to use the Hubble Space Telescope to peer into the Orion Nebula. They quickly found many more proplyds and improved their understanding of the structures of these spectacular and fascinating objects.

Most important, they found that half the objects they scrutinized had protoplanetary structures. Did this mean that planetary systems were common in the galaxy? Up to that time, only a few extrasolar systems were believed to have been detected. This was compelling evidence that more would be found if only the effort was made.

Protoplanetary disks, or proplyds, in the Orion molecular cloud complex show the interplay of forces promoting the formation and destruction of these stars and their attendant planetary systems.

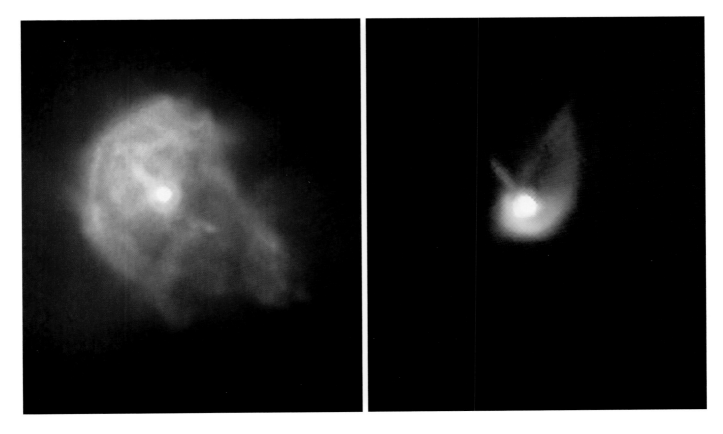

Through the rest of the 1990s, O'Dell and his colleagues probed the nebula. Many other astronomers joined the fun, making observations, developing interpretive models, and constructing simulations. Scientific papers on proplyds continue to this day, but they peaked at more than 25 a year in the years 2000 through 2003. As astronomers studied the dynamics of these objects and the intense forces playing upon them, they realized that they were looking at a tug-of-war between the forces of creation—self-gravitating clumps of gas, grains, and dust drawing material into themselves, including the accreting disks of protoplanetary material—and the forces of destruction—the penetrating and disruptive radiation of the nearby hot stars of Orion called the Trapezium. Not all protoplanetary systems would survive to have planets in attendance.

The tug-of-war became the $64,000 question for astronomers who wanted to know (along with the rest of us) if we are alone in the universe. O'Dell teamed up with specialists like John Bally, who studied the disruptive interactions of dense molecular clouds with hot ionized sources. By 2000, they were achieving higher resolution and clarity than ever before, using deep narrow-band imaging with the WFPC2 at a wide range of wavelengths combined with powerful spectroscopic instruments on Hawaii's Keck telescope.

The astronomers first confirmed, in Bally's words, "that planet formation is a hazardous process." They also found strong evidence that in proplyd systems with sufficient shielding, cold dust grains could sometimes coalesce into clumps of dirty ice, which could eventually develop into rocky planets. Only about 10 percent of the proplyds seemed to have enough mass to survive to form planets, but the astronomers speculated that even in systems where the disks evaporated, enough rocky material would survive to form planets. So the search continued.

A meadow glistens in Japan in November 2010. In this photo by Masahiro Miyasaka, Orion is visible above the southern horizon. The three bright stars in a line mark his belt, and the Great Nebula in Orion is just below the belt.

SHARPLESS 2-106 (S106)

OBJECT: STAR-FORMING REGION
LOCATION: CYGNUS
DISTANCE: 2,000 LIGHT-YEARS
OBSERVED: FEBRUARY 12–13, 2011

In the 1950s, astronomer Stewart Sharpless compiled a catalog of bright nebulae exhibiting hydrogen emission. Many of them, like S106, are regions of star formation. S106 is bipolar, exhibiting two vast lobes of hot gases (blue) emanating from a central star obscured by a dark ring of dust and gas.

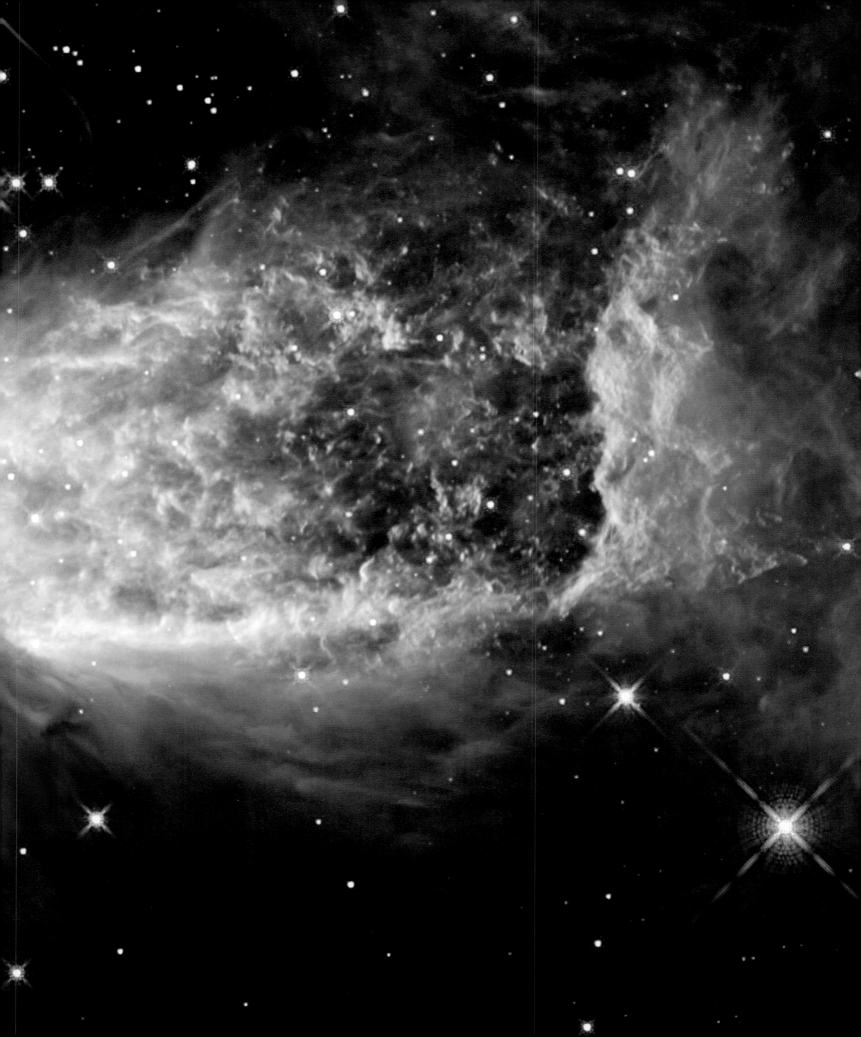

MINDING THE SOLAR SYSTEM

HUBBLE OBSERVATIONS CLEAR THE PATH
TO THE ASTEROIDS AND PLANETS.

WILLIAM HERSCHEL, KING GEORGE III'S astronomer, was often called away from his telescopes to amuse the king and his royal court. But Herschel's sister, Caroline, stayed home, "minding the heavens." They never knew when something exciting might happen in the solar system, so she always was on the alert, and in fact made several significant discoveries. Two hundred fifty years later, the Hubble Space Telescope proudly follows in this tradition.

FIRST PLANET OUT: MARS

For instance, Hubble has kept a watch on the planet Mars since the telescope's launch, joining the array of missions intended to observe the red planet. By the time Hubble was launched, about two dozen missions to Mars had been already attempted by Russian and American craft. The Russian missions—flybys, orbiters, and landers—were mainly failures, although their Mars 3 orbiter returned data for 6 months and Mars 5 provided data a bit longer.

American efforts were more successful. Five Mariner flybys returned more than 7,500 images. The Viking orbiters and landers returned massive amounts of data on the surface and atmosphere. The Viking 1 and 2 orbiters lasted till 1980 and 1978, respectively, and the landers until 1982 and 1980, also respectively. Mars had not been monitored close-up since, and Hubble offered new possibilities.

One of the long-term programs assigned to Hubble was to monitor Martian seasons and climate, looking for changes on the surface of the planet and in its atmosphere, and collecting data useful for understanding its global weather patterns. Using the WFPC in its planetary camera mode,

processed images achieved resolutions significantly higher than could be obtained from large ground-based telescopes at the time. Within a year of the launch, Hubble was producing images of Mars that could resolve high-contrast features as small as 31 miles across.

Only when Mars Global Surveyor dropped into orbit around Mars in 1997 and started observing with its Mars Orbiter Camera (MOC) were Hubble's responsibilities in that direction relaxed. The MOC could resolve surface features less than two feet across as well as monitor the entire globe, making measurements in tune with Mars Global Surveyor's other instruments, which were critical for making plans for a new wave of Martian landings. So Hubble could turn to other objects in our planetary family.

MONITORING THE MINUTIAE

The more we get to know the solar system, the more we realize that its little bodies hold some of the keenest clues to the origin and evolution of our home turf. Comets carry original unprocessed materials from the vast interstellar cloud that collapsed to form the solar system. Asteroids are the

A composite image from exposures by WFPC2 of Mars at its closest approach to Earth on August 26, 2003, from 22:21:52 to 23:12:18 hours Universal Time displays the south polar cap and the Hellas region above the cap and to the right.

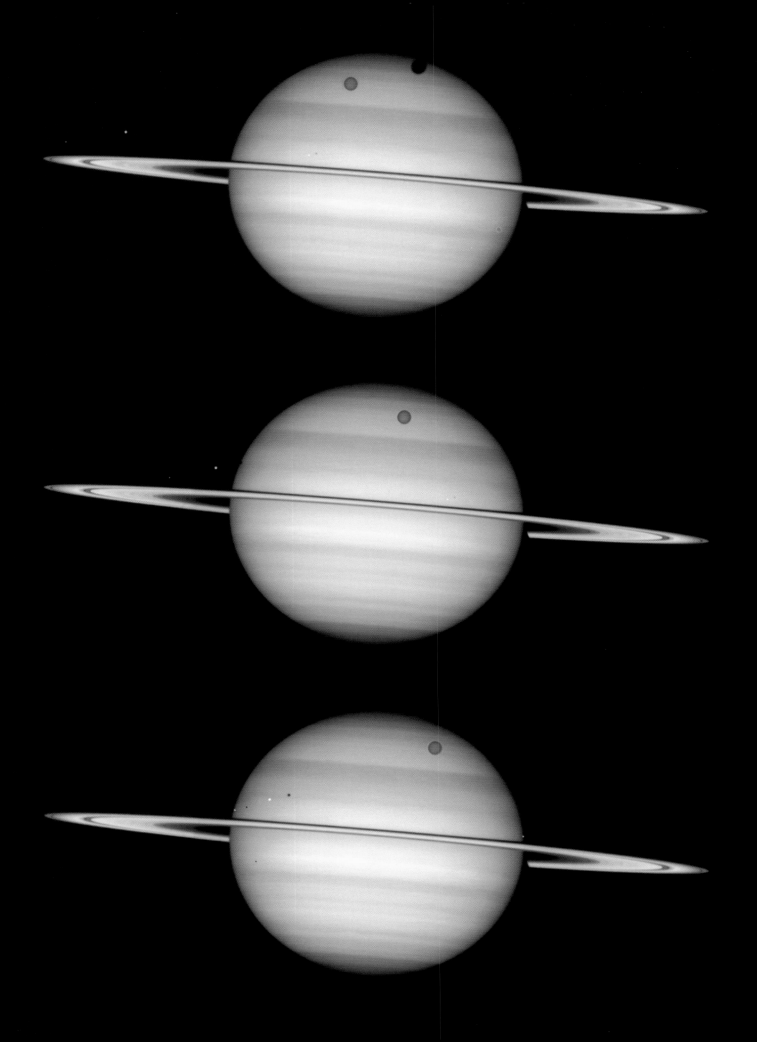

remnants of the collisional processes that formed the planets, or were prevented from coalescing into planets due to the formation of the giants. Their compositions, structures, and dynamical histories help us better understand the accretion processes that built the major planets. When the first asteroid—Ceres—was discovered in 1801, it was regarded as another planet. But when more like it were found, astronomers recognized them as a new class of bodies in space.

Over four days in November and December 1994, Hubble's new Wide Field Planetary Camera 2 (WFPC2) monitored the asteroid Vesta when it was 156 million miles from Earth. Vesta, one of the largest known asteroids at 325 miles in diameter, was imaged continuously to make a full surface map, as well as to assess its rotation rate and overall shape. Imaging Vesta was akin to imaging an American quarter 7.5 miles distant. Even so, Hubble found large and varied features, from lava flows to a spectacular basin, evidently the result of an impact that was so deep it exposed the inner structure of the body.

CHARTING ASTEROIDS

Far from homogeneous, as most theories had assumed, Vesta has differentiated structure, with crust and mantle just like the major planets, indicating that it was originally molten and its denser materials gravitated to the center of the body. Vesta has now been visited close-up by the Dawn mission, which arrived in July 2011 and dropped into low orbit, just 100 miles above its surface. Dawn left Vesta after about a year and will encounter Ceres, an asteroid even larger than Vesta, in 2015. Ceres has been monitored by Hubble since 2003.

Hubble's technologies have given astronomers new ways to look back into the birth process of comets in our solar system. In late 2009, several astronomers decided to do something really creative with the vast accumulating electronic

In 2014 Hubble completed a survey of disks made of dusty debris around stars—the result of collisions between objects left over from the formation of planets around those stars.

archive of Hubble data. In addition to the major instruments on the multifunctional observatory, Hubble has three Fine Guidance Sensors (FGSs), small telescopes that lock onto guide stars to stabilize and point the spacecraft. The data from these sensors are collected and archived to be sure that all factors influencing the observations of the main instruments are preserved and can be checked. But maybe, some astronomers thought, these data might reveal something new about the stars, or, indeed, might record events happening nearby in our solar system, like something tiny passing in front of the guide star, causing it to blink.

Space Telescope Science Institute staff carefully examined the observational data banks to look for interlopers near the plane of the solar system, where they knew that such tiny icebergs were orbiting in the distant region called the Kuiper belt—named for Gerard Kuiper, the astronomer who predicted it existed.

Eventually, they found one, signaled by a single 0.3-second blink. And from its character, assuming it was indeed a Kuiper belt object (KBO) and therefore at about 4 billion miles distant, they determined that it must be only a few thousand feet across. Someday, if this tiny ice world were to be nudged from its orbit by a passing star, it might turn into a nice healthy new comet that would eventually stream into view and grace our evening skies.

MONITORING PLUTO

Pluto's fate was not so different from Ceres'.

As Hubble celebrates its 25th anniversary, a small spacecraft named New Horizons is approaching Pluto. Launched in January 2006 and aimed for Jupiter, New Horizons whipped around the giant planet in a gravity-assisted slingshot maneuver designed to propel it toward Pluto and its moons.

The recent story of Pluto shows how much our understanding of the solar system has changed, affected in part by Hubble's observations. When New Horizons was launched, we knew that Pluto had three moons. Charon, almost as big as Pluto itself, had been discovered in 1978 by astronomers at the U.S. Naval Observatory station in Flagstaff, Arizona.

Saturn is shown here imaged in the ultraviolet by the WFPC2. In February 2009, Hubble provided a 50-frame time-lapse movie showing all four of Saturn's moons transiting the planet, an event visible from Earth only once every 15 years, thanks to the on-edge tilt of the planet's rings. Ultraviolet imaging also reveals the distribution of aerosols in Saturn's atmosphere.

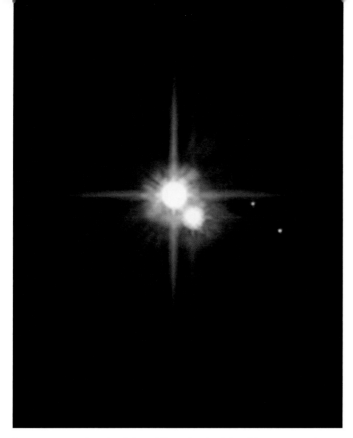

In preparation for the flyby of Pluto by the New Horizons probe in the summer of 2015, Hubble searched for new moons and any other objects of interest to examine. Two tiny moons Hubble discovered beyond Charon, to the lower right in this 2005 image, were named Nix and Hydra in June 2006.

This discovery provided the first solid means for assessing Pluto's mass, confirming as well that it could not be much larger than the state of Alaska. Two more moons, Nix and Hydra, both far smaller and fainter than Charon, were discovered by Hubble in 2005.

That mission brought us more information on Pluto. We know now, thanks to Hubble, that Pluto has at least five moons. Using its Advanced Camera for Surveys (ACS), Hubble was enlisted to search for debris around Pluto in advance of the New Horizons flyby (ACS replaced the Faint Object Camera in the 2002 servicing mission). A dust ring could create havoc for the New Horizons mission, traveling at relative speeds up to 30,000 miles an hour, and Hubble was trained on Pluto to scout out any such dangers.

In so doing, moons four and five, later named Kerberos and Styx, were discovered. The smallest of them all, Styx—named for the river separating the land of the living from the dead in Greek mythology—appeared to be only 10 miles in diameter. There could be countless smaller ones, of course, and even one the size of a pea could do great damage if encountered by the New Horizons spacecraft.

LOOKING CLOSER AT PLUTO

In finding so many little moons, Hubble has also verified that Pluto is indeed not a planet, by the definitions laid down by the International Astronomical Union in 2006. Yes, Pluto orbits the sun, and appears to be spherical—both criteria for being planets. But it has definitely not swept out and cleaned up the space through which it travels. It lacks the gravitational mass to do so, and hence cannot be classed as a planet.

Although there was an uproar over Pluto's apparent demotion—caused as much by media fervor and fascination as by any real public concern—we know now that Pluto is not alone in the Kuiper belt, and that Pluto is, in a sense, a king of the Kuiper belt, a vast region of the solar system beyond the major planets.

Thus, Hubble has not only been looking for rings and moons around Pluto to help New Horizons avoid disaster, but also exploring Pluto's surface, as well as Charon's. It has also detected and imaged some of the larger KBOs, acting as a sentinel for change in the solar system. Hubble's original FOC helped map Pluto's terrain in 1994; and in 2002–2003, its new ACS looked for any changes. Astronomers expected there to be changes because of Pluto's highly elliptical orbit.

As Pluto moved closer to the sun in the 1980s, observations from ground-based telescopes revealed that its atmosphere was growing by a factor of two between its farthest distance from the sun and its nearest distance. The warming planetary surface also showed changes in color and brightness, thought to be due to surface ices sublimating and refreezing. In the 2002–2004 series, even though Pluto was past its closest approach to the sun, more colors were perceived, ranging from dark orange to charcoal, thought due to the evaporation of methane ices, leaving a carbon-rich terrain.

HST FACT

Percival Lowell predicted Planet X in 1908. Scientists at Lowell Observatory, named for him, found it in 1930 and dubbed it Pluto. In 2006 astronomers voted to demote it from planet to Kuiper belt object.

HUBBLE TO THE RESCUE ON THE PATH TO PLUTO

In the 1960s, when Pluto was still a planet, and had no known moons, a loyal band of resourceful orbit calculators and planetary scientists intent on visiting the outer solar system realized that there was going to be a great opportunity to send craft out there at minimum cost. The giant planets Jupiter, Saturn, Uranus, and Neptune were coming into a particular configuration that could assist a craft trying to climb out of the gravitational well created by the sun's mass. This configuration of the major planets would allow the craft to visit the major planets and some of their moons on a "grand tour," and in fact could even set the craft on a trajectory to Pluto. It had to start, though, in the 1970s. Proposals were prepared, but a trip to Pluto, at the time still more odd than interesting, was dropped. Its status changed in the 1980s, after Charon was discovered and the major planets had been visited by the Pioneer and Voyager missions. Visiting Pluto, some scientists argued, would "complete the reconnaissance of the solar system."

But as historian Michael Neufeld has shown, the path to Pluto was anything but direct. In NASA, as well as in the scientific community, every project competes with other projects, each with its own scientific goal. And each project is constantly buffeted by shifting political and institutional priorities. A Pluto mission suffered many births and deaths. At one point in the early 1990s, proposals were thwarted by their high ambitions and shrinking budgets, all exacerbated by NASA's embarrassment after the Hubble's mirror flaw was detected. It is therefore fitting that Hubble eventually came to the aid of the Pluto mission.

Three composite images from the Advanced Camera for Surveys and the Faint Object Camera between June 1994 and June 2003 show changing surface features on Pluto's surface at three different longitudes.

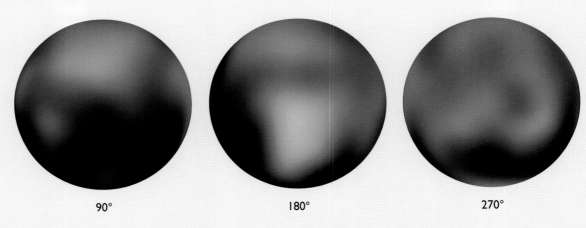

90° 180° 270°

CENTURIES OF HEAVEN MINDING

Even though the data were secured by 2004, it took years to fully process them into a series of images showing these changes. As a member of the team of Hubble-equipped Pluto-watchers reported, "This has taken four years and 20 computers operating continuously and simultaneously to accomplish"—a 21st-century version of Caroline Herschel's continual minding of the heavens.

As the best images reveal, Hubble could only determine that Pluto's surface is far from uniform. But overall, Hubble has helped to prepare the New Horizons team for interesting features to examine, as well as the exposure times and filter choices needed to achieve maximum benefit during the scant time available during the flyby. Aided by Hubble's monitoring from afar, New Horizons is well prepared.

PART | 04

BIG NEW EYE

MORE POWERFUL AND SENSITIVE INSTRUMENTS HELP HUBBLE
DELVE DEEPER INTO SPACE AND FARTHER BACK IN COSMIC TIME.

EINSTEIN VINDICATED

HUBBLE OBSERVATIONS ALLOW SCIENTISTS
TO SEE ACTUAL EXAMPLES OF WHAT
EINSTEIN ENVISIONED THEORETICALLY.

"IN CONSCIOUS EXPECTATION OF the unexpected" read the coffee mug many project members carried during the late 1970s and 1980s, as the Hubble Space Telescope was being built. Hundreds of astronomers had thought very hard about the scientific problems Hubble should tackle, and at the same time they fully expected to be surprised by much of what they finally observed. And so it happened: Many unexpected results and discoveries unfolded, once data were streaming from Hubble.

One of the biggest surprises has been the remarkable importance of "gravitational lenses," a subject very little in evidence in the Hubble project plans of the 1970s and yet a subject that reached back and linked to ideas from an earlier era of history.

Sometimes the builders of worlds on paper predict scientific phenomena so far beyond our capabilities to observe that they become almost forgotten for a time. But then it can happen, thanks to new discoveries or new technologies, that the predicted phenomena come into view, and those examining the sensible world can find them after all.

The greatest builder of worlds in the 20th century was Albert Einstein, and in the years between 1907 and 1915, he fashioned a radical new theory of gravitation: general relativity. Using this theory, Einstein and a few others predicted

a phenomenon that became known as gravitational lensing: the apparent bending of light from distant sources, due to the ability of massive objects to alter the path of light rays. Einstein theorized the existence of this phenomenon, but he judged there was no chance of humans ever observing such a gravitational lens. Even so, within a few years of Einstein's announcement, the idea captured the imaginations of many astronomers and physicists. Émigré Swiss physicist Fritz Zwicky at Caltech, fascinated by all possible interactions between coexisting phenomena in nature, speculated on everything from neutron stars to nebulae as gravitational lenses. Any compact source might create a lens. Princeton astronomer Henry Norris Russell, one of the first to appreciate that extremely compact stars existed, imagined what would be seen from a planet orbiting the white dwarf star Sirius B, when B passed in front of its own larger companion, Sirius A, the "Dog Star" that accompanies Orion the Hunter in our winter skies.

Russell wrote in his popular astronomy column in *Scientific American,* February 1937, that Sirius would appear to be distorted into a series of crescents as B passed in front of it.

Preceding pages: Hercules A, an active radio galaxy some 2.1 billion light-years distant. Composite of Hubble data (optical images in white, including the central galaxy taken by WFC3 on October 8, 2012) and data from the Very Large Array radio telescope in Socorro, New Mexico, taken on November 29, 2012. The pink lobes represent radio noise. Images with diffraction spikes are stars in our galaxy. All other images are distant galaxies.

The galaxy cluster Abell 2218 magnifies and distorts the light from galaxies that lay beyond it. Two of the faint arcs in this image result from a galaxy more than 13 billion light-years away.

He even included sketches of what would be seen. Over the years, theorists explored ways to use the gravitational deflection of light by a dense object in front of some more distant object as a means to reveal useful knowledge about the objects themselves—or about the broader properties of the universe. Observers found strange objects in space that might be lensed images, but the unambiguous detection of a lensing effect remained elusive until the late 1970s. It became one of the many puzzles that astronomers hoped a space telescope might solve. Meanwhile, Einstein's edict persisted.

GRAVITY AS A MAGNIFYING GLASS

The first gravitational lens to be accepted generally was detected by a team of astronomers using large optical and radio telescopes

A galaxy cluster acts as a lens for a quasar ten billion light-years distant. The brightest object in the center is a lensed image of the quasar, but there are four other images of the same quasar close by.

from 1979 to 1983. The object they debated over was a very faint double quasar called QSO 0957+561A/B. (Quasars, or quasi-stellar radio sources, are point sources; hence, they appear starlike.) Almost directly in the line of sight between us and the quasar is a massive object, in this case a galaxy. The "lensing galaxy" produces a double image of the quasar: Although there appear to be two quasars in evidence, there is in reality only one. Ordinary visible matter and a newly discovered form of matter, dark matter (see Moment 14, pages 114–115), in and surrounding the galaxy, combine to act as a lens in the same sort of way that a pair of reading glasses converges light to a focus. By examining the two spectral fingerprints, that is, the spectra of both quasars, and finding them to be identical, astronomers determined that the two images came from just one quasar. But—and this is crucial—the gravitational lens did not just multiply the light of the distant quasar into two images. It also brightened, distorted, and magnified the light. Such gravitational

ALBERT EINSTEIN: FATHER OF GENERAL RELATIVITY

"When I found that my calculations predicted the motion of Mercury exactly, something snapped inside me. The feeling was so extreme. I couldn't work for days. I was beside myself. In all my life, I never felt such joy," wrote Albert Einstein of a time in 1915 when, after years of intense struggle, it seemed that he had at last put into final form his radical new theory of gravitation, general relativity. A small anomaly in the motion of the planet Mercury had troubled astronomers for many years. Now, Einstein believed, an explanation for this motion flowed naturally out of his equations for general relativity. A few years later, following a successful and very widely publicized test of Einstein's prediction of how much starlight passing by the sun would be deflected, Einstein was catapulted to the ranks of scientific superstar and became an international celebrity as well as the most famous scientist on the planet.

For decades after Einstein had developed general relativity, the theory had an aura of being mathematically baffling, generally incomprehensible, and of no application to everyday life. What, after all, did it really mean, for example, to talk about the curvature of space-time, a notion at the heart of general relativity?

But in the 1960s, astronomers began to link general relativity to ever more problems in astronomy and cosmology. Today, millions of people apply general relativity on a daily basis when they use the global positioning system (GPS) on their mobile phones. There is a tiny but measurable difference between the rate of a clock on the surface of the Earth and that same clock in orbit. Without making the correction for the orbital clock, GPS satellites would not be able to provide such precise positions. The corrections, which lead to GPS precision, have to be calculated using general relativity.

In 1912, when he was still battling to complete general relativity, Einstein found that a star could act as a gravitational lens, so that a more distant star that lay beyond the first could be magnified or perhaps even appear double. Such an effect was also discussed in print in the 1920s, once by Russian physicist

Above: As early as 1912, Albert Einstein realized that a consequence of his theory of general relativity was that a massive gravitational field could act as a magnifying lens, making even more distant objects visible. Though he thought the idea fascinating, he doubted it could ever be tested.

Left: A relatively nearby galaxy acts as a gravitational lens for a quasar some 8 billion light-years from Earth. Four separate images of the distant quasar produce an Einstein cross.

Orest Chwolson, who wrote of "fictitious double stars" produced when a distant star is "lensed" by a giant star closer by. He also suggested that under appropriate conditions, a distant single star could appear as a ring of light.

In 1936, Einstein, unaware of Chwolson's studies, wrote about the "Lens-like Action of a Star by the Deviation of Light in the Gravitational Field" in the journal *Science*. He, too, suggested a ring could be formed if a distant star was lensed under the right conditions by a nearer star. At the same time, Einstein reckoned there was "no hope of observing this phenomenon directly." In a private note to the editor of *Science*, Einstein went on to say he had only written the paper because he had been pressed to do so by a Czech engineer. As it was, "It is of little value, but it makes the poor guy happy." In time, the gravitational lens would come to be regarded as an enormously important phenomenon as well as one of the grand triumphs of general relativity theory.

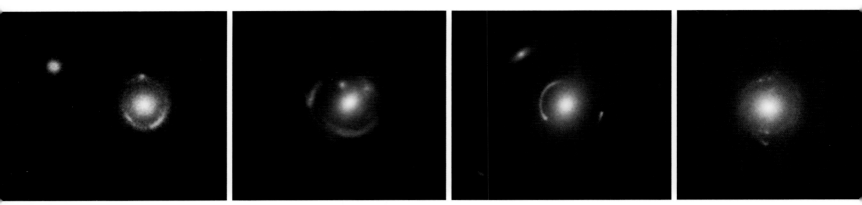

lenses are therefore sometimes referred to by astronomers as "zoom lenses" or nature's "magnifying glasses."

How much the light of a distant object is changed depends on the mass of the intervening object and the geometry of the situation between light source, object, and observer. If a quasar or galaxy sits directly beyond an intervening galaxy, the lensing power of that intervening galaxy's mass can in some cases produce the appearance of a cross, called an Einstein cross, or even a circle of light, now known as an Einstein ring.

HUBBLE'S CONTRIBUTION

In 2005, astronomers using Hubble teamed up with the Sloan Digital Sky Survey to hunt for new examples of gravitational lenses among a collection of some 200,000 galaxies that lay at a distance of roughly 2 to 4 billion light-years from Earth. Among the finds were eight Einstein rings. At the center of each of the rings was an intervening elliptical galaxy that acted as the gravitational lens, warping space and distorting and magnifying the image of a distant galaxy. Astronomers knew that the distant galaxies and their gravitational lenses were almost perfectly aligned, for if they had not been, the distant galaxy would have appeared simply as a small, blue smudge instead of a ring.

There are more sorts of images made by gravitational lenses. Consider a gravitational lens that is not perfectly round: If a distant quasar is almost directly behind an elliptical galaxy, the lensing action can produce four images of the quasar, the pattern that is known as an Einstein cross. In 1990, Hubble's Faint Object Camera imaged an Einstein cross that resulted from multiple images of the quasar G2237+0305. While the quasar is about 8 billion light-years away, the lensing action is the result of an elliptical galaxy at about 400 million light-years from Earth, only the bright core of which can be seen in the Hubble image.

In 2006, Hubble took a picture of a remote quasar that sits behind a large cluster of galaxies at a distance of seven billion light-years. In so doing, Hubble secured, for the first time, five copies of an image of a single quasar. Also present in this image are assorted luminous curving arcs. These are not weird filaments of relatively nearby gas but are, in fact, the distorted forms of galaxies, created by gravitational lensing by the nearer cluster of galaxies. One of the most remarkable examples of such an arc has been produced by the galaxy cluster RCS2 032727-132623 through its action as a gravitational lens on a remote galaxy at a distance of about 10 billion light-years, 3 times more distant than the cluster itself. The distorted image of the remote galaxy turns up several times in the image of the cluster. The most prominent arc is about 20 times larger and much brighter than any that had been detected previously when the first gravitational lens was discovered.

BEAUTIFUL SCIENCE

Perhaps the most spectacular collection of such arcs captured by Hubble is the result of the lensing action of the gigantic

galaxy cluster Abell 2218, located two billion light-years away and containing thousands of galaxies. The Hubble picture displays many curving arcs, the distorted, brightened, and magnified views of galaxies that are five to ten times more distant than Abell 2218 itself. In images such as this, Einstein's theory of general relativity and the curvature of space are clearly visible in a stunningly direct and beautiful manner.

That Abell 2218 was a strong gravitational lens was known to astronomers from ground-based images. The first Hubble images of Abell 2218 were obtained in 1992, before the repair mission of late 1993. Even with an ailing space telescope, the results were promising. The post-repair image of September 1994, however, came as a marvelous surprise, providing as it did a stunning display of luminous arcs. Since then, astronomers have used data from Hubble to calculate distances to some 120 of the arcs visible in Abell 2218 and have thereby obtained distances to galaxies that are tens of times fainter than can be observed with ground-based telescopes.

Abell 2218, and other similar enormous gravitational lenses, therefore serve as vast telescopes that enable astronomers to explore extremely distant objects in ways not possible directly with present telescopes. In 1997, for example, astronomers announced that a galaxy cluster acting as a gravitational lens had enabled them to observe what was then reckoned to be the most distant galaxy ever observed. The astronomers created a theoretical model of the galaxy cluster and used it to "unsmear" the galaxy, or envision it without the distortion created by the intervening cluster.

The corrected image of the galaxy revealed details at a level five to ten times smaller than Hubble could have detected

A gallery of Einstein rings: The blobs at the center of these eight Hubble images are separate elliptical galaxies, each between two and four billion light-years away. Surrounding them are blue rings. Each is the result of the elliptical acting as a gravitational lens on a galaxy that is even farther away than the elliptical, beyond and almost directly behind the elliptical. The light of the distant galaxy was then magnified and distorted into a ring. Variations in just where the distant galaxy lies behind the foreground elliptical cause the variations in the lensing forms.

without the gravitational lens. The astronomers were also able to study star formation in the galaxy, as the corrected image displayed several knots of bright material in the galaxy, regions where stars were forming.

CRITICAL RESEARCH TOOL

Gravitational lenses are now not only a theory proved to be a real phenomenon but also a critical research tool. The different images they produce depend on the amount and arrangement of mass within them, and this relationship has led to perhaps the most important use of gravitational lenses to date: as tools to study the amount and distribution of mass in galaxies and galaxy clusters. These studies have led to the astonishing finding that most of the mass in galaxies and galaxy clusters is invisible, and that there is far more of this invisible stuff, or dark matter, than visible matter (see Moment 14, page 115). The amount of dark matter in galaxy clusters, in fact, makes them much more powerful gravitational lenses than they would be without the dark matter.

We have, then, the striking irony that the dark matter in galaxy clusters, which we cannot observe, brightens and magnifies still more distant galaxies and makes them easier to see.

RS PUPPIS

OBJECT: CEPHEID VARIABLE STAR
LOCATION: PUPPIS
DISTANCE: 6,500 LIGHT-YEARS
OBSERVED: MARCH 26, 2010

A Cepheid variable star is embedded in a dense region of dust. As the Cepheid changes brightness, rings of reflected light migrate through the nebula.

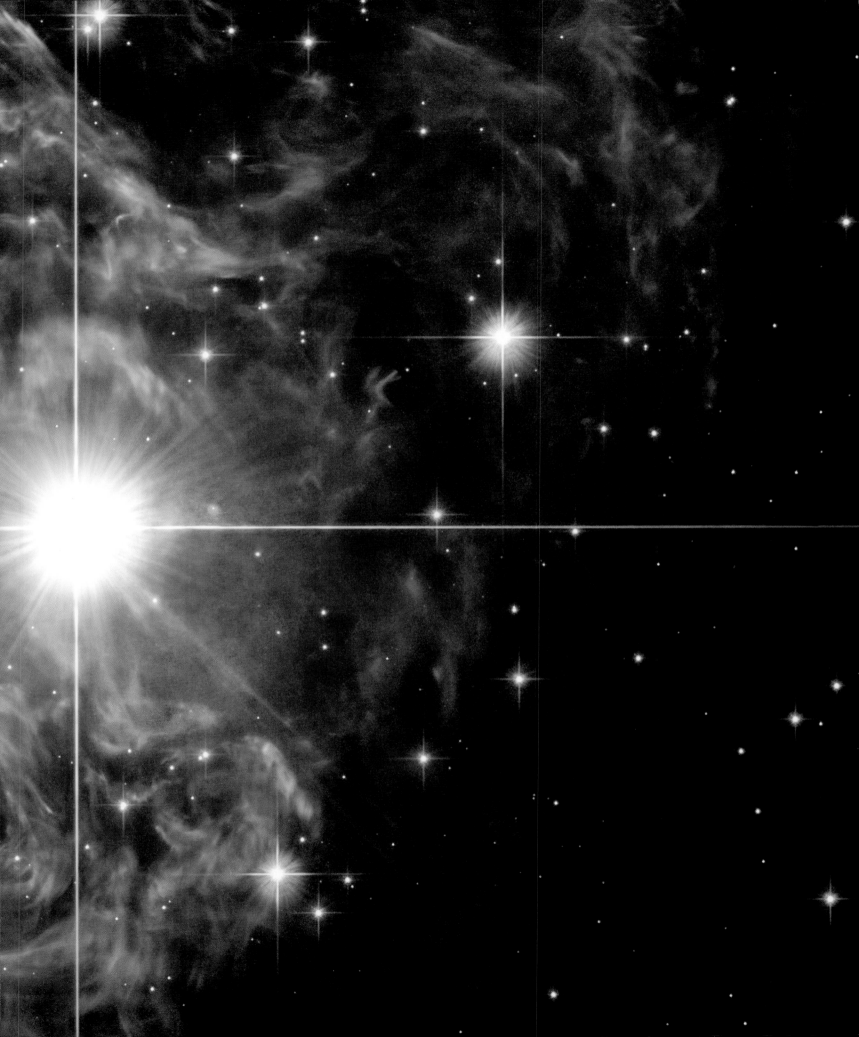

A mosaic composite of Abell 2744, Pandora's Cluster, from ACS and WFC3 combined with x-ray data (pink) from Chandra and optical data from the European Southern Observatory's Very Large Telescope. Dark matter is tinted blue in this reconstructed image.

WHAT DOES "DARK" MEAN? It can be everything from brunette to the shadows, to the absence of light, to the unknown and mysterious. Often, the role of science has been to make visible the previously invisible, to shed light on the dark. In this past quarter century, Hubble has joined the hunt to find what the majority of the mass in the universe is made of, from its very beginning: What we today call "dark matter." • The quest dates back to 1801, when William Herschel

determined that the sun emits invisible rays. He split a beam of sunlight with a prism into the colors of the rainbow, a spectrum, and placed a mercury thermometer beyond the red portion of the spectrum, where no light was apparently falling. Yet he still found the mercury rise in the thermometer—there was energy there, energy his hand could feel. It was heat. In the 1860s, James Clerk Maxwell described light along with electricity and magnetism as traveling in waves, which led to the prediction of radio waves, detected by Heinrich Hertz in the 1880s.

Before German physicist Wilhelm Röntgen discovered them in the 1890s, x-rays were unknown to exist in nature. In a way, all these phenomena—the sun's infrared rays, radio waves, x-rays—were "dark" forms of radiation, unseen even though they were emitted from heated or agitated objects that we knew existed. What is different about what we call "dark matter" today is that there is no form of regular matter we know that can produce it—but, as with its precursors, we have observational reasons to believe that something exists that we can't yet "see," and the Hubble Space Telescope has been a critical tool in those observations.

ACCEPTING DARK MATTER

Before the 1970s, astronomers employed the word "dark" to describe many things: sunspots, bands in planetary atmospheres, places on planetary surfaces, and obscuring regions in space. But after 1978, the word took on a new meaning, wholly new and unexpected, beyond experience. What changed?

Dark matter was not so much discovered at a specific time, as finally accepted after it became impossible to ignore. And once that happened, astronomers and others brought to bear every possible tool, from computers to particle accelerators to telescopes, to find out what is was. To appreciate Hubble's role, let's look at a bit of history.

Some trace the search for dark matter back to efforts in the 1930s to rationalize why clusters of galaxies exist at all, and have not flown apart over the eons. But the professional community did not worry about it until Vera Rubin and Kent Ford at the Carnegie Institution of Washington, in the District of Columbia, showed in 1978 that in order for galaxies like M31 in Andromeda to behave as they do in their outer portions, rotating like rigid LP records and not swirling like a whirlpool around a sink drain, or just flying apart, there had to be an

THE HUNT FOR DARK MATTER

HUBBLE PLAYS A KEY ROLE IN DETECTING THE PRESENCE OF MATTER THAT CANNOT BE SEEN.

enormous amount of unseen but gravitationally active material lurking within and beyond the luminous matter in M31. Soon, they found this to be case for other galaxies.

CLOSING THE GAP

Throughout much of the 1980s, astronomers tried to close the dark matter gap: They knew how visible matter moved and how light was warped and twisted in the known universe, but that could not explain the behavior of galaxies that they were observing. They started looking for "dark matter" thinking it was ordinary matter they just had not found yet: more dark molecular gas clouds, more dim low-mass red stars and brown dwarfs. Could there be more white dwarfs, neutron stars, or even black holes out there? Could it be vast seas of neutral and nearly massless particles called neutrinos or masses at superheated temperatures, radiating deep in the x-ray and gamma ray ranges? Maybe there were oceans of elementary particles not yet discovered. Particle physicists joined the search, but neither theory nor astronomers' observations could find enough mass throughout space to explain why the bright objects (stars, galaxies) moved so fast. Where was the mass that was attracting them and constraining them from

flying apart? In 1990, Canadian astronomer Sidney van den Bergh declared, "Cosmology is in chaos." Incredibly, there was no escaping the conclusion that somewhere between 90 and 99 percent of the universe was not directly detectable, and van den Bergh lamented that the "physical nature of this dark matter is still a complete mystery."

When such a state of uncertainty is declared in science, it is akin to an act of war, and Hubble was front and center in the battle. In the early 1990s, astronomers found that they could map out the distribution of dark matter from how very distant objects' light was distorted by the gravitational lensing.

But what was this stuff? By October 1994, two teams of Hubble users had performed deep surveys in the Milky Way, creating an improved census of red dwarf stars in its halo and in globular clusters that showed conclusively that there were not enough of them, by far, to constitute the dark matter gap. By the mid-1990s, Hubble observations had detected vast sheets of hydrogen between the galaxies. Refining the observations, astronomers soon realized that these might be giant halos surrounding galaxies. By 2000, Hubble's continuing search for low-mass objects helped to clarify the existence of brown dwarfs, objects somewhere between stars and

planets, but even then there could not be enough of them to close the gap.

THE LONG VIEW

The Advanced Camera for Surveys (ACS) was installed on Hubble in March 2002. It replaced the Faint Object Camera in servicing mission 3B and provided double the field of view of the WFPC2 with a monster CCD detector. One of its first targets was Abell 1689, a massive cluster of galaxies in the constellation Virgo. The ACS collected data for some 13 hours, and in addition to the light from the trillions of stars amassed in the cluster, it found many more arc-like images than had been seen before. These images are known to be galaxies far more distant beyond the cluster. Their light was being gravitationally lensed (see Moment 13, page 106) and so distorted by the mass of the cluster itself, some 2.2 billion light-years away. Some of these lensed galaxies are among the most distant galaxies ever detected. But the real value of this survey, which has been repeated using visible and infrared camera modes in the ACS, is that the nature and

distribution of the tiny galaxy arcs can be studied to plot out the three-dimensional distribution of dark matter in the cluster.

ENTER CHANDRA

It always helps to search out mysterious objects with multiple eyes. Collaborations between NASA's Chandra X-ray Observatory, the ground-based Magellan telescopes of the Carnegie Institution, and Hubble created that kind of synergy. They teamed up to analyze 150-million-year-old interactions within two colliding clusters of galaxies called the "bullet cluster." Chandra mapped out the hottest gases glowing in x-rays. Magellan and Hubble mapped out the distribution of the visible galaxies themselves. The two resulting maps were different. In a collision of two clusters of galaxies like this, the stars in the galaxies pass right through the collision zone, disturbed only by gravity. The hot gases, however—the masses seen by Chandra—do interact in the midst of the collision. They lock together because they are magnetically active and pervasive.

Mapping dark matter requires the combined powers of telescopes in space and on the ground. The Very Large Array has been an especially powerful contributor due to its very high resolving power, made possible by the combined powers of 27 82-foot antenna elements spread over many miles of the Socorro desert in New Mexico.

STUDYING DARK MATTER

COSMOS was one of several dark matter projects debated during a special session of the American Astronomical Society annual meeting in Austin, Texas, in January 2008. More than a thousand astronomers and physicists packed the hall to debate "Cultural Perspectives on the New Astronomy," asking how and if astronomers and particle physicists could join forces to study dark matter. The cultural gap between the two disciplines was about as large as the mass deficit in the known illuminated universe. The members of these different cultures behaved differently and followed different rules—from how to treat data to how to treat graduate students.

The result that emerged was a general consensus that astronomers would determine where dark matter is and how much there is of it, and physicists would determine what dark matter is at the particle level. Everyone agreed they wanted to know where dark matter came from, how it changed over time, and why it exists at all. Scientists in the two disciplines may have different methods, but they share ultimate goals.

ON TO COSMOS

In all these investigations, Hubble observations played a critical role. As larger teams collaborated with Hubble, they were able to build three-dimensional pictures of the distribution of dark matter—pictures that could never be captured by one group alone, even in the important large-scale all-sky surveys conducted through the 20th century. One international team of telescopes and astronomers, for example—called the Cosmic Evolution Survey, or, quite appropriately, COSMOS—pushed our knowledge of dark matter forward in two important ways. First, combining Hubble's capabilities with a giant ground-based optical telescope, COSMOS could go far deeper into a smaller area of the sky (three times the area of the full moon). And second, by teaming Hubble with x-ray space telescopes like XMM/Newton; ground-based telescopes, including the Japanese Subaru and the European Very Large Telescope; and radio telescopes like the Very Large Array near Socorro, New Mexico, COSMOS managed to gather the broadest spectrum of data ever, essential to determining the distances to these invisible clumps of dark matter that stretched back halfway to the beginning of time.

The technique used to find dark matter is called "weak gravitational lensing." As light from distant galaxies passes through varying amounts and distributions of dark matter, it shifts and twists, just as visible light is twisted when it passes from air into denser water. By mapping these distortions, astronomers reconstruct the location of the influential dark matter. To be successful, the survey required a camera that could both clearly delineate tiny complex structures and also examine moderately broad fields of view. The ACS aboard Hubble satisfied both requirements.

After 1,000 hours of observations of 575 adjacent fields, and many thousands of astronomer-hours of analysis, the team announced its first comprehensive results in January 2007. They not only found dark matter on a cosmic scale but also discovered that the more distant, and hence younger, clumps were larger than older ones nearer to us. This was the first portrait of the dynamic evolution of dark matter over cosmic time. Some astronomers now use it as a structural skeleton within which they can explore how galaxies have been forming, colliding, and coalescing over billions of years.

FROM COSMOS TO CANDELS

The COSMOS survey consumed some 10 percent of ACS observing time over two years, with additional observations from the WFPC2 and Near Infrared Camera and Multi-Object Spectrometer (NICMOS). Since January 2007, the COSMOS survey has been joined by other surveys using telescopes on the ground and in space, but its cornerstone has been the extreme clarity Hubble imaging has produced.

The success of COSMOS nurtured CANDELS (Cosmic Assembly Near-Infrared Deep Extragalactic Legacy Survey), which has become the largest single project in Hubble's operational lifetime, consuming 902 orbits of Hubble observing time between 2010 and 2013. In addition to refining the distribution of dark matter using the WFPC2's replacement, the WFC3, or Wide Field Camera 3 (see Moment 18, page 144), it is creating a "cosmic movie" of how galaxies change in form over time, and it is testing the revolutionary observation that the rate of expansion of the universe is increasing with time, fueled by dark energy (see Moment 20, page 160).

A composite image of merging galaxy cluster Abell 520, from the WFPC2, Chandra, and the Canada-France-Hawaii Telescope, superimposed on a simulation of the distribution of starlight (orange), hot gas (green), and dark matter (blue)

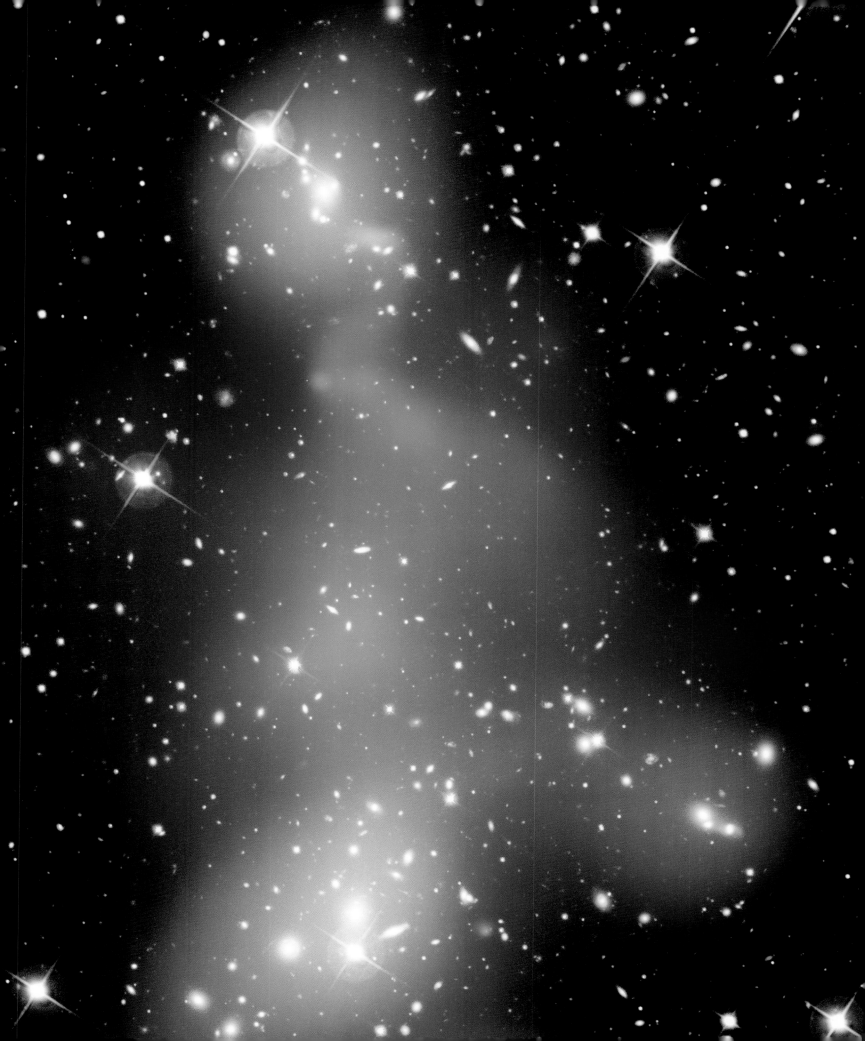

SN 1006

OBJECT: SUPERNOVA REMNANT
LOCATION: LUPUS
DISTANCE: 6,850 LIGHT-YEARS
OBSERVED: FEBRUARY 2006, APRIL 2008

A composite WFPC2/ACS image of a very small part of an expanding remnant from a supernova explosion observed in A.D. 1006. It was called a comet in historical records until historian Bernard Goldstein corrected the mistranslations and showed it to be the brightest recorded supernova in history.

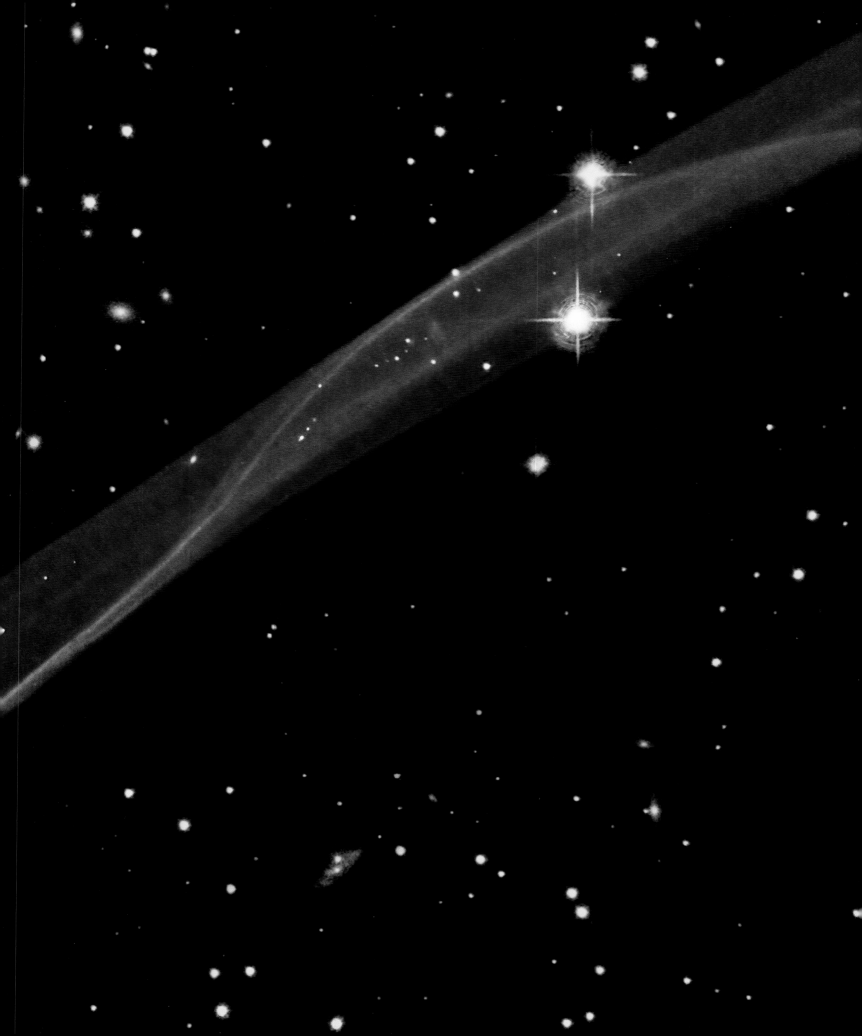

HUBBLE'S PERFECT TEN

AN IMAGE GATHERED AFTER THE LAST SERVICING MISSION SAYS IT ALL: HUBBLE IS BACK IN BUSINESS.

CALLING SOMETHING A PERFECT ten conjures up all sorts of associations, starting with attractive women or men and ranging to car washes, footraces, and gymnastic equipment. Hubble took it literally in 2008. To demonstrate that Hubble was alive and well after a sticky period with more than one shutdown and a delayed servicing mission, the Space Telescope Science Institute issued an image of a pair of galaxies that collided tens of millions of years ago. Oddly enough,

what Hubble displayed—and what was left of the two galaxies—indeed seemed to take the shape of a perfect ten.

It was a serendipitous opportunity. The colliding galaxies appeared to be side by side, yet shaped differently from one another. One was linear, like the number one; the other was ringlike, like a zero. The visual record gave NASA the perfect lead-in to a celebratory press release, issued on October 30, 2008. "Hubble Scores a Perfect Ten," the headline read. It proclaimed, "NASA's Hubble Space Telescope is back in business." It sounded great, but the months leading up to that perfect ten were a real test of nerves.

HUBBLE SCORES AN "ACE" IN THE ACS

The last servicing mission had been in March 2002, when the space shuttle *Columbia* and its seven-member crew made a fourth visit to Hubble and installed the new Advanced Camera for Surveys (ACS). The first major instrument installed in five years, the ACS more than doubled Hubble's imaging powers beyond that of the WFPC2, providing a wider view, sharper images and higher sensitivity from vastly improved sensors, and data processing hardware ten times faster than before.

The ACS has three electronic cameras with two fields of view. Sensitive from the far ultraviolet to the near infrared, these new cameras could help address many questions, from how stars form to what lurks in the hearts of galaxies. The whole system fit into one of the phone-booth-like modular units mounted on the instrument bay.

By the end of 2004, the ACS had scored some truly important results, including an improved understanding of the history of star formation in the outer regions of the nearby Andromeda galaxy (M31). The ACS also followed a dramatic development in the faint constellation Monoceros (Unicorn). There, a complex and highly unusual red star seemed to be embedded in a spectacular expanding cloud of gas and dust. The ACS, however, clarified that motion as a geometrical illusion. There was indeed material expanding from an explosion, but what we see is light from that recent eruption reflecting off a spherical cloud of dust surrounding the star.

Such exquisite detail made the ACS a star of the Hubble armamentarium. But within a few years, its massive sensors

NASA released what it called a "perfect ten" using WFPC2 data in October 2008 to celebrate Hubble's partial recovery. The right-hand galaxy exhibits a blue ring of intense star formation, most likely stimulated by the collision of the two galaxies.

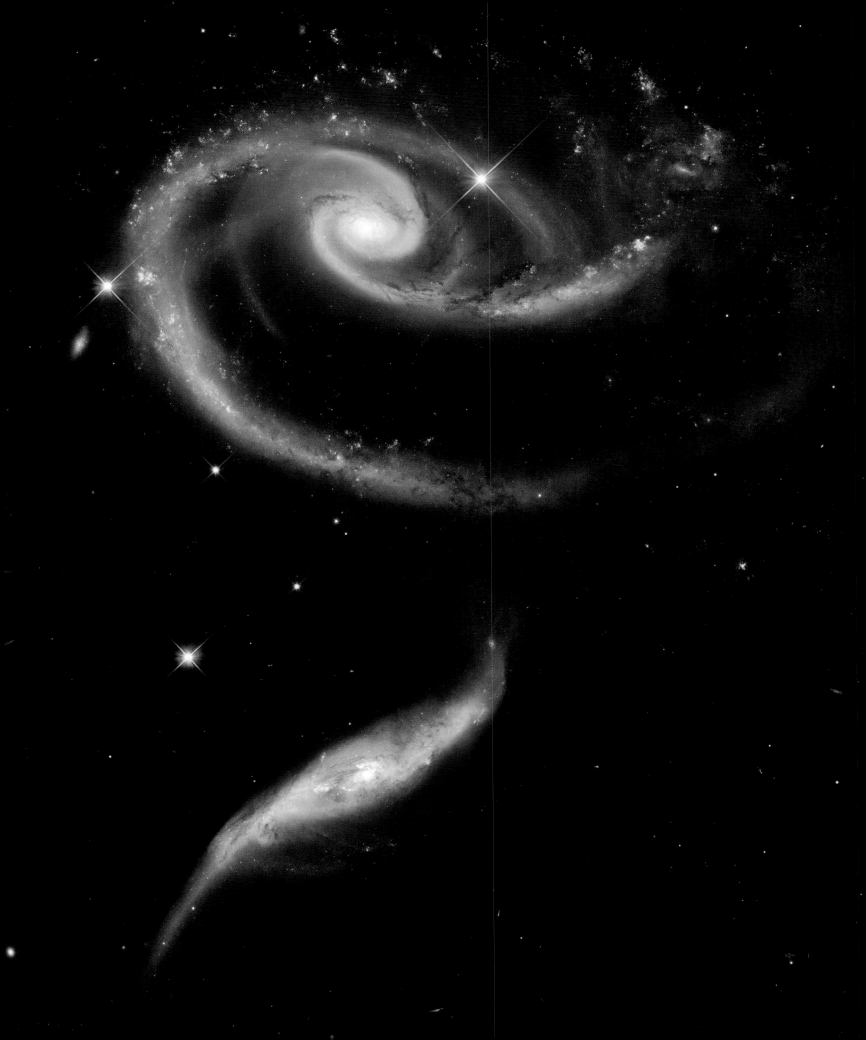

COVERING ALL THE HUBBLE NEWS THAT'S FIT TO PRINT

The media certainly paid attention to the sorry state of the telescope starting in late 2007. Amid continuing stories of Hubble's accomplishments, in December, Dennis Overbye reported in the *New York Times* how frustrated the Hubble team was when a possible servicing mission was delayed until the following August. "It's been a roller coaster ride from hell," Overbye quoted one Hubble project manager. On the positive side, Overbye quoted the director of the Space Telescope Science Institute, predicting, "It will be a brand new telescope, practically." With the new Wide Field Camera 3, the director sensed it would be "a heart-stopping moment."

In May 2008 NASA delayed the servicing mission once again. *Science* reported the first delay clinically, and the *New York Times* reported yet another delay, this time into 2009, with hardly more emotion. Best to quash any expectations. While the Space Telescope Science Institute's press release in October 2008 bragged about the "perfect ten," the accomplishment seems not to have drawn major notice by the media.

But *Times* reporter Overbye kept his sights trained on Hubble's progress. Starting in April 2009, he revived spirits by publishing an extensive profile of astronaut John Grunsfeld, soon to make his third visit to the telescope. It would likely be his last flight, Overbye reported, but he ended his article on an upbeat note, quoting Grunsfeld: "To be the Hubble repairman is really just unbelievable." (See Moment 18, page 148.) From then through the end of May, Overbye delivered nine more reports in the *New York Times*, chronicling in detail the drama of the final servicing mission to Hubble.

Halton C. Arp's famous catalog of peculiar galaxies helped to lead to the modern view of galaxy formation through collisional and accretion processes as well as gravitational collapse processes.

started to degrade, and in mid-2006, its primary electronics support system failed. NASA promptly switched to a redundant support system, but continued operations were dicey. Then, on January 27, 2007, Hubble shifted into a protective "safe mode" condition when the ACS stopped functioning entirely.

Once they knew Hubble was safe from disaster, engineers and astronomers delicately rebooted instruments, including the WFPC2, NICMOS, and the all-critical Fine Guidance Sensors. Although Hubble was back to pre-2002 operations, and all remaining systems seemed to be working smoothly for the moment, the loss of ACS and the flexibility of a stable redundancy scheme was a real blow and consumed the attention of Hubble engineers for months. It was acknowledged as a loss that all hoped to be only temporary. Various teams turned to focus on how the ACS could be repaired by a shuttle visit.

A composite WFC3 image of Arp 273. These beautiful spiral shapes were produced as the two galaxies danced around each other in their tidally induced ballet. Bursts of star formation result after each close interaction.

ACS GOES DARK

The next Hubble servicing mission, however, had already been canceled after the loss of the space shuttle *Columbia*

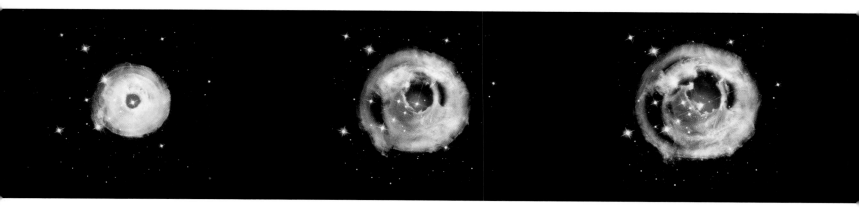

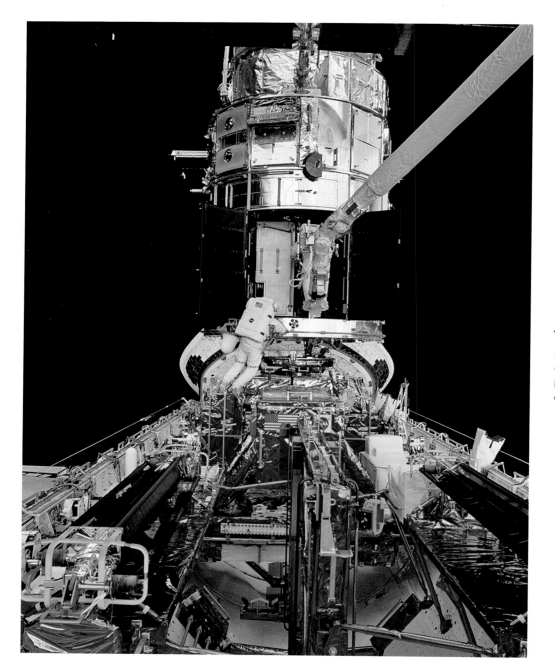

During the fourth servicing mission to Hubble, in 2002, James H. Newman and Michael J. Massimino removed the Faint Object Camera and installed the Advanced Camera for Surveys.

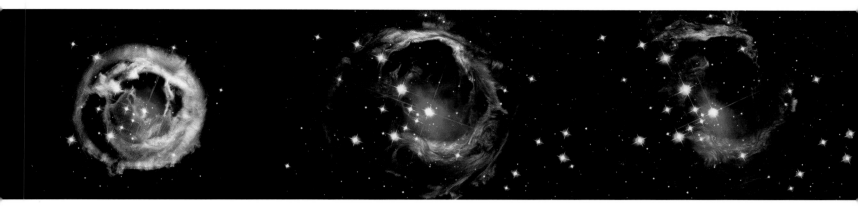

What appears to be an expanding shell around V838 Monocerotis, a supergiant star with a circumstellar shell, is actually a reflection, or a "light echo," from a pulse of light emitted by the star sometime in 2002 that is reaching different portions of a shell of dust ejected many years earlier.

in February 2003. With ACS defunct and another servicing mission still in question, the fear grew that the fate of ACS symbolized what lay ahead for Hubble, and that it would slowly become inoperative as more and more of its aging systems failed.

It was start and stop for many months. Finally, a servicing mission was set for 2008, but before that Hubble started experiencing more troubles and shut down completely. Its Science Instrument Command and Data Handling Unit failed, blocking all scientific data from reaching the ground. Hubble went completely dark. There was a lot of hardware—and a lot of science—on the line. NBC quoted Ray Villard at the Space Telescope Science Institute, saying if the backup switch worked, the first instrument to be brought back online would be the venerable WFPC2. Resuscitating NICMOS would be more difficult due to its cryogenics. The ACS and the Space Telescope Imaging Spectrograph were both beyond hope. And if the switch to the backup data-handling system did not work, it would mean even more difficulties.

"WE'RE STILL HERE"

With no servicing mission in sight, the switch to the backup command and data-handling system was finally approved in late October. After engineering checkout, the telescope

operators wasted no time aiming the telescope in its WFPC2 mode to an object institute officials knew would catch media attention. Technically, the telescope was programmed to observe celestial objects in what was called Cycle 16, a cycle of observations that had been set in late January 2007. Pending shutdowns and sudden opportunities, like a new nova or a wayward comet, the observing schedule was full. But special situations call for quick action, and this was a special situation that had prompted institute staff, including astronomer Mario Livio and the Hubble Heritage Team, to think creatively.

Livio and the team had put together a proposal titled "Different Responses in Interacting Galaxies" (HST Proposal 11902), which was incorporated into Cycle 16 after the fact. The proposal abstract, however, made it clear what was at stake. It was submitted after the shutdown in September 2007, during the deliberations over the risk of switching to the backup electronics. They proposed to observe two objects, interacting spiral galaxies, numbers 273 or 147 in Halton Arp's catalog, not only because they were interesting scientifically, but also because they would "demonstrate that WFPC2 can produce outstanding science [and images] after the transition."

Both of these interacting pairs are truly wild and wonderful, the results of gravitational collisions of hundreds of billions of stars and clouds of gas and dust that result in the universe being composed of every conceivable odd shape. Arp 147 best fit the bill because it would telegraph the message NASA wanted to send out to the public sphere: Hubble was alive and well.

HST FACT

SM4 was actually the fifth servicing mission. Why? Because the third mission to keep Hubble healthy was split into two visits, 3A and 3B.

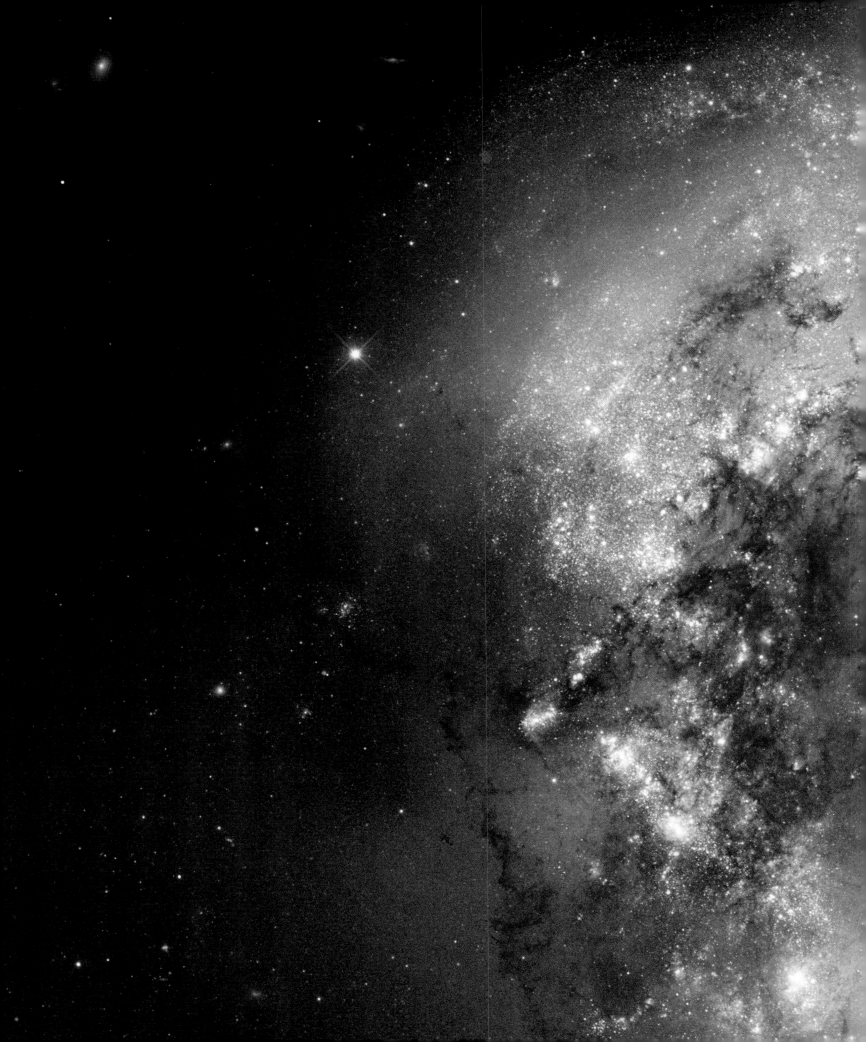

NGC 4038/4039, THE ANTENNAE GALAXIES

OBJECT: INTERACTING GALAXIES
LOCATION: CORVUS
DISTANCE: 62 MILLION LIGHT-YEARS
OBSERVED: JULY 21, 2004; FEBRUARY 16, 2005

A composite of ACS exposures of the central portions of two interacting galaxies so-called the Antennae for wispy tendrils that are out of the scene shown here.

I F LIFE AS WE KNOW IT EXISTS elsewhere in the universe, we think it will leave a mark. Water is necessary, but it is not an unequivocal marker, because water is universal: Wherever conditions allow, we find it, life or no life. We'd like to find it in its liquid state, or on bodies that let it exist as a liquid or vapor, because that's where we think water will support life. • The one distinct marker would be free oxygen: oxygen in a planetary atmosphere not combined with hydrogen, carbon, nitrogen,

or anything but itself. Oxygen is so active it soon combines, unless something is constantly producing it. What does that? Life. On Earth, plant life and photosynthetic bacteria.

Methane could be another indicator of life. Methane, too, is everywhere, especially if you live with cows. It is ubiquitous on Earth, and as physicists and astronomers improved their ability to see into the far red region of the spectrum, they found methane in the atmospheres of the giant planets Jupiter and Saturn in the 1920s and 1930s, and even in some of the cooler stars later in the 1930s. It was found in the spaces between the stars and in giant molecular clouds, tentatively in the late 1970s and, with improved radio techniques, definitely in the 1990s. And finally, hardly more than a decade after confirming that there are planets orbiting stars other than our own sun, Hubble has found methane and water in the atmospheres of a few of those planets. But not oxygen. Not yet.

WHY METHANE?

Methane, while an ambiguous marker, is still a marker of conditions that might be suitable for life. One of the planets outside our solar system found to harbor methane is a bit larger than Jupiter but orbits much closer to its sun. So the planet was dubbed a "hot Jupiter," estimated to be about 60 light-years away from Earth in the constellation Vulpecula (Fox), just southwest of the bright star Vega. The discovery of methane in its chemical mix was exciting to all, especially the astrobiologists—scientists who seek signs of life elsewhere in the universe. A key question they want to answer is, What are the extremes under which life can exist?

What's so important about methane? It is one of the simplest organic compounds, which means that it is a molecule with carbon as its major organizer. Four hydrogen atoms attach themselves to a carbon atom to make a molecule of methane. The major component of natural gas, methane is highly flammable. It can be produced in many ways, some but not all implying a living source (think cow). So when Hubble detected its presence, it didn't mean life on the planet with certainty, but it did make the hot Jupiter a better candidate than many.

Indeed, any clues that suggest the presence of life are intriguing, but all require verification using a powerful array of

THE SEARCH FOR LIFE, OR SOMETHING LIKE IT
PROBING PLANETARY ATMOSPHERES, HUBBLE LOOKS FOR EVIDENCE OF LIFE.

An artist's impression of one of the closest-known exoplanets, HD 189733b, a "hot Jupiter" gas giant orbiting a sunlike star in Vulpecula once every 2.2 days

detectors, usually big telescopes, and an educated sense of how to proceed. In 1933, Paul Merrill, an astronomer at the Mount Wilson Observatory, reflected on how improvements in telescopes and red-sensitive photography were making the study of cosmic chemistry, as he called it, possible. Chemical reactions that allow compounds like methane to survive require relatively low temperatures, far cooler than stars, ranging from hundreds of degrees below zero Fahrenheit to about a thousand degrees above zero. Their spectral signatures are also relatively low energy processes, so their spectral signatures are in the red end of the spectrum, requiring red-sensitive photographic emulsions to capture their presence.

Merrill was fascinated by the question of whether Earth's chemical components could be found throughout the universe. While elements might be detectable, compounds were harder to find, since most objects studied by astronomers are too hot to support them. "An observer on another planet, for example, should have no difficulty in detecting two constituents of the Earth's atmosphere, oxygen and water vapor," wrote Merrill, but nitrogen might be more difficult. In like manner, though little was known about the composition of the "vast open spaces between the stars," Merrill noted that "a few lonesome atoms" had recently been detected—calcium and sodium—and he was sure that more would be found. By the mid-1930s, as Merrill suspected, with continued improvements in photographic sensitivity in the far red regions, methane was detected in the atmospheres of cooler stars. It was definitely everywhere.

A VERY HOT JUPITER

So how was methane detected in the atmosphere of a planet orbiting the star in the constellation Vulpecula? It could not have been a casual observation. First, the planet itself had to be found. In this case, the star itself had been known since the mid-19th century and was cataloged at Harvard as HD 189733. It is visible in amateur telescopes in the same telescopic field as the Dumbbell Nebula, and on very close scrutiny, it turns out to be a double star, one a sunlike orange star and the other a red dwarf. In 2005, a team of French astronomers at France's Haute-Provence Observatory detected the existence of a

HD 189733, the central star in this Sloan Digital Sky Survey image, appears apparently close to the Dumbbell planetary nebula. Who knew that just to the east of this so-called "planetary" nebula were real planets orbiting a nondescript yellow star?

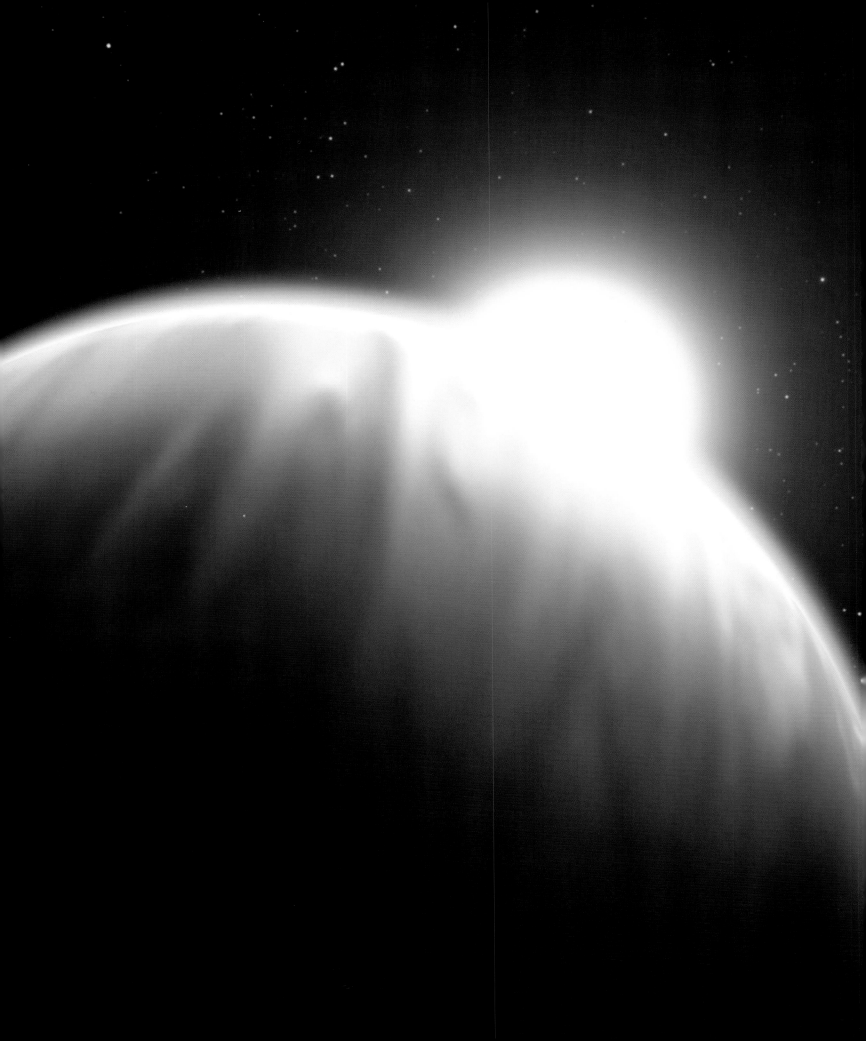

PUSHING HUBBLE IN SEARCH FOR EXOPLANETS

The challenge of detecting the components of life (as we know it on Earth) on other worlds arises because these same elements and compounds are found in our own atmosphere. Telescopes on the ground have to look through our atmosphere to study another planet's atmosphere, and sorting out the difference can be a challenge. The famous case in point was Mars, which has dominated the search for life ever since the late 19th century—inspiring much science fiction and fantasy, from H. G. Wells's *War of the Worlds* in 1897 to the film *Mars Attacks* in 1996.

In the late 19th century, astronomers thought they detected water vapor and oxygen in Mars's atmosphere. Not much, they reckoned, but enough to lead some to believe that life still existed on the Martian surface—a civilization far in advance of our own that had built canals to irrigate its parched lands, drawing water from its visible polar caps. After 1877, some astronomers actually thought they had detected the canals, and this impression persisted for years, even after more conservative studies of possible conditions on Mars, using the rapidly advancing knowledge of the physics of gases, showed that it could not be.

We now know that the Martian surface contains neither life in any major visible form, nor its aftereffects. But could it have in the past? Rovers are now probing the Martian landscape, unraveling its geological history. Meanwhile, we use our telescopes and other tools of perception to look elsewhere. Oxygen is the key indicator, but it has to be stable. In 2004, in fact, a French team working with Hubble found oxygen and carbon in the superhot evaporating atmosphere of another hot Jupiter dubbed Osiris. Hardly stable, but exciting nonetheless.

And we are still looking. Will Hubble someday detect oxygen in an Earthlike planet orbiting a sunlike star at a distance that allows liquid water to flow freely? Astronomers will continue to try, no doubt, but they know they need much more powerful tools to increase the odds. The "transit spectroscopy" technique—catching and deciphering the addition of a planet's feeble light to the flood from its parent star—uses Hubble's powers at their extreme limit. But one never knows. Some astronomer soon may just get really lucky. But if you ask one of them, they'll probably say they are waiting for the next generation of exoplanet search technology: the James Webb Space Telescope (see Moment 25, page 200).

planet around the primary orange star by measuring a slight periodic shift in the star's spectrum, indicating that the star was moving back and forth because it was being perturbed by an unseen planetary companion.

The planet, HD 189733b, was named after its star. Its orbit causes it to pass in front of its star, allowing astronomers to examine other properties, such as size and atmospheric composition. When the planet passes in front of the star, it eclipses a portion of the star's light. And when the planet passes behind the star, it disappears from view. But when the planet edges out from behind the star, part of its atmosphere appears in profile, looking like a series of bright lines that can be studied only by very high precision devices, like NICMOS on Hubble. Astronomers called HD 189733b the "nearest, brightest, and highest contrast

transiting extrasolar planet known." Astronomers from the United States and the United Kingdom teamed up to tackle the challenge of analyzing the planet's atmosphere. European astronomers using the infrared Spitzer Space Telescope had already determined that there quite likely was water vapor in the atmosphere of HD 189733b, and the new studies found, in the words of the investigators, "the first clear spectral signature of a carbon-based molecule in an exoplanet atmosphere." They had found methane on a planet circling another sun.

Even with water vapor and methane, though, HD 189733b is no place to look for life. The planet is so hot—approximately 2200°F—that its atmosphere is rapidly evaporating. Additional observations with the Chandra x-ray telescope have revealed that the planet's atmosphere is hugely bloated. And Hubble observations have recently shown that this huge atmosphere preferentially scatters blue light, so the planet must look like a vivid blue sphere—like Earth.

When exoplanet HD 189733b made news in 2008, NASA engaged an artist to depict the planet eclipsing the star.

NGC 602, N90

OBJECT: HOT YOUNG STARS WITHIN STAR-FORMING REGION
LOCATION: SMALL MAGELLANIC CLOUD IN TUCANA
DISTANCE: 196,000 LIGHT-YEARS
OBSERVED: JULY 14 AND 18, 2004

A dramatic example of how massive stars, once formed out of collapsing dark clouds of gas and dust, illuminate remaining material and push it away to form a vast hole in space.

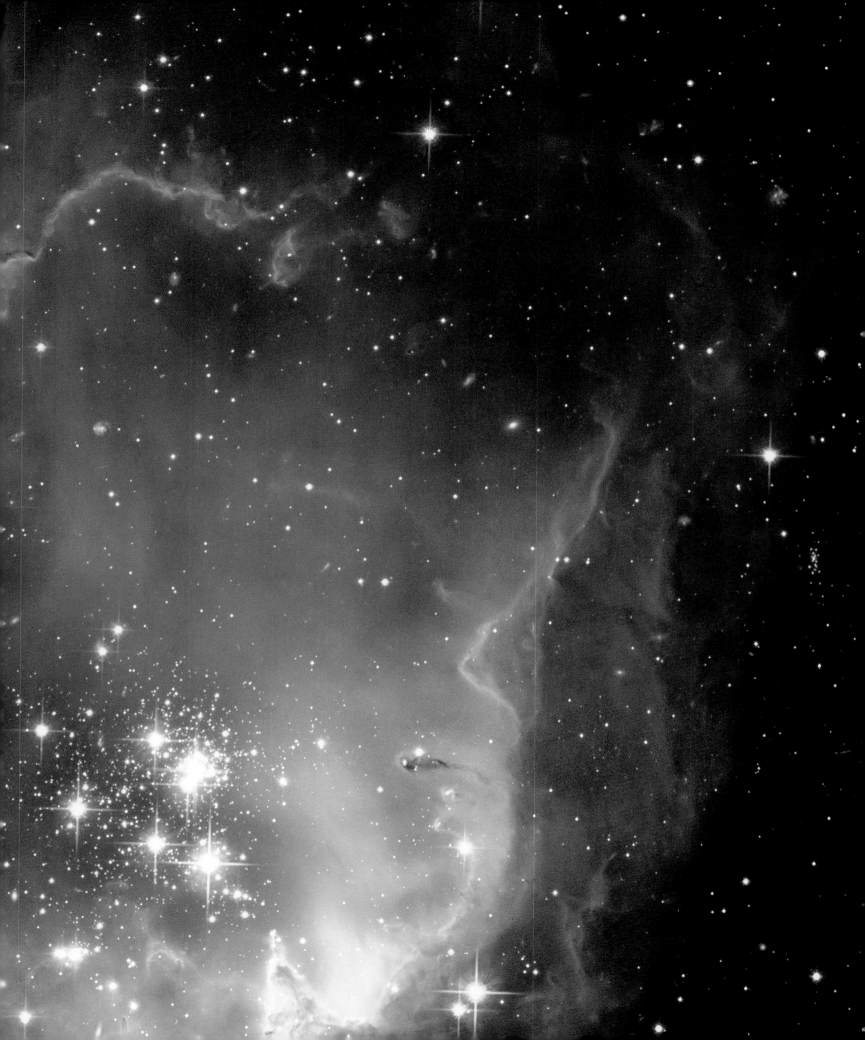

For the International Year of Astronomy, the Hubble Heritage Team mounted a "You Decide" competition to give the public a chance to decide where to point Hubble. This group of galaxies in Virgo, Arp 274, received 67,021 out of some 140,000 votes.

THE INTERNATIONAL YEAR OF ASTRONOMY

HUBBLE HELPS CELEBRATE THE 400TH ANNIVERSARY OF GALILEO'S USE OF A TELESCOPE.

G ALILEO WAS NOT THE FIRST person to look at the heavens through a telescope. Nor did he invent the telescope. But he was the first to build one powerful enough to begin to fathom the astronomical universe. Most important, he did more than anyone else at the time to use his observations to try to convince the world that the Copernican theory was the right one—that Earth and planets circled the sun. To honor his work and the momentous shift in understanding that it began 400 years

before, astronomers worldwide designated 2009 and the first half of 2010 as the International Year of Astronomy (IYA).

Planning and organizing the celebration took years. At the 2006 meeting of the International Astronomical Union in Prague, Richard Feinberg, then editor of the popular *Sky & Telescope* magazine, proposed as a goal for the IYA that everyone in the world get the chance to look through a telescope. This challenge set the spirit: Astronomers agreed to do all they could to provide inspiration, guidance, and telescope access as broadly as they could. NASA and the Space Telescope Science Institute's educational efforts went into high gear, with enhanced news releases, educational materials, traveling exhibits, student ambassadors, and even a contest to participate in observations with the Hubble Space Telescope. Driving all these efforts was the desire to get more people than ever interested and engaged in astronomy. Attention focused on four days in April 2010, designated "100 Hours of Astronomy."

"YOU DECIDE"

The Space Telescope Science Institute staff designed the contest and called it "You Decide." They invited the public to cast votes for what Hubble would observe during the IYA's 100 hours. The institute distributed a list of 100 candidate targets that Hubble had not yet looked at, and the public responded by casting 140,000 votes online. By early March, the decision was announced: More than half the votes cast went for one target: a threesome of galaxies in the constellation Virgo, a tightly knit group called Arp 274, so named because it was the 274th entry in Halton C. Arp's *Atlas of Peculiar Galaxies* (see Moment 15, page 122).

A series of wide-field exposures created the composite image, which spans a field of space some 200,000 light-years across, with objects at distances between 400 and 600 million light-years from Earth. Regions of young hot stars show up in blue and bluish white hues, while active regions of star formation create pinkish hues. Their beautiful symmetries make them what astronomers call "grand design" galaxies, their shapes undistorted by any gravitational interactions as the light has traveled to Earth in recent cosmic history. As beautiful as the formation might be, though, the galaxies may not be interacting or even related, despite their appearance.

A goal of the IYA was to encourage as many people as possible to observe the heavens through telescopes and binoculars.

SEEING IS BELIEVING, FROM GALILEO TO THE HUBBLE SPACE TELESCOPE

Why are Hubble's images so important? We have Galileo to thank for that. He employed images as evidence, argument, and inspiration, and we have been following in his footsteps ever since. Galileo was not the first to use a telescope to scan the heavens, but he was the first to tell the world about the heavens in ways that were provocative and compelling. In modern parlance, he employed visualization as argument and as evidence. His drawings of the moon, sun, planetary bodies, and fields of stars were carefully crafted to convince his audience that these things were real and physical manifestations of nature.

But more to the point, Galileo argued eloquently that the views secured through the telescope were superior to, and more informative than, those collected by the unaided eye alone. Telescopic observations provided authority, and this set in place the conviction that the more powerful the telescope, the greater the authority of the observation. In the following 400 years, the telescope's powers increased as technology and patronage allowed, defined mainly by the changing goals of astronomical practice. For the first two centuries after Galileo, astronomers were most concerned with determining positions and motions of planets and stars, so the telescope became a tool for positional precision. There were a few efforts to map the moon and even scrutinize the planets, but that was about it.

By the late 18th century, William Herschel wanted to increase his powers of "penetrating into space" and so built telescopes with huge mirrors to efficiently increase light-gathering power to explore the natural history of the heavens. Few astronomers followed that lead, though, until the 20th century, when, again aided by new technologies and new forms of patronage, giant apertures became possible. Even after American astronomer George Ellery Hale completed his 100-inch reflector for the Mount Wilson Observatory in California—the very telescope Edwin Hubble had used to discover that the universe is composed of galaxies, not stars— he was still not satisfied, musing in 1928: "Starlight is falling on every square mile of the earth's surface, and the best we can do at present is to gather up and concentrate the rays that strike an area 100 inches in diameter. From an engineering standpoint our telescopes are small affairs in comparison with modern battleships and bridges." Today, the legacy of Hale's penchant for gathering photons remains undiminished. But even he could not have imagined that within the same century that saw the 100-inch telescope at its outset, a telescope of similar aperture was launched into space, continuing in the practice set by Galileo 400 years earlier—and named for the man Hale had hired to scan the skies with his telescopes: Edwin Hubble.

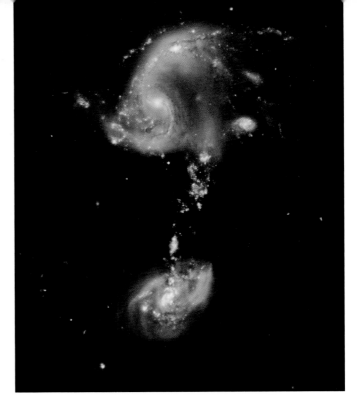

One of many images issued from Hubble during the IYA. The two galaxies at the top of the field in Ursa Major are closely interacting. The galaxy at the bottom is much farther away, even though one of the tidal streamers of hot young blue stars seems to reach out and touch it.

Also as part of the IYA, but more in line with NASA's penchant to issue celebratory images showcasing celestial oddities caused by collisional forces, another spectacular view was released in April, this time a pair of galaxies truly interacting—going "bump in the night," as the NASA press release proclaimed. This image displays another Arp object (number 194), and shows how strong gravitational interaction stimulates star formation, as the distorted galaxies at the top of the image sport a highly distorted blue spiral arm torn from the pair, the blue color indicating bright hot young stars barely a few million years old. As with Arp 274, a third galaxy in the image, at the bottom, is actually unrelated and at a greater distance from Earth.

UNVEILING THE GALACTIC CENTER

The IYA gave astronomers the stage to show how new tools were discovering a universe far different than we had previously imagined. Focusing the three Great Observatories, each with its own spectrum—Hubble (visible), Chandra (x-ray), and Spitzer (infrared)—on the same region of space, they created a revolutionary new image of the center of our Milky Way galaxy, long a region of great interest (see Moment 10, page 86.) As Hubble scientists wrote in their research proposal, the galactic center offered a fascinating site for "a detailed study of a multitude of complex astrophysical phenomena." The Spitzer Space Telescope directed its infrared camera array toward the target area twice during 2004 and 2005; the Chandra X-ray Observatory provided data collected between 2000 and 2007. Astronomers from seven different institutions employed Hubble's NICMOS during 2008 to observe massive stars and the gas and dust swirling between them, looking for clues to their formation and their relationship to younger star clusters, large-scale magnetic fields, black holes, and other extreme phenomena.

The data were combined into a single massive mosaic representing this portion of the heavens. Top-quality prints of the resulting image went up across the country, in schools and colleges, libraries, museums, planetaria, and science centers. From the Pink Palace Museum in Memphis, Tennessee, to the National Soaring Museum in Elmira, New York, to the Mohave Middle School in Scottsdale, Arizona, 150 locations displayed the large mosaics, with descriptions of each contributing observatory, all modern extensions of Galileo's spirit.

A TRIUMPHANT YEAR

In September 2009, astronomy and space science education and outreach specialists gathered near San Francisco to examine the IYA efforts and determine what had been effective, and what programs could work well in the future. Rather than isolating Hubble as a separate mission, the interdependent nature of all space missions was emphasized. In the NASA presentation, the only ground-based telescope mentioned was, not surprisingly, Galileo's, the one that started it all. Accordingly, they commemorated the connection by reproducing a banner that astronaut John Grunsfeld carried on the final servicing mission to Hubble, celebrating the mission as "a fitting accomplishment in the International Year of Astronomy."

CENTER OF THE MILKY WAY

OBJECT: VARIED NEBULAE AND STARS
LOCATION: SAGITTARIUS
DISTANCE: 26,000 LIGHT-YEARS
**OBSERVED: SEPTEMBER 3, 2004 AND SEPTEMBER 15, 2005
(SPITZER IRAC); MARCH 2000–JULY 2007 (CHANDRA ACIS); FEBRUARY
22–JUNE 5, 2008 (HUBBLE NICMOS)**

Detail of an image of the central regions of the Milky Way, released as part of
NASA's contribution to the International Year of Astronomy

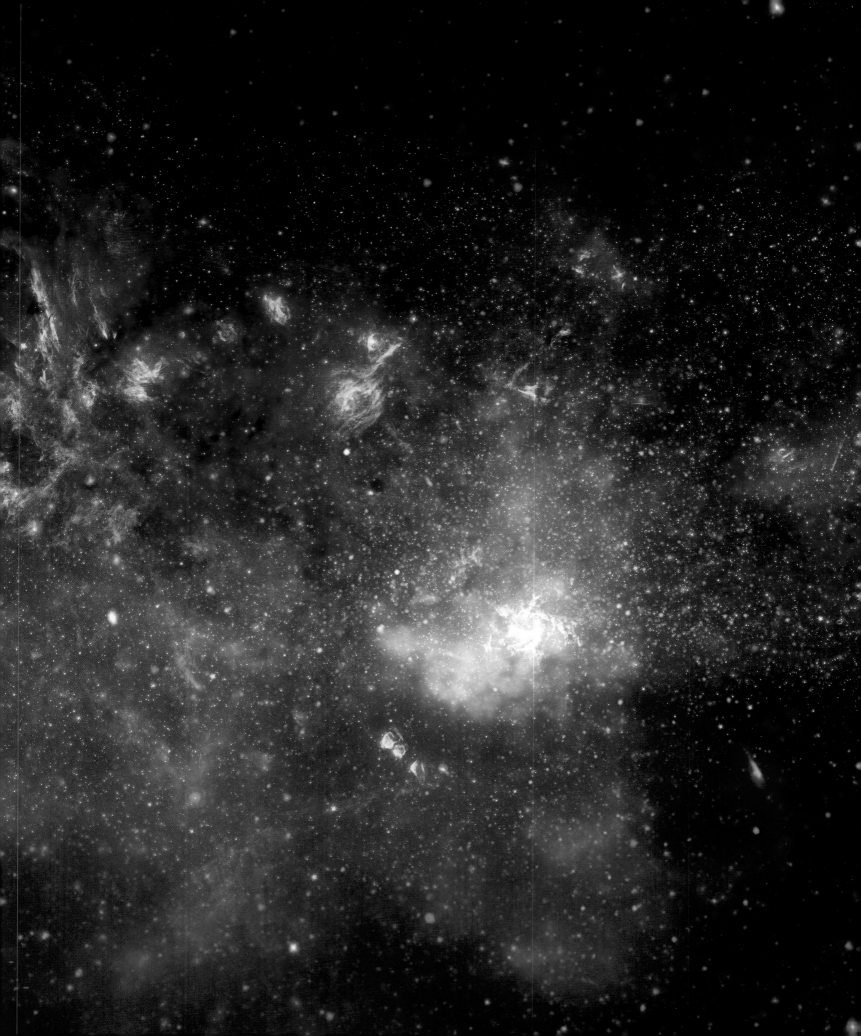

I N JANUARY 2004, JOHN GRUNSFELD, NASA's chief scientist, was attending a meeting in Atlanta when he was told to return to NASA headquarters in Washington, D.C. Grunsfeld, an experienced astronaut who had flown in space four times and had visited Hubble twice, expected that the call back to Washington involved scheduling the final shuttle servicing mission to Hubble. But, in fact, Administrator Sean O'Keefe had canceled the flight. There would be no more servicing

missions to Hubble. In O'Keefe's view, such missions were too risky. The very future of the space shuttle was in question, and using it to service Hubble was not a high enough priority to keep it flying. But the shuttle was the only means to service the space telescope. Indeed, Hubble had been painstakingly designed with that plan in mind. Pulling the plug on shuttle visits to Hubble surely would hasten the telescope's demise. Deeply shocked, Grunsfeld said he felt as if he had been "hit by a two-by-four."

For the next five years, Hubble's future took a roller coaster ride, plunging to bleak and soaring to bright, with Grunsfeld riding the ups and downs, determined to find a way for NASA to service the telescope one more time.

MISSION CANCELED

The decision to scrub the Hubble servicing mission was made in the shadow of events on February 1, 2003, one of the grimmest days in the history of the U.S. space program. The shuttle *Columbia* was scheduled to make a routine return to Earth after two weeks in space and dozens of scientific experiments. Unknown to the crew or managers and engineers on

the ground, the orbiter had been fatally damaged during launch. Solid foam falling from the shuttle's fuel tank had ripped a hole in *Columbia*'s left wing. During reentry, superhot atmospheric gases drove into the left wing, leading to *Columbia*'s fiery disintegration and the death of the seven astronauts aboard.

The shuttle *Challenger* had already been lost in 1986, with the death of seven astronauts. The destruction of a second shuttle prompted high-level policymakers to make a shift.

In January 2004, in a speech at NASA headquarters, President George W. Bush laid out an ambitious new "Vision for Space Exploration," which included sending astronauts to the moon and, later, to Mars. "We will build new ships," Bush declared, "to carry man forward into the universe, to gain a new foothold on the moon and to prepare for new journeys to worlds beyond our own." The remaining space shuttles would be retired from service as soon as the construction of the International Space Station was finished.

O'Keefe's announcement of NASA's abandonment of Hubble came two days later. New safety mandates, he had decided, would be violated by another shuttle servicing mission

MOMENT
18

SERVICING HUBBLE
ONE REVOLUTIONARY FEATURE IS ITS SERVICEABILITY: ASTRONAUTS VISITED IN PERSON FOR FIXES, REPLACEMENTS, AND ENHANCEMENTS.

John Grunsfeld at work on a space walk during his third and final visit to Hubble in orbit in 2009. In the reflected image on his space suit visor, Earth and fellow astronaut Drew Feustel are visible.

to Hubble. Money saved from Hubble could be switched over to the project to return to the moon.

O'Keefe's decision provoked a loud outpouring of opposition. Hubble's leading supporter on Capitol Hill, Senator Barbara Mikulski, insisted Hubble's future should not be settled "by one man in a back room." Prominent astronomers and fans of Hubble from among the general public joined in the outcry. Newspapers began calling Hubble "the people's telescope." Hundreds of emails poured into Congress and NASA in protest every day, echoed by a barrage of opinion pieces and editorials. "The public and Congress," an editorial in the *Denver Post* stated, "are letting NASA know they understand the real value of the Hubble Space Telescope—even if NASA doesn't."

Hubble's images had forged a community, an often vocal group who felt a personal relationship with the spacecraft in orbit hundreds of miles above Earth. Web pages, letter-writing campaigns, and petitions against O'Keefe's decision popped up. Hubble had become a media superstar, its images splashed on television, newspaper reports, magazine covers, websites, coffee mugs, and T-shirts. If O'Keefe thought Hubble's diverse supporters would accept his decision without a fight he had miscalculated badly. There was an army of "Hubble huggers" out there, and they would not let their space telescope go down without a fight.

ROBOTS TO THE RESCUE?

Working away in NASA, Grunsfeld was intent on overturning the cancellation of SM4, the fifth servicing mission to Hubble (SM3 had been split into two missions, 3A and 3B). At first, he and others pushed the possibility of sending a robotic spacecraft to Hubble for repairs and servicing. O'Keefe, buffeted by the protests against his original decision, agreed NASA should explore robotic repairs. "Our confidence is growing that robots can do the job," he said in 2004. Many understood

Following the final servicing mission, Hubble observed various astronomical targets to underline that it was back in business. One target was a giant pillar of gas and dust in the Carina Nebula, inside of which stars are forming.

HST FACT

When *Atlantis* blasted off on May 11, 2009, a second shuttle, *Endeavour*, sat on a launch pad at the Kennedy Space Center, poised to launch at short notice if the *Atlantis* astronauts needed rescue.

this suggestion was never technically feasible, however. Twenty-seven former astronauts, in fact, sent a petition to O'Keefe urging a shuttle mission rather than robotic servicing. But Grunsfeld and his colleagues understood that the robotic option would keep key NASA staffers engaged on the question of servicing the telescope, so that if and when the day came when SM4 was reinstated, these engineers and managers would be ready to go.

In 2005, the National Academy of Sciences assembled a group of top experts from diverse backgrounds to report to the U.S. Congress on the "Options for Extending the Life of the Hubble Space Telescope." There were mixed opinions among this group, but in the end Congress came out strongly for another shuttle mission and urged NASA to get on with the job as soon as the shuttles were flying again.

GRIFFIN TAKES CHARGE

Sean O'Keefe left his NASA post before the National Academy of Sciences report was submitted. He was succeeded by Michael D. Griffin, an experienced aerospace engineer. Soon, Griffin had reopened the question of SM4, especially since shuttle flights with scheduled visits to the International Space Station were already on the books.

In October 2006, Griffin announced to an audience at the Goddard Space Flight Center that NASA would indeed fly the shuttle to service and repair Hubble one more time. "I am fully confident," he explained, "that this fifth [servicing] mission will go as flawlessly as any of us can imagine." The NASA employees greeted the news with a standing ovation. Senator Mikulski praised NASA for seeking a second opinion "from the engineers, not the accountants." Griffin also announced the crew for the 11-day servicing mission. Grunsfeld was one of them.

PREPARING FOR FLIGHT

Two new scientific instruments, the Wide Field Camera 3 and the Cosmic Origins Spectrograph, were due to be installed in Hubble during SM4. Another instrument already aboard Hubble, the Space Telescope Imaging Spectrograph (STIS), needed to be repaired. Hubble's batteries were also scheduled

In 2002, John Grunsfeld journeyed to Hubble as a member of the crew for the fourth servicing mission. No astronaut visited Hubble as many times as Grunsfeld—a total of three.

A PORTRAIT OF THE ASTRONAUT AS HUBBLE'S REPAIRMAN

A physicist by training, John Grunsfeld became an astronaut in 1992. In all, between 1999 and 2009, Grunsfeld flew into space five times and visited Hubble three times.

On his second trip to Hubble in 2002, Grunsfeld had helped install the Advanced Camera for Surveys, which he then repaired in 2009. That 2002 mission to Hubble had been aboard the shuttle *Columbia,* which had disintegrated on its return to Earth in its very next mission. When Grunsfeld told questioners that Hubble's scientific potential was such that he was willing to risk his life for the telescope, it was with an extremely clear understanding of the risks. Grunsfeld regarded Hubble as "arguably the most important scientific instrument ever created" and over the course of his three servicing missions, he made himself into a Hubble repairman par excellence.

After the fifth and final space walk of *Atlantis*'s journey to Hubble, Grunsfeld delivered some parting words to the telescope he knew so well. "Hubble is not just a satellite," he said. "It's a symbol of humanity's quest for knowledge."

to be replaced, as were a Fine Guidance Sensor and all the gyroscopes (critical for pointing and controlling Hubble), as four of the six had failed.

But matters still did not go smoothly for SM4, originally scheduled for October 2008. First, Hubble's main command and data-handling unit for the scientific instruments failed in September. A backup unit enabled Hubble to continue its scientific mission, but if that also failed, it would be the end of Hubble as a scientific observatory. Plans had to be made as to how astronauts would replace the defective data-handling unit. Then, another scientific instrument, the

Advanced Camera for Surveys (ACS), installed in 2002, started showing serious problems, and tackling them was added to the astronauts' to-do list.

The two new challenges on the list were unprecedented. It was one thing to install or remove scientific instruments as complete modules, but neither the ACS nor the STIS had been designed to be fixed or even maintained in orbit. Engineers had to design procedures and fabricate many new tools for these novel repairs. Of all the SM4 repairs, work on the broken-down STIS was one of the most challenging. It required an astronaut wearing bulky space suit gloves to

remove 111 screws and fasteners, gain access to the instrument's power supply card, and remove and replace it, all the while making sure none of the fasteners were lost into the instrument or into space.

TO HUBBLE AT LAST

The space shuttle *Atlantis* finally blasted off for its rendezvous with Hubble on May 11, 2009. Grunsfeld made his third visit to Hubble, two new instruments were added, and another two repaired. There were a few difficulties, though. Removing one of the bolts on a handrail to get access to the 111 screws on the STIS, for instance, proved unexpectedly tricky. In the end, astronaut Michael Massimino had to apply brute force to get the handrail off. But overall the mission went remarkably smoothly. Nobody knew for sure, though, whether the repairs had worked and the replacement parts would perform as they should. A few months later, the answer was made public. NASA and the Space Telescope Science Institute released a batch of new images of various astronomical objects—including Omega Centauri, the Butterfly (NGC 6302), Stephan's Quintet, and a jet in the Carina Nebula. Hubble was back in business—and, indeed, was better than ever: a much improved and scientifically more powerful space telescope.

Hubble, its aperture door reopened after the telescope was serviced in the payload bay of *Atlantis,* was released one final time by the space shuttle crew on May 19, 2009.

PART | 05

ULTIMA THULE

HUBBLE KEEPS ON EXPLORING, A KEY PLAYER IN THE SEARCH
FOR ANSWERS TO THE ULTIMATE QUESTIONS ABOUT THE ORIGIN
AND EVOLUTION OF STARS, GALAXIES, AND THE UNIVERSE.

A STAR IS BORN

WITH INCREASED SENSITIVITY IN THE INFRARED, HUBBLE EXPLORES THE BIRTH OF STARS.

A FTER THE FINAL SERVICING mission in May 2009, the Hubble program had new eyes in the sky: the Wide Field Camera 3 (WFC3) and the Cosmic Origins Spectrograph (COS). The new camera expanded the capabilities of its predecessor (WFPC2) and complemented those imaging instruments still on board and revived from the servicing mission, NICMOS and the ACS. The WFC3, in fact, has about 30 times NICMOS's discovery efficiency (or sensitivity multiplied by its field

of view, which equates to its ability to discover interesting things) in the near-infrared spectrum, and 50 times that of the WFPC2 and even the ACS in the ultraviolet spectrum. The WFC3's capability complemented the high sensitivity of the new spectrograph, which was designed to concentrate on extremely faint small objects. Now, even more than before, it was time to uncover new territory, reaching for Ultima Thule—regions beyond the borders of the known universe.

Since Hubble is a community observatory, committees and not individuals determine who gets what time slot and how much time is allotted. Still, those key astronomers who have devoted years to building Hubble and guiding the project do get some discretionary time. They are the most tuned in to the instrument's powers, so they get to be the first to make it work right. The WFC3 is largely governed by the WFC3 Science Oversight Committee and Early Release

Science team. Once the WFC3 was in operation, Robert W. O'Connell, a senior astronomer at the University of Virginia, and his international team were able to train it on the big questions of galaxy evolution: What stimulates bursts of star formation, and what generations of stars can be found within galaxies? The WFC3 governing committee dedicated more than half of its discretionary research time—about 200 orbits—to explore star formation in different galaxy environments in the nearby universe.

The WFC3 and COS were designed to dig deep not only into the distant universe but also into the vast realms of the local universe where stars and planets are forming. In a way, those regions, within our own galaxy or in local galaxies, have remained just as unknown and unobserved as objects many millions of light-years away. This early focus of the WFC3 promised to open them up, locally and not so locally.

Preceding pages: A mosaic composite from the ACS and WFC3 of Abell 2744: Pandora's Cluster, a massive galaxy cluster in Sculptor, 3.7 billion light-years distant. Part of the Frontier Fields program to employ lensing to image even more distant objects (see the multispectral image on page 114).

STARS BEING BORN CLOSE BY

In the mid-1990s, Hubble explored two of our closest star-forming regions: the Eagle Nebula and the Orion Nebula (see Moments 07 and 11, pages 62–63 and 90–91). Now its goal

A composite WFC3 image of a bright blue cluster of young massive stars formed from clouds of gas and dust in the Carina spiral arm. John Herschel observed it in 1834, thinking it could be a globular cluster.

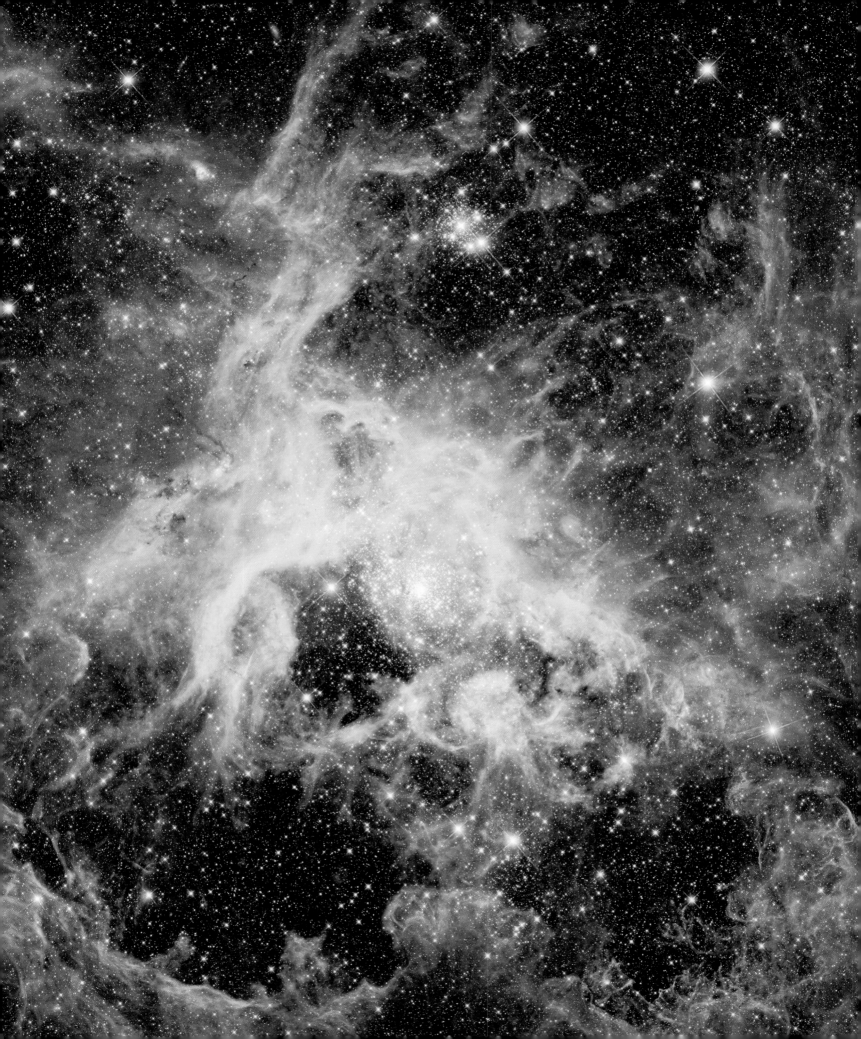

was to move out farther, diving 20,000 light-years down the trunk of our local spiral arm, in the direction of the southern constellation Carina. In August and December 2009, using both the infrared and visible modes to follow tendrils of glowing sulfur, hydrogen, and iron as they were revealed through an array of five filters, the WFC3 recorded a cluster of massive young stars shedding its embryonic sack. The combined scene was breathtaking—and, judging by its frequent inclusion in scientific papers since then, critically important to astronomical science.

In 5.3 hours of exposure time on August 27 and December 3, 2009, the team collected enough data to produce a wide range of combinations of images to search out specific phenomena relating to what stimulates and retards star formation. In images of NGC 3603, a tightly packed open star cluster in Carina, one can see literally hundreds and hundreds of bright blue stars within a volume of space not much larger than the distance between the sun and our nearest star, Alpha Centauri. Just imagine what the night sky must look like from a planet going around one of those stars. Indeed, the stars in this tight cluster cannot be more than a few hundreds of thousands of years old. From that imagined planet, you might see thousands of stars brighter than the brightest in our night sky, Sirius. What astronomers now think they are looking at here, with additional observations from radio telescopes, is the result of a very recent burst of star formation caused by a collision of two gigantic clouds of gas and dust a mere one million years ago.

STARS BEING BORN FARTHER AWAY

In December 2009, NASA also released images of "Cluster R136 in Nebula 30 Doradus, the Tarantula Nebula in the Large Magellanic Cloud." Nebula 30 Doradus shines distinctly in the southern sky, even though it is 160,000 light-years away. It is so large that if it were at the distance of the Orion Nebula, it would consume a large portion of the night sky and would be bright enough to cast shadows. It has long been a subject of interest to astronomers, going back to the 17th century.

Dorado, a constellation in the deep southern sky, variously known as the Dolphinfish or the Swordfish, sits at a point in

The Tarantula Nebula complex (30 Doradus) is imaged in the infrared by WFC3. The region includes star clusters, dark dust lanes, and glowing gases, portions of which appear on pages 16–17, 54–55, and 156, showing the varied inhabitants of this wild place.

A composite WFC3 image including its infrared channel of the left central portion of the Tarantula Nebula (30 Doradus) imaged on the previous page, centered on the cluster R136

the sky directly perpendicular to Earth's orbit around the sun. The bright object within this constellation was first delineated in star atlases of the early 17th century, and by the middle of the 18th century, astronomer Nicolas-Louis de Lacaille recorded it as an irregular fuzzy cloud. In the mid-19th century, William Henry Smyth, a retired British admiral, collected reports of it from many observers. John Herschel had described the object as a complex of many loops; Smyth romanticized the description, calling it the True Lover's Knot. From Herschel's description, it came to be known as the Great Looped Nebula, cataloged as NGC 2070 in the *New General Catalog of Nebulae and Clusters of Stars* compiled by J. L. Dreyer in the 1880s. Dreyer classified it as looped and as "a magnificent or otherwise interesting object."

This object continued to attract observers and catalogers over the years, each giving it a new name and designation. New and more powerful telescopes and cameras built in the Southern Hemisphere, by Harvard in South Africa and by the Sydney Observatory in Australia, showed it to be a nebula

FACT

M83 is the name of a critically acclaimed French electronic music band formed in 2001. The band named itself after the galaxy.

with many looping arms, prompting astronomers by the early 1950s to name it the Tarantula. By then, however, their increased telescopic powers revealed what looked like a tight cluster of blue stars surrounding an intensely bright singular object. In 1960, it was given the designation R136 by Radcliffe Observatory astronomers who mapped the brightest stars in the Large Magellanic Cloud. From that time on, astronomers debated if it was a single star, by far the largest known, or an incredibly dense cluster of hot blue stars (see Moment 10, pages 84–87). By the late 1970s, astronomers were pretty sure that it was a cluster. That hypothesis was confirmed in 1985, when the Tarantula was observed by an ingenious technique called speckle interferometry, revealing a cluster of about eight stars. Hubble offered even greater resolution, revealing details of the Tarantula Nebula never seen before.

By the time Hubble's WFC3 viewed the Tarantula in 2009, astronomers generally believed that clusters of super stars like this one had formed in bursts through the massive collisions of giant gas clouds, and that they could be studied through the

faint remnants of those mergers: the wisps of gas and dust that had not become absorbed into the stars. Now, they could bring the wide-field capabilities of the WFC3 to bear on these questions, yielding a mosaic that neatly depicts the relationship of the stars in the cluster, their distribution, and the remnant structure of the clouds that collided and produced them.

STARS BEING BORN VERY
FAR AWAY: THE BIG PICTURE

The new WFC3 also sharpened astronomers' views of stars forming on a large scale, homing in on the nearest massive grand design spiral galaxy, M83, in the constellation Hydra. Like the Tarantula Nebula, this object had been known to early astronomers, who named it the Southern Pinwheel. It is distinctly visible with small telescopes and even binoculars. As noted in Moment 17, since the 1960s, astronomers have used the term "grand design" to categorize galaxies with long, symmetrical, spiral arms: In other words, they exhibit a high degree of dynamical order without the sort of messiness a recent collision or tidal interaction may have caused. As a result, they best represent one of the most popular theories for how spiral arms form, the density wave theory. So, careful study should help to test that theory. Density waves are theorized to stimulate star formation. Thus, close examination of the character and distribution of star-formation regions can test the density wave theory.

At 15 million light-years away, about 7 times more distant than the Andromeda galaxy, M83 is still one of the closest massive galaxies to us, and its open, nearly face-on orientation makes it an excellent candidate for close scrutiny of its many parts. In August 2009, WFC3 exposures ranging from just a few seconds to up to 45 minutes were taken behind a wide array of filters, and calibrated and processed to reveal starburst regions in the arms, the nucleus, and parts of the outer regions. Observers searched for tight clusters of hot stars embedded in bright pink clouds of ionized hydrogen gas (hydrogen atoms that had lost their electrons). By cataloging the size, distribution, and character of these objects, they learned about the distribution of mass and the ages of the stars within each cluster. From these compilations, astronomers found that the processes of star formation and destruction are not only uniform throughout M83, but also consistent with the processes at play in our own Milky Way.

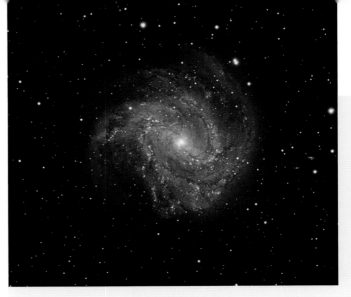

A wide-field view of M83 compiled by Robert Gendler from Hubble's cameras, combined with ground-based telescopic data from Japan's Subaru Telescope and David Malin of the Australian Astronomical Observatory

PROJECT STAR DATE:
M83—CITIZEN SCIENCE
IN ACTION

M83, the grand design spiral galaxy also called the Southern Pinwheel, became the focus of a collaborative astronomy project between the Space Telescope Science Institute and citizen scientists organized through Zooniverse, an online portal through which anyone can participate in astronomical research—from exploring the surface of the moon to monitoring explosions on the sun to finding planets around other stars. Like other citizen science projects, Project Star Date: M83 used the crowd power of many interested participants to perform a task, this time to estimate ages for 3,000 star clusters in M83. What humans can still do better than computers (for the moment at least) is sense patterns in shapes and other qualitative (or chaotic) variables. For this project, participants looked at images from the WFC3 online and described the shapes and colors of star clusters, noting in particular the presence or absence of the pink clouds of hydrogen emission, the distinctness of the images, and the overall color of the clusters. A short tutorial helped participants appreciate how to make helpful observations, and each observer looked at one cluster at a time, answering questions such as: Is this object fuzzy or sharp?

Launched on January 13, 2014, Project Star Date: M83 was complete by April, with a healthy number of citizen astronomers having participated. While that portal is closed to further input, there will be more opportunities for citizen scientists to help study the mechanisms of star formation, so stay tuned.

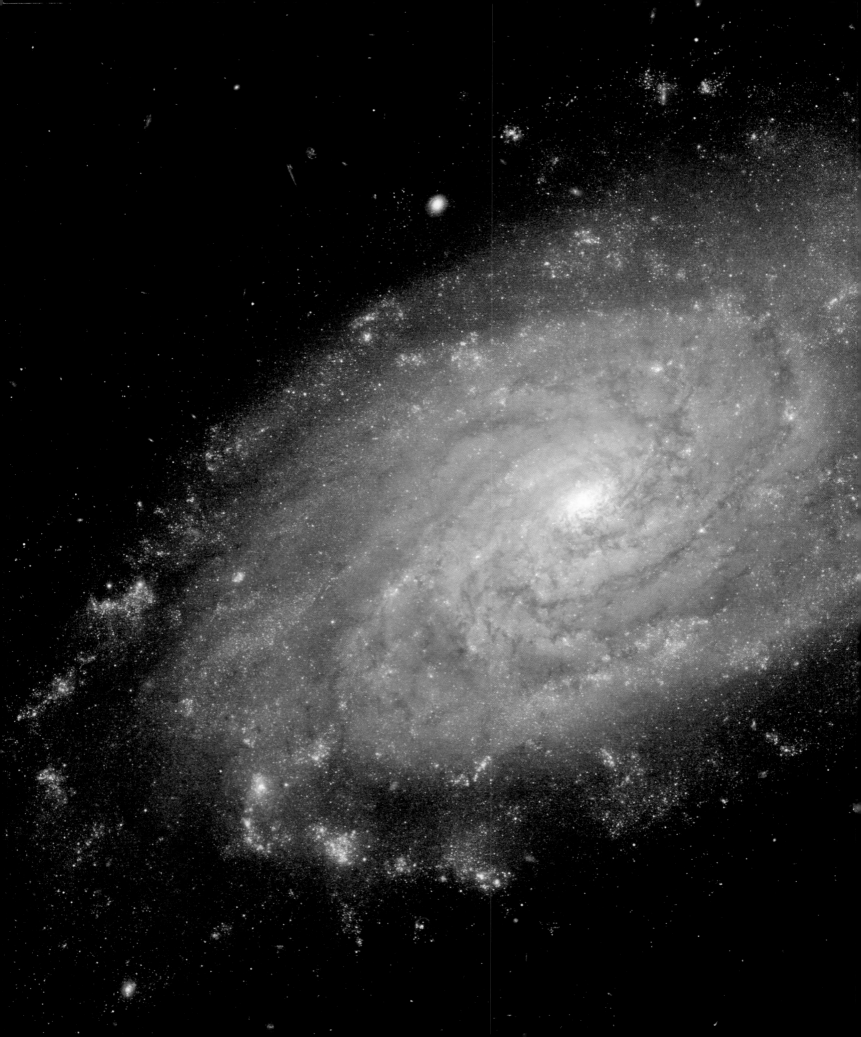

NGC 3370

OBJECT: SPIRAL GALAXY
LOCATION: LEO
DISTANCE: 98 MILLION LIGHT-YEARS
OBSERVED: APRIL–MAY 2003

Composite ACS image of a galaxy showing well-defined arms and dust lanes. In November 1994, a Type Ia supernova flared within it, momentarily out-shining the combined light of the galaxy. Astronomers use supernovae of this type as standard lamps to calibrate the Hubble redshift/distance relationship.

THE DISCOVERY OF THE EXPANSION of the universe in the years around 1930 was one of the great finds of 20th-century science. Just as unexpected, and maybe even more startling, was the discovery at the end of the 20th century that not only is the universe expanding but the expansion is speeding up. Scientists debated that idea intensely, many of them resistant to giving up long-cherished assumptions about the large-scale behavior of the universe. But Hubble's

observations were crucial in helping to show that the universe's expansion was indeed accelerating over time. To appreciate Hubble's contribution, we need to chronicle our understanding of a particular type of star called a supernova.

TYCHO'S SUPERNOVA

Danish nobleman Tycho Brahe was the greatest observer of the skies before the invention of the telescope. On November 11, 1572, Brahe was on his way home for supper after working in his laboratory. Long familiar with the planets and positions of the stars in the heavens, he was startled by the appearance of a remarkable object he'd never spotted before. Located in the constellation Cassiopeia, well known even to casual night sky observers because of its W shape, the object was brighter than any planet or star but did not resemble a comet. Since it had newly appeared in a familiar constellation, Brahe named it *stella nova*—Latin for "new star." He continued to observe it, and the conclusions he reached persuaded him that change could occur in the heavens, thereby raising serious doubts about the prevailing conception of an unchanging celestial cosmos. Today, we would term Brahe's object a supernova,

and astronomers accept them and the changing universe they represent, as fact. But more recent observations of supernovae have again undermined the accepted view of the universe.

STELLAR FIREWORKS

Supernovae are stellar fireworks on the biggest scale (see Moment 02, pages 30–31). They are exploding stars, and on the cosmic scale, they happen quickly and disappear. Typically, when a supernova flares up, it will rival if not outshine an entire galaxy of one hundred billion stars for a few weeks, and then it fades. This means supernovae can be seen at huge distances. For Hubble users, who explore the farthest reaches of the universe, supernovae are therefore exceptionally powerful tools for determining astronomical distances—if a way is found to calibrate them.

Today, we know there are different types of supernovae, each type defined by the cosmic forces causing a massive stellar explosion and by the variations in their brightnesses over time. By the 1950s, astronomers generally agreed on two types. One type was found in the arms of spiral galaxies, regions rich in stars. Spectral analyses revealed that they contained hydrogen

THE ACCELERATING UNIVERSE

HUBBLE HAS HELPED TO SHOW THE UNIVERSE WILL NOT END IN A BIG CRUNCH.

A composite image of a supernova remnant SNR 0509-67.5 in the Large Magellanic Cloud. At a distance of 170,000 light-years, it is estimated to be 23 light-years across, expanding at a rate of 11 million miles an hour.

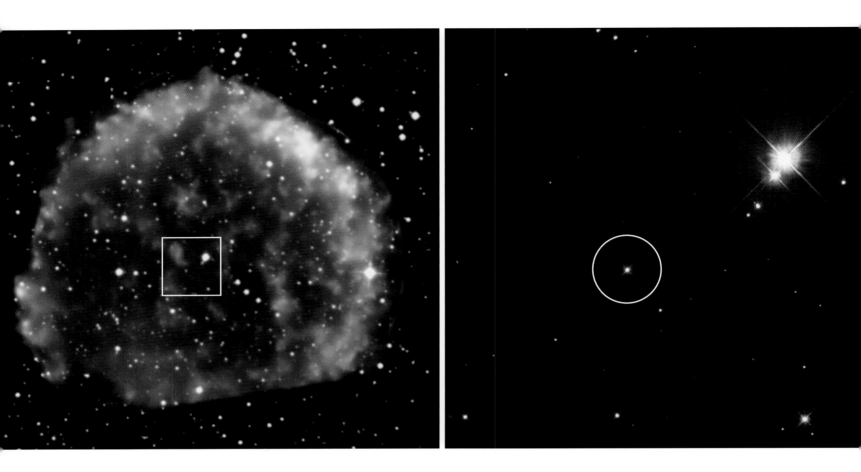

A Chandra image (above left) with inset and a Hubble WFPC2 image (above right) of the inset field. The latter shows the white dwarf remnant of Tycho's star, the 1572 supernova explosion witnessed by Danish nobleman Tycho Brahe.

and various kinds of metals. Further research showed these supernovae to have emerged from huge stars, much more massive than our sun, whose cores had undergone a rapid collapse, triggering a titanic explosion. These supernovae were labeled Type II.

Type I supernovae, by contrast, displayed little or no hydrogen in their spectra. Astronomers reckoned their progenitors to be white dwarf stars, but white dwarf stars with nearby companion stars so that, by tidal attraction, they pulled gas from a nearby companion star, eventually provoking a gigantic thermonuclear explosion that marked the violent death of the white dwarf. Alternatively, the companion star might have been another white dwarf, the collision of two white dwarfs producing this type of supernova.

By the 1990s, astronomers had further subdivided the Type I supernovae into Types Ia and Ib. Objects of Type Ia are

the most interesting because the great majority of them consistently reach the same maximum intrinsic brightness, providing a very powerful technique for determining accurate distances to the galaxies in which they were observed.

SUPERNOVAE AS DISTANCE INDICATORS

The apparent brightness of an object, be it a flashlight, streetlamp, or Type Ia supernova, is a function of its distance from us. That function is called an inverse square. In other words, if you are 100 feet from a streetlamp and measure its brightness with a light meter, and then walk another 100 feet away from it (or twice the distance), your meter will register only one-quarter as much light from the lamp. Conversely, if you do not remember how far you've walked, your light meter can be your guide, telling you that you are receiving only one-quarter as much light as you would standing 100 feet away. Such is the case with Type Ia supernovae.

Therefore, astronomical distances can be measured by comparing the apparent brightness of a Type Ia supernova

with its known actual brightness. Astronomers have long used this technique to determine that the universe is expanding, comparing the maximum apparent brightnesses of Type Ia supernovae to their observed redshifts, or velocity of recession (see Moment 09, page 78). But as Hubble helped astronomers observe supernovae at larger and larger distances—that is, billions of light-years away—they found that the relation of the redshift of a supernovae to its brightness started changing. As Robert Kirshner recently explained it: "When a supernova explodes in a distant galaxy, the light travels to us through an expanding universe. If the expansion is slowing down while the light is on its way to us, the distance traveled when it gets here will be smaller than in a universe that expands at a constant rate. The supernova will appear brighter. Astronomers were expecting that result, because gravity slows things down, just as a ball you throw up into the air will soon slow down and return to Earth. But they were astonished to see that explosions in very distant supernovae (several billion light-years away) were dimmer than they would be in a universe expanding at a constant rate. That meant the universe had extra expansion along the path, as if it was speeding up while the light was on its way to us. This was the evidence for the accelerating universe."

AN ACCELERATING UNIVERSE?

This presented a very big puzzle. Astronomers have long regarded the universe to be dominated by the attractive action of gravity. Accordingly, the expansion of the universe that began with a "big bang" some 13 to 14 billion years ago would eventually slow down as every bit of matter exerts a gravitational attraction on every other bit. With time, the drag of gravity would reduce the speed of a receding galaxy. Perhaps, some astronomers suggested, the power of gravity would ultimately cause the expansion to reverse itself, leading to what astronomers refer to as the "big crunch"—as the universe shrinks in upon itself and eventually collapses down to a singularity, a tiny point containing all the universe's matter, energy, and radiation.

HST FACT

In his science fiction novel *Tau Zero,* Poul Anderson imagined that the universe cycled through a big crunch, then a big bang, over and over —an idea some astronomers have considered too.

Given this theoretical construct, no wonder that many astronomers viewed the notion of an accelerating expansion as bizarre when it was first advanced. The example of the ball Kirshner provided us tells the tale. Earth's gravity acts on the ball to slow it down so that it arcs back toward the ground. The notion of the speeding up of the universe's expansion is akin to seeing the ball, when thrown up, fly skyward at an increasing speed. So strange and unexpected was the notion of an accelerating universe that some physicists and astronomers were openly skeptical.

But as astronomers hunted out more Type Ia supernovae, the earlier results stood up very well. Observations with Hubble were especially telling. In 2002 and 2003, Hubble joined with Spitzer, Chandra, and some ground-based observatories in the Great Observatories Origins Deep Survey (GOODS). GOODS targeted two representative regions in the sky—one each in the Northern and Southern Hemispheres. The newly installed Advanced Camera for Surveys made Hubble into a much more powerful survey tool and supernova-hunting machine. The telescopes visited each chosen survey field every 45 days, recording hundreds of individual exposures. These exposures enabled astronomers to search for supernovae in some 50,000 or so galaxies, all potentially containing supernovae that brightened and faded from one exposure to the next. Computer programs adjusted the GOODS exposures to show only those objects that changed in brightness between exposures. Once astronomers detected candidate supernovae, they scheduled follow-up observations with Hubble in combination with powerful ground-based telescopes to measure the redshifts of the supernovae.

In 2004, two large teams of astronomers, including Kirshner, published findings on dozens of Type Ia supernovae—and the results were consistent with an accelerating universe. In 2011, the three main figures in these early team investigations—Saul Perlmutter of Berkeley, Adam Riess of Johns Hopkins and the Space Telescope Science Institute, and Brian Schmidt of the Mount Stromlo/Siding Spring Observatory—shared the Nobel Prize in physics for establishing the accelerating universe.

One evening in 1572, Tycho Brahe, the greatest observer of the pre-telescopic era, was startled to find that a new star had suddenly appeared in the skies in Cassiopeia.

HUNTING FOR SUPERNOVAE

Once every few seconds, somewhere in the universe, a Type Ia supernova bursts forth. There is, then, no shortage of such phenomena—the problem is detecting them, as Nobel Prize winner Saul Perlmutter has pointed out. First, supernovae are far from common in an individual galaxy. Perhaps two Type Ia supernovae will explode in a typical galaxy per century. Pointing a telescope at a single distant galaxy and waiting for a supernova almost certainly guarantees a very long wait, so searchers need to observe many galaxies in a short time to improve the chances of success. Second, supernovae flare up without warning, and so astronomers have no advance notice of where precisely to point their telescopes to catch a remote supernova. Third, supernovae are at their brightest for only a short period, a matter of weeks. Astronomers, therefore, have had to craft novel observing strategies to get around these problems, and the massive data collecting abilities of Hubble and other more recent telescopes have advanced the search tremendously. This is one of the many problems that has stimulated the creation of the next generation of survey telescopes.

OVER TO THE DARK SIDE

These findings pushed theoretical physics in a new direction. If Einstein's theory of general relativity is correct, but the universe is expanding at an accelerating pace, then something must be interacting with the force of gravity, not only resisting but also overwhelming that pull. Today, we call that extra something dark energy. As Riess recalls, this new idea "was a total surprise. And nobody knows what dark energy is. It may have to do with totally different physics, or it may be related to our lack of understanding of how gravity really works on large scales in the universe."

To date, astronomers and physicists have advanced many possible explanations for dark energy, none of which have

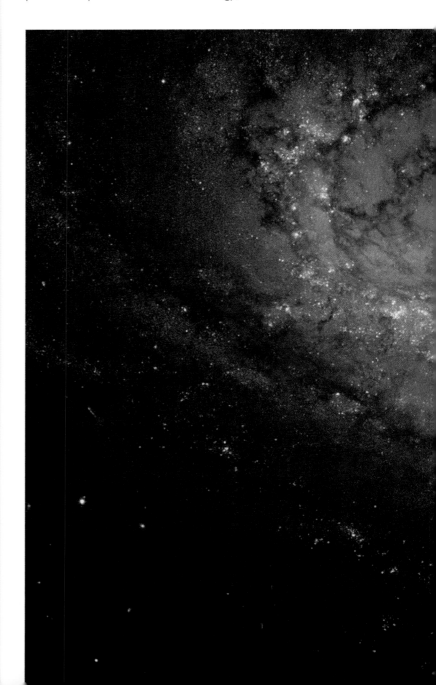

drawn much in the way of strong support. What has become clear, however, is that dark energy accounts for something like an astonishing 74 percent of the substance of the universe, dark matter (see Moment 14, pages 114–115) constitutes 22 percent, while the regular, visible matter we know about—planets, stars, even galaxies—makes up a measly 4 percent. Thanks to the GOODS observations and recent Hubble studies of more Type Ia supernovae, astronomers have refined the expansion history of the universe further. The current theory is that the universe expanded extremely fast after the big bang and then started to slow down due to the action of gravity. But after about eight or nine billion years, dark energy won its battle to overcome gravity and started to drive the acceleration of the expansion that we now observe. Thanks to its observations of the Type Ia supernovae, the Hubble Space Telescope has helped modern astronomers paint an amazing new picture of the universe. This shift is as momentous as the discoveries of external galaxies and the expanding universe in the early 20th century. The universe is composed chiefly of stuff that we can't see—dark energy and dark matter—the properties of which have to be inferred from their effect on the visible matter we can see.

Supernova 2004 dg (circled) exploded in the spiral galaxy NGC 5806 in 2004, and it was observed by Hubble in 2005 in order to try to determine the exact position of the supernova, the yellowish star circled in this reproduction.

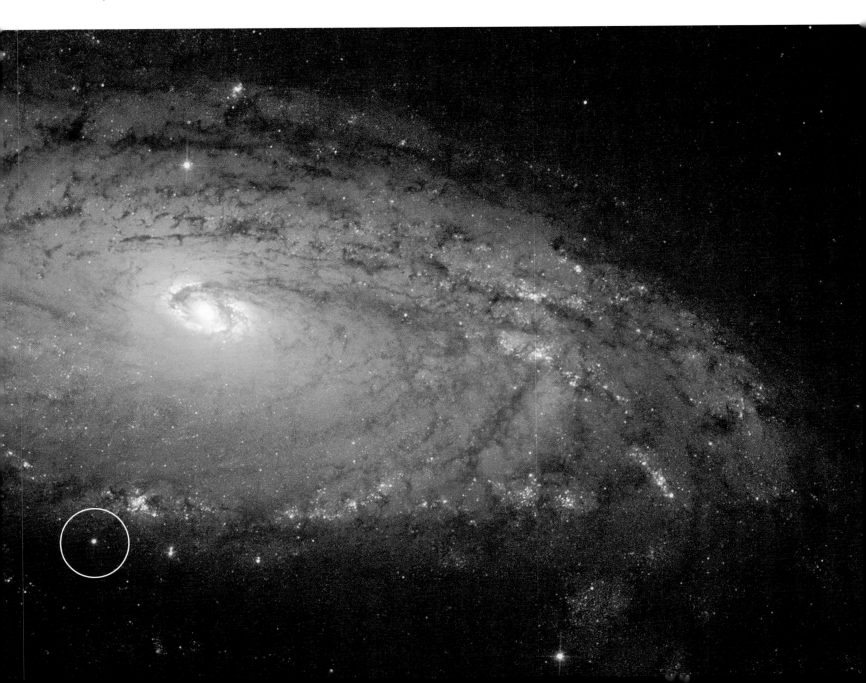

CORE OF THE ORION NEBULA

OBJECT: **EMISSION NEBULA**
LOCATION: **ORION**
DISTANCE: **1,400 LIGHT-YEARS**
OBSERVED: **OCTOBER 2004–APRIL 2005 (HUBBLE ACS), DECEMBER 11, 2001 (ESO 2.2-METER TELESCOPE); CIRCA 2006 (SPITZER)**

A composite mosaic of the inner portion of the Orion Nebula from Hubble's ACS and from the European Southern Observatory's 2.2-meter telescope at La Silla, Chile, and from the Spitzer Space Telescope

NGC 5189

OBJECT: PLANETARY NEBULA
LOCATION: MUSCA
DISTANCE: BETWEEN 1,800 AND 3,000 LIGHT-YEARS
OBSERVED: JULY 6, 2012

A composite image from WFC3 data of a chaotic planetary nebula. The remnant star at the center of this maelstrom is believed to be a white dwarf or even a binary star spewing gases wildly into space.

An artist's impression of HAT-P-7b in transit across the face of its parent star, a star hotter than our sun. The planet, larger than Jupiter, orbits its star in less than three days and is almost ten times closer to its star than Mercury is to our sun.

WHAT'S IN A MILLION?
HUBBLE MAKES ITS MILLIONTH OBSERVATION DURING A SEARCH FOR HOT JUPITERS.

WHAT IS IT ABOUT A MILLION? Literally or metaphorically, it's a big number. If you count, one number a second, 24 hours a day, it would take you more than 11 days to get to a million. When you say you've done something a million times, it's an accomplishment (or a drag). In the life of the Hubble Space Telescope, the millionth observation was not only a symbolic milestone but also a great story, one that developed from the work of many different people working at many observatories on the ground and in space.

Hubble made its millionth observation on July 4, 2011—a suitably patriotic date. Early that morning, the telescope briefly monitored the brightness of a faint star in the constellation Cygnus (Swan). Three years earlier, this star had attracted attention. Digital cameras operated robotically at the Harvard-Smithsonian Center for Astrophysics (CfA) observing stations in Arizona and Hawaii found that the star's brightness had varied by the tiniest amount. What was causing this variation? Astronomers needed a closer look, and so they put the star, along with others like it, on the roster for Hubble to take that look.

SPOTTING A HOT JUPITER

The Harvard-Smithsonian robotic network had been created soon after Harvard graduate student David Charbonneau found the first transiting exoplanet in 1999. Using a telescope not much bigger than the kind an amateur astronomer would use, Charbonneau detected an object cross in front of a star and dim it briefly. This was not a casual observation. Charbonneau's little telescope carried a very sophisticated digital camera that was hooked up to a computer that could notice the slightest amount of change in brightness. Turns out Charbonneau had found a hot Jupiter (see Moment 16, page 130), a planet far larger than Earth and very near its parent star.

Astronomers have known for centuries that stars often come in pairs and sometimes eclipse each other, causing the total brightness of the system to drop. Arabic astronomers called a bright star in the constellation Perseus Ras al Ghul—Demon's Head—because it winked at them every three days. By the late 19th century, astronomers realized that the wink was caused by the eclipse of one star in the system by another star. In time, hundreds and thousands of such star systems have been found and studied. Timing such eclipses provides information about the sizes, masses, and hence the densities of these stars. Naturally, astronomers thought that if they could somehow detect the tiniest of eclipses, maybe they could actually detect bodies the sizes of planets—only a hundredth or a thousandth the apparent area of their stellar hosts.

Transiting exoplanets became very exciting objects to study. They are planetary bodies orbiting other stars, with orbiting pathways that make them pass in front of their host stars—hence the word "transiting." When they transit, they

block out a tiny portion of the host star's light. Only with today's amazingly sensitive solid state light detectors (charge-coupled devices, or CCDs, like those in your camera), and powerful computer techniques for sifting signals from noise, did Charbonneau's discovery become possible. His success stimulated many emulators, who realized that they could join in the fun alongside scientists who saw the value of thinking small, thinking creatively, and most important, acting collectively. A group of Hungarian astronomers soon teamed up with Harvard-Smithsonian staff to create a far-flung ground-based network of small telescopic cameras equipped with powerful charge-coupled devices and computer technology. In a few years, the team, calling themselves HATNet (Hungarian Automated Telescope Network), started reporting new planets, including hot Jupiters. Cameras at the CfA's Whipple Observatory in Arizona first found HAT-P-7b, and soon all the other telescopes in the network were finding it. It was publicly reported early in 2008 by a team of 17 authors from 7 institutions, after they had verified their observations through telescope time, first on the 60-inch Tillinghast Telescope at the Whipple Observatory and then through follow-up photometric and spectroscopic observations on one of the huge 10-meter Keck telescopes atop Mauna Kea in Hawaii. What they found was truly wild.

Imagine a planet almost twice the mass of Jupiter that is racing around a star hotter than our sun, making a complete orbit in just over 2 days! It is barely 3.5 million miles away from its star, or about a tenth the distance between Mercury and the sun. It must be extremely hot and, if it possesses a gaseous atmosphere, a place of violent weather. Depending on how fast it rotates on its own axis, all the heat absorbed on its daytime side either builds up or is rapidly transferred to the other hemisphere.

One way or another, seeing how a body reacts to such compelling processes should reveal what gases and compounds exist there as well as the structure and dynamics of its atmosphere. This planet is so big and hot, its light should also be measurable, even when it goes behind the star, by observing how the star's light changes. And being so close to its star, and so massive, its behavior could tell astronomers something

about its parent star as well, and especially the orbital dynamics and tidal interaction they might share.

All these factors made HAT-P-7b a prime target for the world's ground-based telescopes.

ENTER KEPLER

HAT-P-7b was also a prime target for our space telescopes. Happily, it was in a part of the sky soon to be explored by a new planet-finding space telescope called Kepler, which launched in 2009. Unhampered by Earth's atmosphere and capable of 24/7 operation, Kepler conducted pinpoint surveys, not an all-sky survey, all the better for observing planetary bodies transiting stars. By concentrating on one field alone, for weeks, months, and years, Kepler could detect transits with longer periods, and hence larger orbits than those detectable by ground-based telescopes. That meant it studied planets with orbits large enough to place them far enough away from their stars so that they lived within temperate zones suitable for life.

Kepler employs techniques similar to those employed by HATNet and other survey teams. Light from an area of the sky near the constellation Cygnus, looking down the Orion spiral arm, is collected, reflected, and concentrated by a 55-inch-diameter mirror directly onto a curved plate of CCD sensors containing 95 million pixels. As Kepler stares at a single part of the sky, the pixels report every six seconds what they see to a computer that is looking for any variations in light intensity from any one of upwards of 100,000 stars.

So with Kepler, astronomers began an even more intensive exploration of HAT-P-7b. Within a year, enough data had been collected and analyzed to be confident that HAT-P-7b—now also called Kepler 2b, since it was the second extrasolar planet to be logged in by Kepler—was a charmer and a strong candidate for a bit of the very competitive telescope time on Hubble.

SEARCHING FOR WATER VAPOR

In late 2009, University of Maryland astronomer Drake Deming—a prolific and vocal exponent for the study of hot Jupiters—submitted a proposal for observing time on the

HST FACT

From May 1990 to July 4, 2011, Hubble made one million observations: about five observations an hour!

THE SCIENCE BEHIND THE MILLIONTH OBSERVATION

Hubble's Wide Field Camera 3 produces images in visible, ultraviolet, and infrared light and can also spread the light into a spectrum to search for information about the composition and structure of the object it is viewing. The camera has a special optical device called a "grism," a combination of a prism and a grating, to produce the spectrum, which can also be adjusted so that a selected wavelength of light continues through the camera in a straight line to form an image. The rest of the light is dispersed. When an astronomer wants to know an object's composition, structure, or motion, instructions are given to Hubble engineers to insert the grism into the camera's field of view. In this way, readings that reveal the nature of the target can be recorded. To observe HAT-P-7b, the grism was set to the near-infrared range, which is especially suited to penetrate through dust and to look at cooler stars and hot Jupiters.

To date, a few hot Jupiters have shown water vapor in their atmospheres. The 10-meter Keck telescope and an armada of linked 8-meter telescopes at the Very Large Telescope facility operated by the European Southern Observatory in northern Chile have shown with high confidence that planets going around stars in the constellations Boötes and Pegasus do contain spectroscopic evidence of water vapor and other molecules.

No matter how powerful these ground-based telescopes might be, they still have to peer through Earth's atmosphere, looking for the very same chemical signatures that earthly atoms and molecules produce. Hubble, operating in space,

avoids that masking effect, which makes it, in Deming's view, still "our best tool to explore the molecular absorption spectra of the atmospheres of exoplanets, particularly water vapor absorption"—the best, Deming believes, until the James Webb Space Telescope begins operation, planned at the end of the decade (see Moment 25, pages 200–201).

Yet it must not be forgotten that HAT-P-7b was detected not by a big telescope, or a telescope in space, but by a small, highly creative camera system, well within the grasp of advanced amateur astronomers today.

The observations displayed here in graphical form cover 15 orbits of HAT-P-7b around its parent star. The top graph shows how the light varied due to the transits of the planet, and the bottom graph discloses the planet has pulled its parent star into the shape of an ellipsoid.

If a planet passes in front of its star (top), it will reduce the combined light of the two objects by a very slight amount, as depicted in this graph of brightness versus time (bottom).

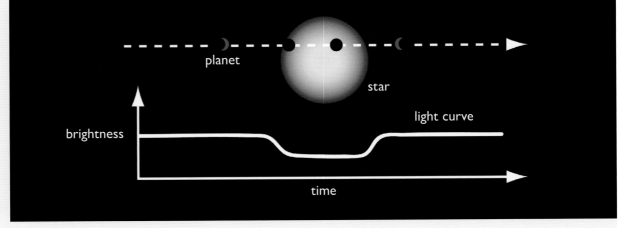

Hubble Space Telescope to study these amazing objects. Deming had 40 years of experience and almost 500 publications to his name, centered on infrared techniques for probing planetary atmospheres.

His proposal, specifically, was to search for water vapor in some 13 hot giant exoplanet atmospheres, observing them all in transit across the stellar disk, and some of them in eclipse behind the star. HAT-P-7b was among them, because the planet was expected to be bright enough to be detectable in eclipse, and, as Deming notes, "because it's one of the hottest and most prominent planets in the Kepler field, so we also have Kepler data to accompany [the Hubble Space Telescope data]."

THE MILLIONTH ONE

Deming proposed a series of short (ten-second) exposures with the WFC3 equipped to create a spectrum. His experiment needed exposures of both transit and eclipse, and so his team accumulated many observations, and the counter advanced quickly during his project to the one million mark. The timing of the observations was determined completely by the characteristics of the planet's orbit: The most important views came during those brief moments when transit or eclipse took place. Just after 2 a.m. EDT, on July 4, 2011, Hubble snapped another shot of HAT-P-7b and recorded its millionth image. Deming was most likely fast asleep.

NASA's public affairs office wanted to publicize the milestone moment, and they wanted a full explanation of the observation that clocked in at one million. When NASA contacted Deming, he warned them that the search for water vapor "is an extremely precise observation and it will take months of analysis before we have an answer." Their work had just begun, and for months and years after, they would be studying the Hubble images, supplemented by spectroscopic data from other Hubble instruments as well as data from ground-based telescopes. It may have been Hubble's one millionth, but it was just another in a continuing stream of observations and data collection, telling the story of planets and solar systems hundreds and even thousands of light-years away.

An all-sky map shows where Hubble has been pointed during 21 years of operational life. Yellow dots indicate observations of objects within the plane of the solar system. A composite of Hubble fields is superimposed on the infrared Two Micron All Sky Survey (2MASS), the hazy band that crosses the center of the map.

- Solar System
- Stars
- Star Clusters
- ISM/Nebulae
- Galaxies/AGN
- Galaxy Clusters
- Other

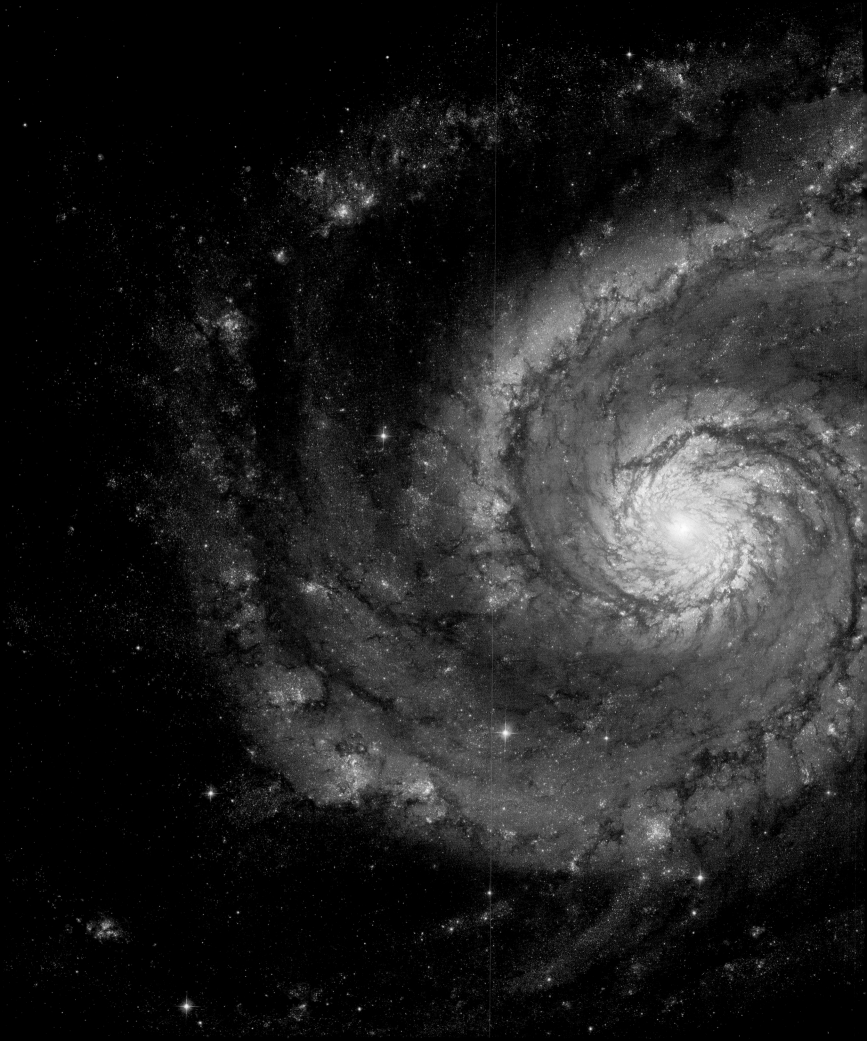

M51, THE WHIRLPOOL GALAXY

OBJECT: GRAND DESIGN FACE-ON SPIRAL WITH INTERACTING COMPANION
LOCATION: CANES VENATICI
DISTANCE: 31 MILLION LIGHT-YEARS
OBSERVED: JANUARY 18–22, 2005

ACS/WFC mosaic. M51 was the first spiral identified by William Parsons, third Earl of Rosse, in 1845. His observations with his 6-foot reflecting telescope were rendered into drawings that galvanized imaginations as much as Hubble's images do today.

An artist's rendering of planetary body Fomalhaut b orbiting parent star within a debris field. IRAS detected the debris field, and Hubble imaged the planet, some one billion times fainter than its parent star.

THIS IS A STORY OF HOW HUBBLE imaged a planet orbiting a distant star, how the planet was lost, and found again . . . maybe. In January 2008, astronomers announced that the Hubble Space Telescope had seen a planet going around a star in the sky. They were not inferring the presence of a planetary mass by its gravitational tug on the star it was orbiting; they were not sensing the presence of a planet by the minute dimming caused as it transited across the face of its star.

They were actually seeing an orbiting planet—and there is nothing like actually seeing an extrasolar planet to underline that such a planet really exists.

WHAT'S IN A NAME?

On clear evenings in autumn, a lonely star hangs low in the south, visible from Washington, D.C. You can find it on a star chart easily enough: Fomalhaut. But you might ask, what kind of name is Fomalhaut? It's from the Arabic name Fum al Hūt, meaning "fish's mouth," and it's the brightest star in Piscis Australis (Southern Fish). Known since antiquity, it has been given many names, used as a point of reference in Dante's *Divine Comedy,* and called by at least one 19th-century writer the central sun of the universe. Its bright, solitary appearance made it a popular candidate to keep track of time and position in star catalogs used for navigation. Interest in the star seemed to have faded in the 20th century, as astrophysics overtook traditional astronomical practice. But in the 1980s, new technology brought it center stage again, and Fomalhaut became a target for the most powerful telescopes on Earth and in space.

Good astronomical practice requires that you already have a clear idea where the interesting objects are before you enlist time on a major telescope, so the instrument's powers can be effectively used. Astronomical catalogs and atlases are therefore crucial tools. The classic Palomar Sky Survey dates back to the 1940s and 1950s, and was repeated in the 1960s, resulting in catalogs of objects that still offer many puzzles for astronomers to solve (like the Abell clusters we mention here and there in this book).

Some of the first telescopes operating beyond the atmosphere in new wavelength ranges were mappers—looking to see what was there. The Infrared Astronomical Satellite (IRAS) was launched in January 1983, and for the next 10 months mapped the sky in a wide range of infrared wavelengths, cataloging more than 250,000 new celestial objects. Many of the discoveries were galaxies with strong infrared emission, indicating star formation was taking place.

Also, many stars in our own galaxy were found to have an excess of infrared radiation, perhaps indicating that they were encircled by vast clouds of cool dust and possibly planets. Astronomers had postulated the existence of planets

SEEING PLANETS BEYOND THE SOLAR SYSTEM
HUBBLE EXPLORES FOMALHAUT, A STAR THAT HARBORS A YOUNG PLANET.

around other stars for centuries. Now, the race was really heating up to find one.

SEARCHING FOR PROTOPLANETARY SYSTEMS

Within a year, teams of researchers found evidence that at least four stars, including Fomalhaut, exhibited "emission from shells of orbiting particles [clouds or disks of dust], possibly connected to the process of planet formation." They imaged one of the systems with ground-based telescopes using a special technique called coronagraphy, which revealed it to be a disk surrounding a star.

By the late 1980s, IRAS's mapping, added to ground-based studies and results from the International Ultraviolet Explorer, generated enough excitement among astronomers that the American Astronomical Society's Division of Planetary Science formally recognized the study of "Extra-solar Planetary Science" in its annual reports. Conferences included special sessions on the subject, and in May 1988, the Space Telescope Science Institute held a workshop on how best Hubble could be used to find planetary systems beyond ours. Fomalhaut soon became a Hubble target.

Using the Goddard High Resolution Spectrograph (GHRS) on Hubble after the first servicing mission in 1993, researchers made successful observations in 1994, showing spectral features that were consistent with a rotating disk structure. Through the 1990s, astronomers continued work on many fronts: The key was to find irregularities, clumps, or gaps within the disks, which could indicate the presence of a large body like a planet. In 1998, submillimeter radio observations with the 15-meter James Clerk Maxwell Telescope on the high, extremely dry summit of Mauna Kea produced an especially provocative image of the distribution of matter around Fomalhaut.

LOOKING FOR PLANETARY BODIES

By the late 1990s, improved modeling techniques in conjunction with submillimeter radio observations sharpened astronomers' abilities to pinpoint just where to look for planetary bodies within debris disks. They looked for clumpy shapes where these bodies might be lurking. Fomalhaut's shape presented a particularly sharp edge and asymmetries, signatures of a planet-size body shepherding, or exerting gravitational influence on, the disk. Observations combining data from the Advanced Camera for Surveys (ACS), the Near Infrared Camera and Multi-Object Spectrometer (NICMOS), and the Space Telescope Imaging Spectrograph (STIS) confirmed the very sharp inner edge of the asymmetric debris field. The ACS also showed light reflecting off dust, but nothing anyone could call a planet.

Astronomers kept looking, applying new observing techniques, using every trick in the book and then some, to separate the intrinsic noise in the system from what they hoped would be a planet's signature. One of the most indefatigable Hubble observers, astronomer Paul Kalas, who had been poking at Fomalhaut and other stars since the early 1990s, teamed up with other scientists to mount a series of "Fomalhaut Campaigns." Finally, in May 2008, they homed in on a speck of light just inside the sharp inner edge of the debris disk. Renewed scrutiny over time revealed that the speck of light moved, and the path moved with Fomalhaut, and even looked like an orbit. They made an announcement that they had detected a planetary body. Then, the fun started.

Astronomers everywhere started looking, but no one found the planet. Questions, debates, even accusations surfaced. Most troubling, the Spitzer Space Telescope, the latest successor to IRAS and the most powerful infrared instrument in civilian orbit, saw nothing. Popular media called it an "astronomical altercation."

And to make matters tenser, the ACS failed in January 2007. But astronomers stuck to their telescopes, reexamined the evidence, and searched for new ways to make the breakthrough observation. Those arguing for the planetary body's existence suggested that the missing planet was possibly too "blue" to be seen easily in the infrared. Those more skeptical suggested that they had found not a planet but merely a clump of debris.

HST FACT

Dutch-American astronomer Peter van de Kamp of Swarthmore College searched for more than 30 years for "unseen planetary companions of stars." He thought he found some, but none has been confirmed.

The planet-forming debris field surrounding the star Fomalhaut, the brightest star in the southern constellation Piscis Australis. Near right: Imaged by the Atacama Large Millimeter/submillimeter Array of radio telescopes, superimposed on Hubble data (blue). Far right: The same field imaged by the infrared satellite Herschel.

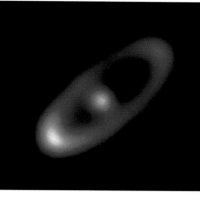

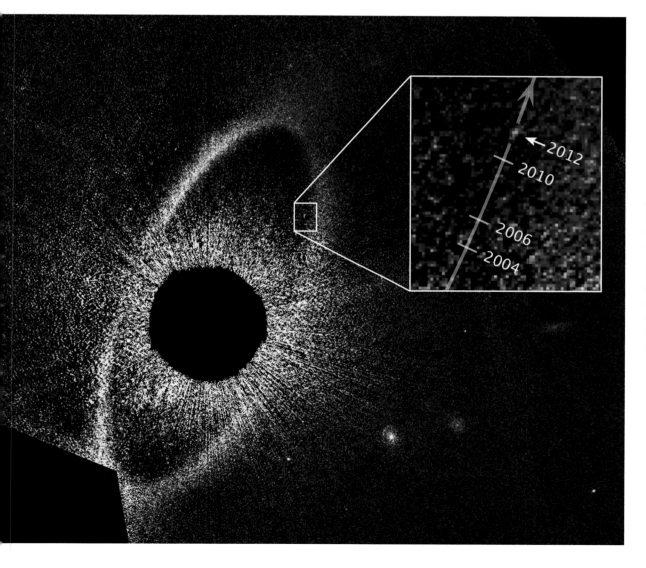

A composite image by STIS showing details of the debris structure around the star Fomalhaut. The star itself has been blocked out to render the extremely faint debris field visible. The inset displays the motion of the planetary body over eight years of observations.

Virginia astronomer Alex Parker constructed this representation of Vincent van Gogh's "The Starry Night" using 100 images from Hubble's cameras selected by the European Space Agency. In effect, each Hubble image, built up of countless pixels of information, became a pixel itself in this remix of a cultural icon that itself was inspired by astronomers' detection and description of spiral forms in the heavens.

LOOK TO THE STARS FOR NAMES,
BUT FIRST MARK THEIR MEANINGS

Rigel sounds like a lovely name for a newborn child, but beware, before you saddle the kid with any celestial moniker, look up its origins. R. H. Allen's *Star Names and Their Meanings* is a classic authority. Many bright stars in the sky, organized into forms, were named to describe specific parts of those forms. Rigel stems from the Arabic name Rijl Jauzah al Yusra, or the Left Leg of the Jauzah, the herdsman of camels. To Westerners, the herdsman has become the hunter, Orion, and Rigel remains anatomical, commonly referred to as the "foot."

How about Betelgeuse, the bright red star in Orion? Its name is also anatomical, from the "armpit of the central one." Other Arab authors more felicitously call it the "shoulder," or the "arm," or even the "hand." Bellatrix then logically would be Orion's left shoulder, but, in fact, it is a Female Warrior, the Amazon Star, or the Conqueror. A much better choice.

What if you have twins? Castor and Pollux, the twin stars of Gemini, would seem like the right ticket. They were the "founders of Thebes, and men of mighty name." But beware

what you're strapping your twins with: Castor, the horseman, was mortal; whereas Pollux, the boxer, was immortal. Oddly, Pollux was the son of Zeus, and Castor the son of someone named Tyndarus.

How about triplets? The belt of Orion has three bright, beautiful stars: Mintaka, Alnilam, and Alnitak. These, too, are descriptive: the first is the "belt," the second the "string of pearls," and finally the "girdle."

The three stars of Orion's belt point southeast, directly to the brightest star in the night sky, Sirius. Allen devotes ten dense pages of description to this star, since throughout history it has attracted the most commentary. The Egyptians watched for its rising along with the sun, for it marked the season when the Nile would flood. To both ancients and moderns, it is the Dog Star accompanying Orion, whether he be a herdsman or a hunter. Bright enough to visually scintillate in our night sky, shifting rapidly from red to blue, it was called by some the Sparkler or Scorcher.

PLANET OR CLUMP?

For years, Kalas and colleagues kept to their task, using the STIS to authenticate the object as a planet. In June 2013, after a series of high-contrast imaging runs, they reported that Fomalhaut was indeed accompanied by a "candidate planet" with "unexpected characteristics." It was a low-mass planet surrounded by a large dust cloud, which explained its blue cast—literally a reflection of the parent star, which is bluish white. Its trajectory, now traced between 2004 and 2012, produced a definite orbit and evidence that the planet was perturbing the dust belt.

So, as of 2013, findings from Hubble confirmed: Fomalhaut, the lonely star in the fish's mouth, has a planet surrounded by a cloud. Not everyone is comfortable with this interpretation of the data—and the matter is not settled—but most agree it's a breakthrough discovery.

Fomalhaut is just visible due south in the late fall after dark from mid-northern latitudes, as recorded here by astrophotographer Akira Fujii. Zoltan Levay added the outline of the constellation Piscis Australis.

CARINA NEBULA DETAIL

OBJECT: STAR-FORMING REGION
LOCATION: CARINA
DISTANCE: 8,000 LIGHT-YEARS
OBSERVED: APRIL 18, 1999

Portion within vast nebular complex in Carina originally called the Keyhole by John Herschel. European Space Agency astronomers note that the "defiant" finger in the upper left corner of the image is the result of photoevaporation caused by massive bright stars just out of the field.

A neutron star lurks within the debris (N49 nebula) of a supernova that exploded in the Large Magellanic Cloud. The neutron star was the source of a gamma-ray burst in 1979 that was detected by several spacecraft.

I N T H E 1 9 2 0 S , A S E D W I N H U B B L E and other astronomers began to explore the universe beyond the Milky Way, they assumed that we inhabit a relatively peaceful cosmos in which galaxies cartwheel gently through space, despite the occasional eruptions of stars in the form of novae. Today, our conception of the universe is utterly different. The big bang that kicked off the universe is only the most extreme of many staggeringly violent events in its history. Collapses of very massive stars

that provoke a brief but huge outpouring of gamma rays likely represent the most titanic explosions since the big bang. Hubble has played a major role in teasing out the properties of these amazing, and, for decades, very enigmatic events called gamma-ray bursts. Hubble, to be sure, cannot "see" gamma rays. But it can pinpoint what is left after the burst has run its course.

Gamma rays are the most energetic of all known forms of electromagnetic radiation. They have wavelengths smaller than 0.01 nanometers, which is even shorter than the wavelength of x-rays. Gamma rays can't be focused in the manner of, say, visible light or infrared radiation: With such a tiny wavelength, they simply pass through mirrors or lenses. Hubble, therefore, can't directly detect gamma rays, only their aftermath.

Our first discovery of gamma-ray bursts came thanks to satellites that were not designed for astronomy at all. Part of a U.S. Cold War monitoring system from 1963 to 1979, the Vela satellites kept a lookout from high above Earth for the detonations of nuclear weapons in space and the upper atmosphere. In 1967, four Vela satellites detected an intense burst of gamma rays that lasted less than a millionth of a second.

More sensitive satellites were launched in 1969, and in the next three years these sensed 16 more such bursts. But there were no known nuclear tests happening anywhere that coincided with these reports. By 1973, researchers were hypothesizing that the bursts were of cosmic origin, produced by astronomical sources. Astronomers soon regarded the explanation of these gamma-ray bursts as one of the outstanding problems in the field.

Six pairs of Vela satellites were launched between 1963 and 1970, and they observed these bursts. During the 1970s, other spacecraft detected gamma-ray bursts too. NASA's IMP 6 satellite was designed to monitor solar flares, but its gamma-ray detector captured bursts, as did, for example, the Soviet Union's Kosmos 461 satellite. And, as we note below, the second of NASA's Great Observatories (Hubble was the first) was the Compton Gamma Ray Observatory, which, over the course of its nine years in space, detected about 2,700 gamma-ray bursts.

LOCAL OR DISTANT?

All sorts of ideas surfaced to explain the bursts. Two astronomers suggested that a burst could be generated by

MOMENT
23

BURSTING OUT ALL OVER
HUBBLE HELPS US UNDERSTAND GAMMA-RAY BURSTS, THE BIGGEST BANGS SINCE THE BIG BANG.

GIFTS OF THE COLD WAR

The start of gamma-ray astronomy was a gift of the Cold War. The first detections of gamma-ray bursts from astronomical objects were made by satellites built for quite different ends.

The United States established programs to devise means to detect the telltale signs of other powers testing nuclear weapons in Earth's atmosphere: the gamma rays, x-rays, and neutrons any such explosion would spew forth. Earth's atmosphere would block such radiation from a nuclear explosion in space or the upper atmosphere from reaching detectors on the ground.

To watch for evidence of nuclear explosions, the U.S. Air Force launched a series of satellites that would orbit many tens of thousands of miles above Earth. This is a substantial fraction of the distance from Earth to the moon, unlike Hubble, which orbits only a few hundred miles above Earth. These satellites were called Vela, from the Spanish verb *velar*, to guard or to watch over. The first of these satellites were launched in 1963.

Hubble, too, is in many ways a gift of the Cold War. Spy satellites were one of the key technologies in the battle for supremacy between the United States and Soviet Union. They were designed to observe sites on Earth from space. The main contractors for Hubble, Lockheed and Perkin-Elmer, were central players in the construction of spy satellites, and gained invaluable experience that they could bring to bear in building Hubble. As George Keyworth, President Reagan's science adviser, put it, Hubble is new, but very much draws on the experience of building satellites for the purposes of national security.

a comet crashing into a neutron star. Other astronomers proposed that the bursts were from much more distant sources in other galaxies. If so, they must emerge from sources vastly more powerful than any in our own galaxy and release in a matter of seconds more energy than our sun is expected to emit in its ten-billion-year lifetime. This extragalactic proposal seemed so outlandish, many astronomers were skeptical of it.

In 1979, nine satellites netted a powerful outburst of gamma rays that faded, then brightened periodically. The source seemed to be a neutron star—the collapsed core of a spent supernova—associated with a supernova remnant in the Large Magellanic Cloud, a dwarf galaxy close to but beyond the Milky Way at a distance of around 160,000 light-years. Neutron stars are stars at the end of their lives. When a massive star several times the mass of the sun exhausts its nuclear fuel, it becomes unstable and blasts off its outer layers while compressing its inner core. The inner core collapses further under the crushing pull of gravity and forms a neutron star. A neutron star typically has somewhat more mass than our sun, but it is all packed into a tiny sphere only 12 miles or so in diameter. One teaspoonful of neutron star material weighs a staggering one billion tons. Neutron stars were favored by some people as the source of gamma-ray bursts. These individuals opposed an extragalactic origin because they considered the juxtaposition of the gamma rays and the supernova remnants a coincidence rather than a true physical linking.

However, when NASA launched the Compton Gamma Ray Observatory, designed specifically to detect gamma-ray bursts, in 1991, it detected thousands that were located randomly throughout the sky. The bursts did not follow the plane of our Milky Way galaxy, as astronomers predicting local origins of the bursts had expected. The evidence was now pointing strongly to the bursts as events within distant galaxies.

COLLAPSARS AND THE AFTERGLOW

In early 1999, Hubble and other telescopes captured the visible light afterglow of the biggest explosion ever recorded, equivalent to the output of 100 million billion (10^{17}, or 100,000,000,000,000,000) stars. The observation was a

Active star-forming and star-destroying region N44C in the Large Magellanic Cloud. Some massive stars in the cluster at the lower left have already exploded as supernovae, and the circled star in the center of the field, a massive Wolf-Rayet star, is a candidate for becoming a supernova in the not too distant cosmic future.

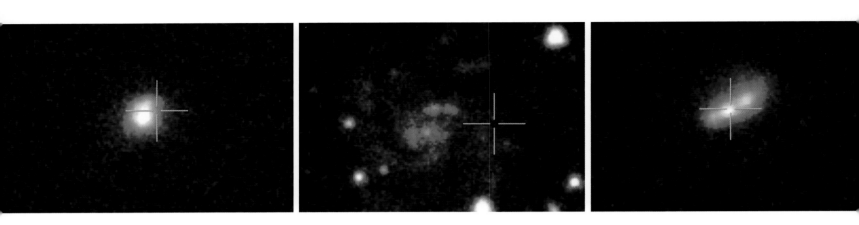

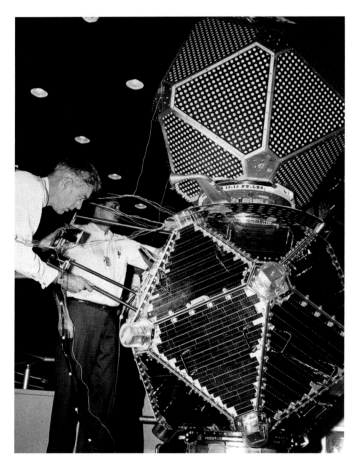

Vela satellites were developed for purposes quite different from astronomy. They nevertheless made possible the discovery of gamma-ray bursts in 1967. Here, two Vela satellites are being readied for ground testing in 1968.

great example of cooperation among the world's astronomical observatories.

The Compton Gamma Ray Observatory caught the start of a bright gamma-ray burst on January 23, and NASA immediately radioed that information to other telescopes and satellites. Two days later, astronomers used one of the Keck telescopes atop Mauna Kea in Hawaii and measured the distance to the host galaxy of the gamma-ray burst: nine billion light-years. Hubble was directed to the galaxy on February 8 and 9. Even though the light that followed the burst—the afterglow—had by this time become far dimmer, Hubble was still able to distinguish the fading fireball. The Keck telescope and Hubble found the host galaxy contained many blue (and therefore new and very hot) stars, supporting the idea that such gamma-ray bursts are associated with regions of highly vigorous star birth.

In April 2008, alerted by the Swift gamma-ray satellite (designed as a rapid response system to warn astronomers of events in progress), Hubble picked out another fading afterglow, the optical counterpart of a spectacular gamma-ray burst, in a galaxy in Boötes (Herdsman), a well-known constellation in the Northern Hemisphere, at a distance of around 7.5 billion light-years. For about one minute on March 19, astronomers reckon, the source of the gamma-ray burst, a single star, shone as bright as ten million galaxies. Despite its huge distance from Earth, it was even visible to the naked eye briefly, appearing as a faint star in Boötes.

What caused this colossal explosion? Some astronomers suggested it was a hypernova, the explosive demise of a star

tens of times more massive than the sun, hence considerably more powerful and luminous than a typical supernova. If so, this burst probably involved a collapsar, or collapsed star. While most of the star explodes in a hypernova, the core of the star implodes to form a black hole, forming an intense gravitational field that hauls more material in. An accretion disk forms and a jet of material shoots outward. Blobs of matter in the fireball collide, resulting in gamma rays and the burst that our telescopes observe. When the fireball smashes into the stuff of the interstellar medium, first x-rays and then visible and infrared light result, thereby producing the afterglow, which is what Hubble detected.

MERGERS

Short-duration gamma-ray bursts (typically those that last for less than two seconds) represent a different sort of cosmic event, astronomers now believe. Two superdense stellar objects merge—perhaps two neutron stars or a black hole and a neutron star—and spiral together, leaking energy away in the form of gravitational waves. That energy loss nudges the two superdense objects to move closer together. As the two merge, radioactive material is emitted. The material heats up and so produces an upsurge of visible and infrared light, creating a kilonova, about a thousand times more powerful than a nova but not as powerful as a supernova or hypernova. Astronomers have employed Hubble to investigate the merger theory. In 2013, for example, Swift detected an intense

Long duration gamma-ray bursts (those that last more than a second or two) appear to occur most frequently in small, faint galaxies that are irregular in shape. This collection of images shows six such host galaxies. These bursts signal the collapse of the cores of massive stars exploding as supernovae.

burst that lasted for around one-tenth of a second in a galaxy some four billion light-years away. Hubble observed the infrared afterglow of the burst, which provided strong evidence that the source of the burst was a kilonova—a "smoking gun," some interpret, in favor of the merger theory.

At this point, astronomers have developed a two-part picture of gamma-ray bursts: Short-period bursts are the result of kilonovae and longer-period bursts result from especially energetic supernovae and the formation of collapsars.

But plenty of puzzles remain, and this two-fold division has proved a bit too neat. In 2006, for example, Swift detected a long-duration gamma-ray burst that lasted more than 100 seconds in a galaxy about 1.6 billion light-years away in the constellation Indus (Indian), visible from the Southern Hemisphere. A team of astronomers immediately put Hubble to work hunting for the supernova that theoretically should have produced the gamma-ray burst. The host galaxy was near enough so that if a supernova had erupted, Hubble should have located it. But astronomers found no trace.

Lots of puzzles remain about gamma-ray bursts for Hubble to help tackle.

HST FACT

One teaspoonful of neutron star material weighs a staggering one billion tons.

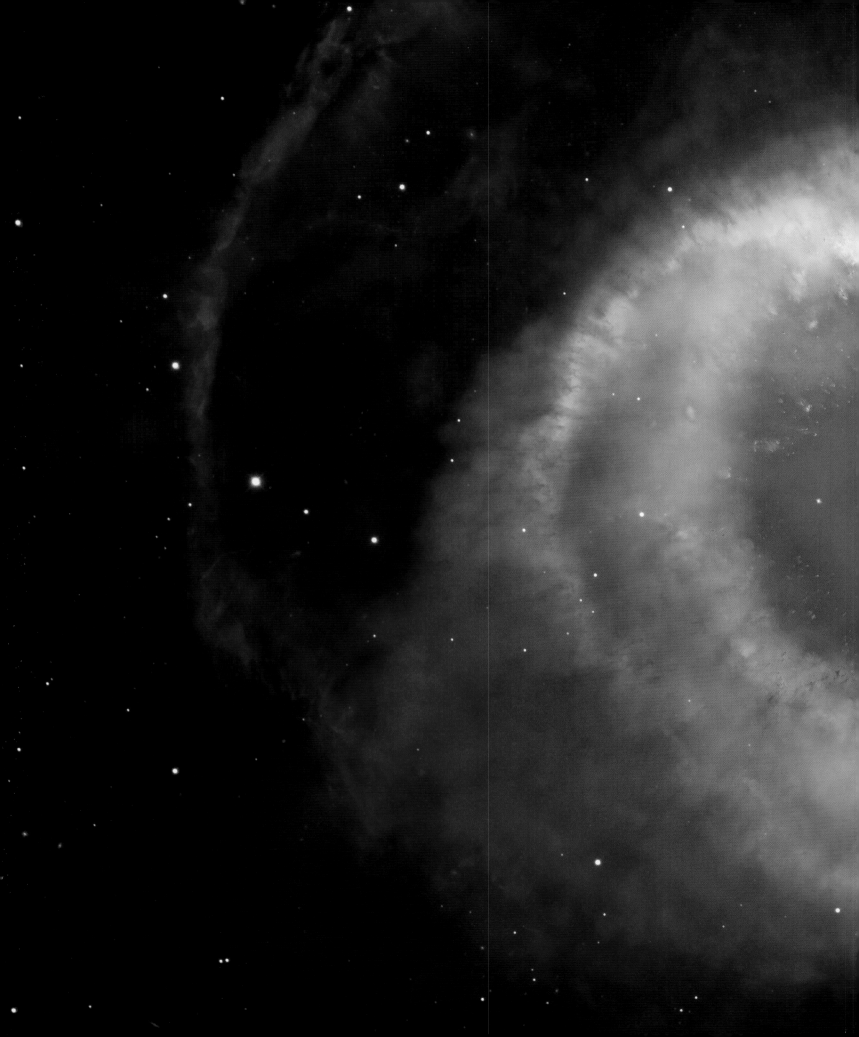

NGC 7293, THE HELIX NEBULA

OBJECT: PLANETARY NEBULA
LOCATION: AQUARIUS
DISTANCE: 690 LIGHT-YEARS
OBSERVED: NOVEMBER 19, 2002 (ACS/WFC); SEPTEMBER 17–18, 2003
(MOSAIC II CAMERA ON CTIO 4-METER BLANCO TELESCOPE)

The complex Helix has long fascinated astronomers, who now realize it is composed of structures from various mass ejection events: One, bagel-shaped, is interacting with interstellar gas and dust, creating a shock front that appears as a large ring.

Hubble observed comet ISON as
it plunged into the inner regions of
the solar system. The round coma
appears blue because ice and gas
in the comet's nucleus preferentially
reflect blue light. The dust grains
in the tail display a redder tint.

ON JULY 4, 2005, HUBBLE, in tandem with Spitzer and some 80 other telescopes, captured one of the most dramatic events in the history of exploration of the solar system. At that moment, an 820-pound "impactor" launched from the NASA interplanetary space probe Deep Impact piled into the nucleus of comet 9P/Tempel 1 at around 23,000 miles an hour. By staging this deliberate impact, scientists hoped to delve into the early times of the solar system, learning about the origins of

MOMENT 24

THE NATURE OF COMETS AND ASTEROIDS

HUBBLE PENETRATES THE DEPTHS AND EXAMINES SMALLER BODIES CLOSE TO HOME.

Earth and the planets from the composition of a comet swinging by. Seventy-four million miles away, Hubble was watching.

For Hubble, that was a relatively close-up encounter. So many of the objects it has been trained on over the years are millions of light-years, not millions of miles, away. But in fact, one of Hubble's important research roles has been to work in combination with spacecraft and ground-based telescopes to learn more about our own solar system. Early on, astronomers expected Hubble would spend most of its time observing stars, nebulae, and galaxies. But even before its launch in 1990, those studying the solar system recognized Hubble's potential for their work. That expectation has proved to be true, most spectacularly with the images Hubble provided of comet fragments crashing into Jupiter in 1994 (see Moment 06, pages 56–57). But there have been many other examples, and Hubble has played a key role in helping us understand more about the nature and evolution of comets and asteroids.

A VIEW FROM A HILL

The study of visible comets and asteroids goes back centuries. Johannes Kepler, one of the most famous figures in the history of astronomy, endured a miserable and squalid childhood, but there were two bright memories that shone out of the gloom of his early years. One was observing a lunar eclipse. The other was walking at the age of six to a hillside with his mother to view the great comet of 1577. With its majestic tail stretching across a large part of the sky, this was one of the most striking comets in all of recorded history, and it is no wonder that it made a lasting impression on the young Kepler.

The 1577 comet also drew the attention of Tycho Brahe, the finest of astronomical observers before the invention of the telescope, who in time would form with Kepler one of the great partnerships of astronomy. Students of nature had long believed comets to be atmospheric phenomena, occurring close to Earth, but Brahe's careful observations convinced him the comet was a celestial traveler, farther out in the solar system. That observation was an important step in scientific progress. But in other respects, Brahe stuck to established views, seeing comets as portents to be used for prognostication. The 1577 comet foretold calamities for Europe west of Denmark, Brahe interpreted, but it would also "spew its

venom" over the Tartars and Muscovites to the northeast because its tail swept in that direction.

Entering the 20th century, most understood that comets were physical bodies traveling through the solar system. That did not keep an imagination like that of H. G. Wells, the brilliant pioneer of science fiction, from building on the human impulse to find meaning in a star streaking across the sky. In his 1906 novel, *In the Days of the Comet,* Wells reversed Brahe's interpretation of the disastrous effects of a comet's tail. In the novel, a comet flies close by, its tail grazing Earth, but instead of venom, its gases exert a peaceful influence on the planet, so that a new era of human history dawns, free of war, injustice, and suffering.

The impulse to mythologize comets and meteors is irresistible, but the quest to understand them scientifically is all the more fascinating. We now know that Earth regularly passes through the debris and dust streams left in the wake of comets. The Perseid meteor shower peaks in August every year, for example, the result of Earth sweeping up material from comet 109P/Swift-Tuttle as both orbit the sun.

These meteor showers provide more than wonder, excitement, and inspiration for those who stay up late to view them on clear dark nights. In the early 1950s, Harvard astronomer Fred Whipple analyzed how the meteors break up as they enter Earth's upper atmosphere. Meteors from comets, Whipple found, broke up much higher up in the atmosphere than meteors from the asteroid belt. Cometary meteors were fragile, made of ices. From this observation, Whipple determined that comets were nothing more than dirty balls of ice. In the 1930s he had surmised that comets were definitely a part of the solar system and were not interlopers from the interstellar deeps. These realizations heightened astronomers' interest in comets, which they reckoned could well be the leftovers from the formation of our solar system of planets. Studying comets closely might well reveal our origins.

HUBBLE AND COMETS

In 1979, a small group of astronomers gathered at Princeton University to debate the most productive uses of Hubble, then 11 years from launch. One of the attendees was Mike Belton, who argued early on that Hubble could assist in making major advances in the study of comets and asteroids, but only if partnered with spacecraft dedicated to fly to comets and asteroids. Twenty-six years later, the collaboration between Hubble and Deep Impact as it rendezvoused with comet 9P/Tempel 1 manifested the promise Belton had seen.

HUBBLE'S ROLE IN REDEFINING CERES: ASTEROID, DWARF PLANET, OR SOMETHING ELSE?

In 1800, astronomers knew that the solar system contained four sorts of bodies: our local star (the sun), the planets, the moons of planets, and comets. But on New Year's Day 1801, Italian astronomer Giuseppe Piazzi discovered a new sort of object. He called it Ceres, and initially he thought he was observing a comet. But then he decided it was a planet. The following year, a similar but smaller body was observed and given the name Pallas. Over time, astronomers decided they had to add another class of body to the inventory of the solar system: asteroids. We now know that both Ceres and Pallas orbit in the asteroid belt between Mars and Jupiter.

Ceres is the biggest of the asteroids, and astronomers now generally classify it as a dwarf planet, like Pluto. According to one theory, it was the powerful gravitational pull of Jupiter that prevented Ceres from accreting enough material in the early history of the solar system to form into a full-fledged planet.

Hubble has greatly enhanced our knowledge of Ceres. Only about 600 miles in diameter, Ceres has a number of surface features that have been mapped, although there is no general agreement on the nature of these features. NASA's Dawn spacecraft mission, flying by Ceres in 2015, counts on information from Hubble about the dwarf planet it will encounter.

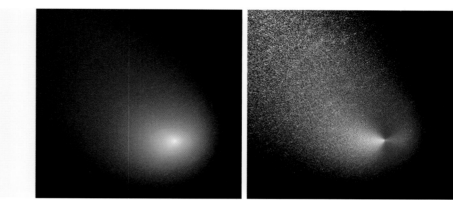

Near right: Comet Siding Spring, whose icy nucleus is not large enough to be resolved by Hubble. Far right: The light from the comet's coma has been subtracted using special image-processing techniques. Now visible are two jets of dust being emitted from the nucleus.

As Whipple realized, every comet has a nucleus—a center called a dirty snowball that is actually a porous collection of ice, dust, frozen gases, and a bit of carbon-based organic material. There may be trillions of comets in the solar system, some estimate. Their nuclei range in diameter from hundreds of feet to a few dozen miles. The vast majority of comets spend their lives traveling in the outer reaches of the solar system, a deep freeze so far removed from the sun that these icy nuclei have survived over the 4.5 billion years of the history of the solar system.

As a comet's nucleus sweeps toward the sun, it heats up. Gas and dust are driven off in jets, forming an atmosphere called the coma, which appears to us on Earth as the head of the comet. These can expand out to a remarkable 50,000 miles wide.

Comets that journey into the inner reaches of the solar system as they swing around the sun develop impressive tails. This is what we notice from Earth in famous comets, such as Halley's comet. Comet tails are actually created two different ways: The dust tail is the result of rock dust driven from the coma by the action of sunlight, and the gas tail is created when the coma shirks off charged particles streaming out from the sun.

Of course, we no longer consider comets portents of the future. In fact, astronomers regard comets as relics from the past, holding clues to the earliest history of the solar system, when the planets were forming. By studying the material composing comets, they can obtain information on that youthful stage in the solar system's evolution. Hence, the mission of Deep Impact on July 4, 2005.

HST FACT

The Perseid meteor shower is so called because the meteor trails point back toward the constellation Perseus.

The idea was to fire the impactor into the nucleus of comet 9P/Temple 1, an icy, potato-shaped object roughly half the size of Manhattan. Driving below the comet's surface, the impact released deep-lying material that spewed into space, where its chemical composition could be analyzed remotely by astronomers using sensors on the parent craft as well as on Hubble, and on many other telescopes. Telescopes watched the growing plume from the impact for many days, gathering data on the composition of the dust and gas, and securing new insights into the structure of comet nuclei.

The Hubble Space Telescope has also investigated comets on its own. Comet 73P/Schwassmann-Wachmann 3, for example, first appeared in the inner reaches of the solar system in 1995–96, when it was very active and split into several substantial chunks. In 2006, the comet swung back around, headed toward a close encounter with the sun, and astronomers made a point of observing it with Hubble. As the comet was warmed by the sun, it disintegrated further. By March 2006, ground-based telescopes observed at least eight fragments. In April, Hubble found many more. The comet had been transformed into a string of more than three dozen fragments, followed by dozens of bits called mini-comets or mini-fragments, some estimated to be no bigger than a house in size and all ejected from the surface of the comet's nucleus.

HUBBLE AND ASTEROIDS

The Hubble Space Telescope is advancing our knowledge of asteroids as well. Millions of asteroids orbit between Mars and

Jupiter, the rocky leftovers from the formation of the solar system. Observations with Hubble have underlined that some asteroids are far from just chunks of rock flying around in space that display no evidence of change. David Jewitt, a leading comet and asteroid expert at the University of California, Los Angeles, reckons that collisions between modestly sized asteroids occur often, about once a year, and he and his colleagues have been using Hubble to learn more about these collisions. In 2010, for example, they detected an object no larger than 400 feet across that had probably been a bit larger several months earlier, before a smaller rock, 10 to 15 feet in size, smashed into it at a speed of around 11,000 miles an hour—many times faster than the fastest bullets. The collision vaporized the smaller rock and created lots of debris. Under the pressure of sunlight, that debris developed a tail similar to a comet's.

Later in 2010, astronomers noticed that an asteroid named Scheila, estimated to measure about 70 miles across, had suddenly become much brighter. They directed Hubble and the Swift satellite toward the asteroid and concluded that they were probably seeing the result of a collision between it and a smaller asteroid, perhaps 100 feet across, leading to the ejection of more than 660,000 tons of dust and plumes of material emanating from Scheila.

In 2013, Jewitt and his colleagues used Hubble to examine what they considered a "weird and freakish object" orbiting in the asteroid belt between Mars and Jupiter. It displayed comet-like behavior but it appeared fuzzy, unlike most asteroids, which appear in a telescope as a point of light. Hubble was pointed toward this object, named P/2013 P5, on September 10 and again 13 days later. In just that short time, they saw astonishing changes. "We were literally dumbfounded," Jewitt reported. As it belched out dust, as he phrased it, the shape of its tail changed so dramatically that, as he said at the time: "It's hard to believe we are looking at an asteroid." Based on these observations, Jewitt and his colleagues have proposed that a small fraction of asteroids, like this one, are different from the rest and better termed "active asteroids." Clearly, the asteroid belt is much more active than astronomers assumed 25 years ago.

A composite of WFC3 exposures records comet Siding Spring (long exposure) and Mars (short exposure) superimposed to show their relative positions at 2:28 p.m. EDT, October 19, 2014. A single exposure long enough to reveal the comet would have overexposed Mars beyond recognition.

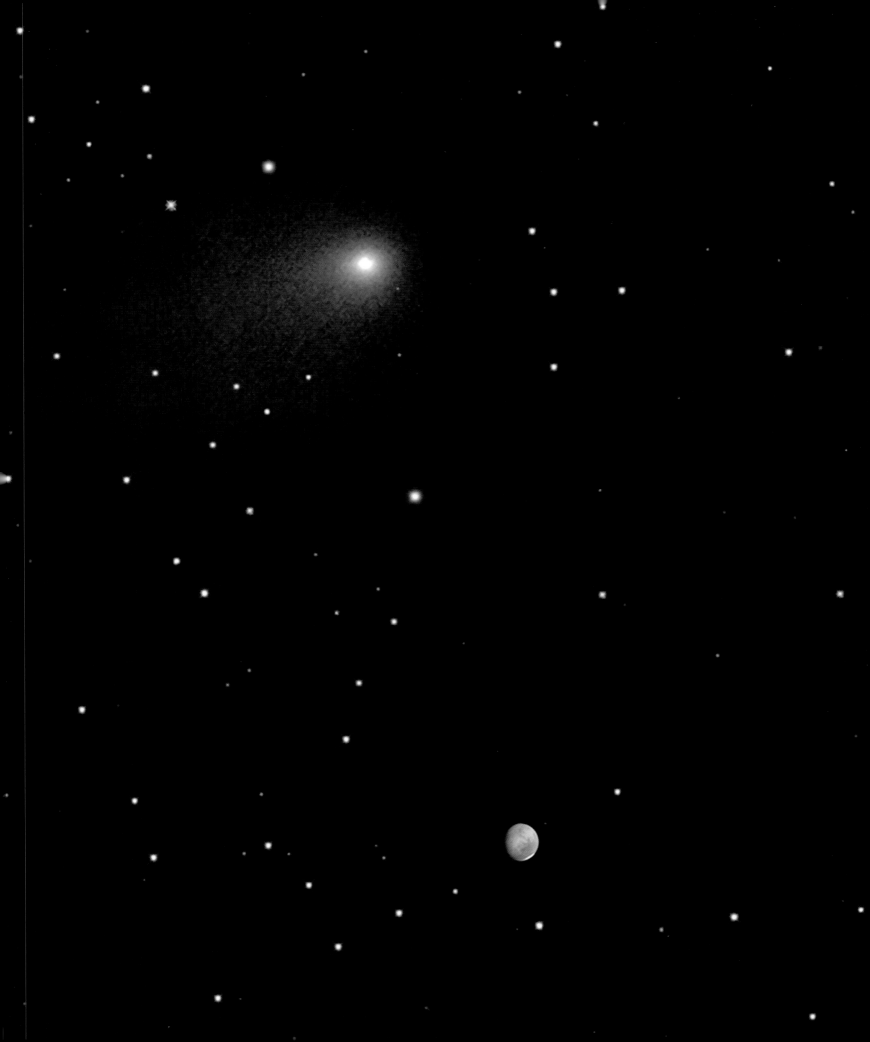

CENTRAL REGION OF THE MILKY WAY IN THE INFRARED

OBJECT: VARIED NEBULAE AND STARS
LOCATION: SAGITTARIUS
DISTANCE: 26,000 LIGHT-YEARS
OBSERVED: SEPTEMBER 3, 2004, AND SEPTEMBER 15, 2005 (SPITZER IRAC); FEBRUARY 22–JUNE 5, 2008 (HUBBLE NICMOS)

Composite mosaic of the Milky Way's center, released in 2009.
Compare with image on pages 142–143, which added Chandra data.

The eXtreme Deep Field is a compilation of data from the ACS and the WFC3 of the central portion of the Hubble Ultra Deep Field, using two million seconds of exposures overall. The field of view is a small fraction of the apparent size of the full moon.

EXPLORING THE EXTREME EDGES of the universe by observing the light from the very first stars and galaxies is one of the grand enterprises of modern astronomy. The Hubble Deep Field (see Moment 08, pages 70–71) was a triumph for Hubble, an emphatic demonstration of its prowess, and one of the great milestones in the human pursuit of cosmic origins. Still, there is more to learn. The Hubble Deep Field did not reveal the light from the very earliest stars and galaxies, but it

did point the way to still deeper surveys. Soon after the Deep Field success, astronomers exploited Hubble to push even farther into the distant universe in pursuit of their elusive quarry.

Astronomers worried that the findings of the Hubble Deep Field, which focused tightly on one area of sky near the Big Dipper, might be unrepresentative about the universe as a whole. So astronomers turned south, observing a small region of the sky in the southern constellation Tucana (Toucan). This campaign became known as the Hubble Deep Field South (with the original becoming the Hubble Deep Field North). Both presented far-off galaxies markedly different from the familiar spirals and ellipticals visible near the Milky Way.

In the middle of the 20th century, some astronomers believed that very distant and relatively nearby galaxies were essentially similar, that the universe did not originate in a big bang but rather had existed for an infinite time. For supporters of this so-called steady state theory of the universe, matter was being continuously created, and the universe, when seen over a sufficiently large scale, would appear pretty much the same at whichever epoch it was viewed. Remote

galaxies, therefore, should match nearby galaxies in their properties. The Deep Fields showed that the galaxies do not match, which was a dramatic reconfirmation that the steady state theory was not credible.

GETTING THE GOODS

In 2002, Hubble joined forces with other great observatories—the Spitzer Space Telescope, the Chandra X-ray Observatory, ground-based telescopes, and the European Space Agency's Herschel and XMM-Newton space observatories—to pursue the Great Observatories Origins Deep Survey (GOODS), two regions of the sky chosen to answer questions about the formation and evolution of remote galaxies (for more on GOODS, see Moment 20, page 160).

In 2003, astronomers announced that the evidence from observing tens of thousands of galaxies in the GOODS field indicated that as the universe aged from one billion to six billion years old, the sizes of galaxies increased. Galaxies did not develop from the breakup and fragmentation of enormous clouds of material. Instead, they grew in size from smaller units,

MOMENT

25

THE FARTHEST REACHES OF THE UNIVERSE

HUBBLE PAVES THE WAY FOR THE NEXT BIG SPACE OBSERVATORY, THE JAMES WEBB SPACE TELESCOPE.

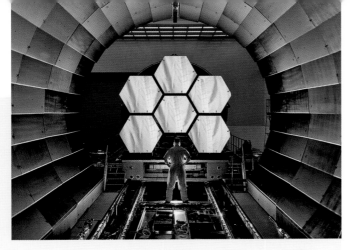

The primary mirror of the James Webb telescope is about 21 feet across and is made up of 18 segments, 6 of which are seen here.

THE NEXT GENERATION OF SPACE TELESCOPE

In 1996, NASA Administrator Dan Goldin issued a warning and a challenge. Hubble would not last forever, and astronomers' plans for a telescope with a mirror slightly bigger than Hubble's, at 94.5 inches, "was not good enough." He dared scientists to "think big" and design a space telescope for the next generation with a mirror substantially larger than the 13-foot mirror they had been considering. His challenge grew into the James Webb Space Telescope, due for launch in 2018.

With a primary mirror 21 feet in diameter that is made up of 18 hexagonal segments and optimized for infrared observations, the Webb—named for the longtime NASA administrator during the Apollo era—will see dim and very distant (and so substantially redshifted) objects with unprecedented clarity. Located beyond the moon and directly opposite the sun at more than 900,000 miles from Earth, it will operate far beyond the reach of any astronauts. Thus, it will not be serviceable in the manner of Hubble. This location was picked to keep the telescopes as cold as possible. The extremely faint signals Webb will detect from astronomical objects might be drowned out by the heat from the telescope itself, if it is too warm. How to avoid this? Webb and its instruments must be kept at frigid temperatures. Webb therefore carries a large sunshield to screen out light from the Earth, moon, and sun and needs to be in an orbit where all three orient at about the same direction. To this end, Webb will orbit well beyond the moon.

Many consider the James Webb Space Telescope a "first light machine," able to reach even deeper into space than Hubble can. Success will mean that Webb can detect the light from the very first stars and galaxies to form after the big bang.

with dwarf galaxies colliding and merging as well as accreting lesser galaxies to form larger ones over eons of time.

Here then was another quite different picture from the one painted by the steady state theory, one that underlined the remarkable evolutionary history of the universe and that was consistent, too, with the newest ideas astronomers had developed about dark matter. Here, the notion was that aggregations of dark matter in the early universe had attracted and drawn in gas that had then condensed to form star clusters and dwarf galaxies.

HUBBLE ULTRA DEEP FIELD

The year after the first results from GOODS were presented, Hubble secured the deepest-ever optical image of the universe, the Hubble Ultra Deep Field (HUDF). Using the powerful Advanced Camera for Surveys, Hubble was able to detect galaxies some two to four times fainter than before.

For some 400 orbits and 800 exposures during a period of more than four months, the Hubble Space Telescope was aimed at a tiny region of the sky in the constellation Fornax (Furnace) for an actual viewing time that lasted more than 11 days—roughly one million seconds—and captured some 10,000 galaxies of different colors, shapes, and sizes, called by one report "a zoo of oddball galaxies littering the field. Some look like toothpicks; others like links on a bracelet." The HUDF results again underlined that galaxies grow in size over time, with the biggest increases coming one or two billion years after the big bang.

Astronomers debated whether the HUDF, in fact, displayed the earliest star-forming galaxies, and the answer that emerged is "no." Rather, astronomers expect that galaxies born earlier than 400 million years after the big bang will not be observable with Hubble. They should, however, certainly be observable with the James Webb Space Telescope. If all goes to plan, Webb will discover the very first galaxies.

Meanwhile, astronomers continue to dive deeper into the HUDF, and in 2012, they released a new image of its center, called the eXtreme Deep Field, or XDF. The result of a two-million-second exposure, it was the deepest image

A composite image of the two colliding Antennae Galaxies, created with data from Hubble (gold and brown), Chandra (blue), and Spitzer (red). In the early history of the universe, galaxy mergers and collisions were more common than now.

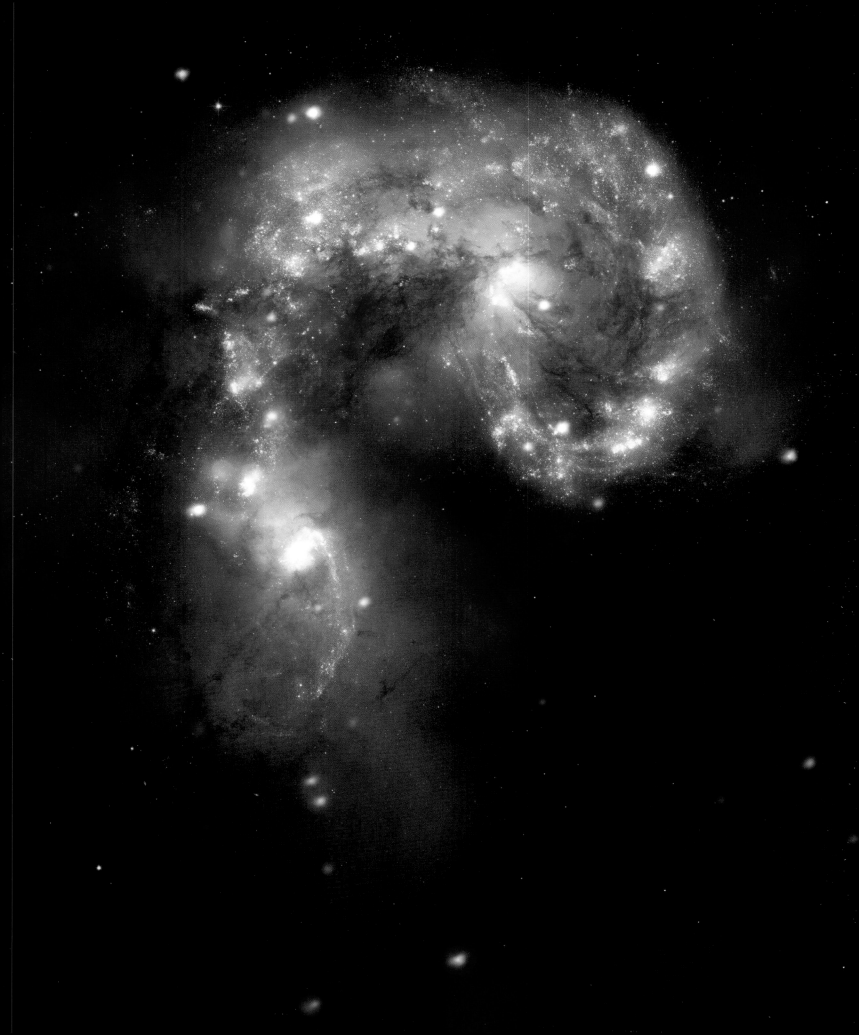

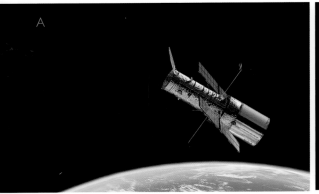 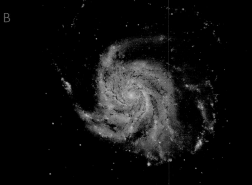

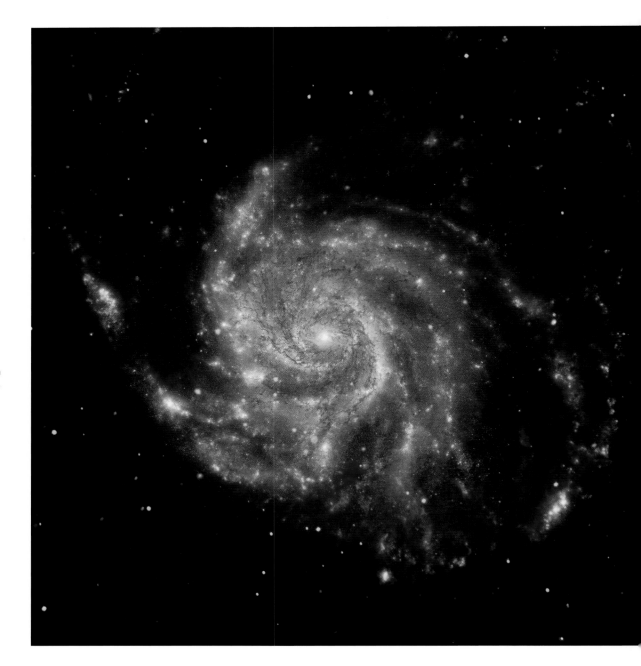

A composite image of the face-on spiral galaxy M101 using data from three of NASA's Great Observatories—Hubble, Spitzer, and Chandra. The observations of each observatory reveal different aspects of the galaxy.

Four observatories have been launched as part of NASA's Great Observatories Program, and three are shown here, separated by their respective color-coded images of spiral galaxy M101, combined at left. From left to right: (A) Hubble Space Telescope, (C) Spitzer Space Telescope, and (E) Chandra X-ray Observatory. The Compton Gamma Ray Observatory is not pictured.

ever of the sky. By compiling ten years of images from Hubble's cameras, including many from the WFC3 installed in 2009, the image disclosed galaxies so dim that the faintest one shone at only a very tiny fraction of the brightness detectable by the human eye. From a very small area of the sky, the XDF revealed some 5,500 galaxies and carried astronomers back in time to observe galaxies forming 13.2 billion years ago—only 450 million years after the big bang. This accomplishment meant that Hubble and its companion observatories had expanded our view so far that it now covers 96 percent of the life span of the universe.

BLANK FIELDS AND GRAVITATIONAL TELESCOPES

For the first two decades of its operational life, Hubble explorations followed two basic strategies in the hunt for extremely faraway galaxies: (1) pointing Hubble at relatively blank areas of sky to accumulate light for long periods (as in the Hubble Deep Field and the Ultra Deep Field), and (2) using clusters of galaxies as gravitational lenses to brighten and magnify galaxies that lie beyond the galaxy cluster (see Moment 13, page 106).

In 2013, the Space Telescope Science Institute announced plans to join these two approaches. The Frontier Fields program linked Hubble with Spitzer and Chandra to secure images of distant galaxies some 10 to 100 times fainter than any observed before. To this end, astronomers planned for Hubble to inspect 6 fields centered on a strong lensing galaxy

HST FACT

To visualize the size of the area of sky covered by the Hubble Ultra Deep Field, imagine looking through an eight-foot-long soda straw.

cluster and 6 blank fields adjacent to the cluster. The first galaxy cluster Hubble observed was Abell 2744, also known as Pandora's Cluster.

DEEPER INTO THE FUTURE

At 25 years old, the Hubble Space Telescope promises even more. Paired with other remarkable astronomical instruments, it helps us push ever more deeply into outer space and ever farther back toward the origins of our universe. Just over a century ago, George Darwin, son of Charles Darwin and a very distinguished scientist in his own right, assumed that it was as futile to imagine that humans "can discover the origin and tendency of the universe as to expect a housefly to instruct us as to the theory of the planets." Astronomers undermined Darwin's assumption within decades of his confident declaration. What on Earth would he have made of the profound and remarkable efforts to pin down the age of the universe, to explore what lies at the most distant reaches of space, and the quest to determine the rate of the universe's expansion—all advances in our understanding in which Hubble has played such a very significant part?

NGC 1275

OBJECT: ACTIVE ELLIPTICAL GALAXY
LOCATION: PERSEUS
DISTANCE: 230 MILLION LIGHT-YEARS
OBSERVED: JULY AND AUGUST 2006

NGC 1275 is one of the closest galaxies to the Milky Way that contains a supermassive black hole, which has expelled huge nets of gas that ring the visible portion of the galaxy and mark its complex magnetic field structure. A NASA press release in August 2008 aptly described it as a "magnetic monster."

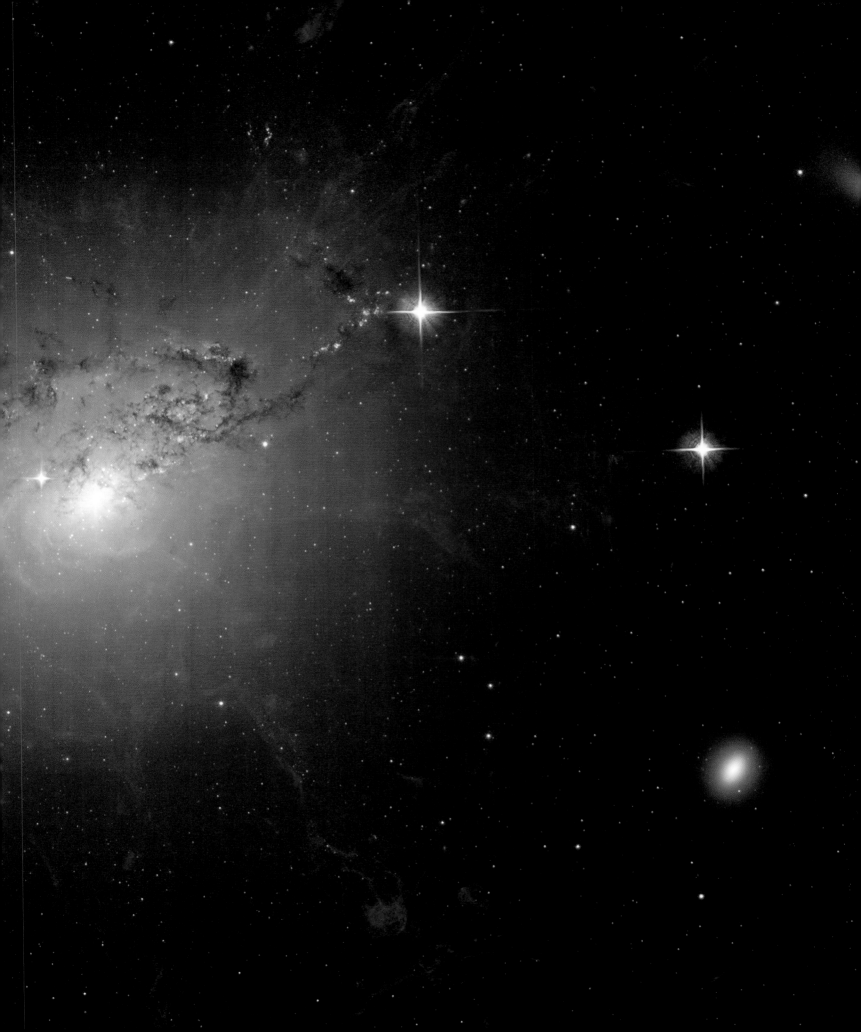

25 YEARS AND COUNTING . . .

DAVID H. DEVORKIN

Walking west down the National Mall to the Smithsonian Metro one evening recently, I became captivated by a dark cloud bank on the horizon with an irregular but somehow compelling presence. Dark tendrils curled around a bright orange hole in the clouds. It was a momentary vision; the hole had closed in the few minutes it took me to reach the escalator and descend into the Metrorail system.

This vision lingered in my mind. I had just read through the rough draft manuscript for this book, and the vision made me think of the ardent quest in the 1870s of astronomer Edward S. Holden to collect drawings of the Orion Nebula that could possibly show change over time. He worked in Washington, D.C., at the Naval Observatory, then at the extreme western end of the Mall in Foggy Bottom. But, of course, there was no Metro then, no modern Mall, nor was there a Hubble Space Telescope. The Naval Observatory did boast one of the largest telescopes in the world, but it was not built to examine nebulae or deep space.

The clouds over my head were probably moving at tens of miles an hour, and were able to close that hole in a matter of minutes. The feature was transitory. But the vision reminded me of the vast difference in scale between what we experience in our daily lives, and what telescopes like Hubble are telling us about the universe we spend our lives living in. Despite Holden's passionate quest, his more conservative colleagues of the day soberly sensed the challenge of detecting change. The Council of the Royal Astronomical Society had declared in the late 1860s: "When one reflects on the vast dimensions of the Nebulae of Orion, it is difficult to realize the probability of changes occurring to such an extent in the distribution of nebulous material matter as to be recognisable at very short intervals."

Today, we know from observations with instrumental powers unimagined in Holden's time, including those accomplished by Hubble, that the tendrils in the Great Nebula in Orion are moving with turbulent velocities in the thousands of miles an hour. But instead of the few fractions of a mile traversed by earthly clouds, Orion's tendrils have unimaginable distances to cover before any motion could be perceptible from the largest telescopes available to Holden. The astronomers sitting on the august council predicted that it would be centuries before real change could be perceived. But neither they nor Holden could have predicted that telescopes like Hubble could perform the task in decades.

Thoughts like these help us appreciate how far the technologies of astronomy have brought us in barely more than a century. Throughout this book, we have repeatedly encountered distances, sizes, ages, and scales of space and time beyond human imagination. If Hubble has helped us better appreciate the nature of the universe we inhabit, it has done so with visions of what is out there that evoke awe when we are told of the sizes and scales involved.

So, with the retirement of the space shuttle, and no new servicing missions to the Hubble Space Telescope, what will the future hold? NASA, of course, and many of the world's astronomers, hope that Hubble will survive long enough (both operationally and financially) to be able

Part of a series of images of Saturn when it appeared at maximum tilt, revealing its rings and southern hemisphere of its disk. The full series over different wavelength ranges provided astronomers with information on the physical and chemical characteristics of the rings, which is useful for understanding the dynamics of the system.

to shake hands with its successor, the James Webb Space Telescope, due to launch in 2018. Advocates even now are listing the many advantages to having them both in operation to allow them to calibrate against one another and thereby increase the time base against which changes in the heavens can be monitored, and through these changes come to a better appreciation of the dynamics that drive the sorts of changes that help us understand why we exist as we do: How stars form, and planets, and life.

One thing is for sure. As long as it lives, Hubble will continue to perform valuable science. In the course of writing this book, when we prepared Moment 12 in the summer of 2014, Hubble was still searching for suitable objects in the Kuiper belt that New Horizons might be directed to meet and study after it whizzes by Pluto. In October, after searching for more than three years, it found several candidates, none larger than $1/50$ the size of Pluto itself (or from only 15 to some 40 miles in diameter). New Horizons' scientists were quoted as being "over the moon" with enthusiasm for Hubble's detection.

Another legacy Hubble will leave is its demonstration of the importance of rendering scientific data into images that capture the attention of the world. The image detection and processing technologies that Hubble grew up with, adapted, and in some ways helped to create, are now applied by scientists of all stripes. One need only examine the major science journals, both for professionals and for the public, to appreciate the vast differences in how innovation in imaging and presentation have changed during Hubble's operational life. The use of false color to enhance physical, chemical, and biological properties in nature's realms started out as suspect a quarter century ago. Now it is common, and, in fact, expected.

Hubble Heritage Team astronomers were not the first to employ color coding, or "staining," of course, but as Elizabeth Kessler points out in her seminal study of the development

of Hubble's image legacy, *Picturing the Cosmos,* some of the people who first developed the image processing systems at the Jet Propulsion Laboratory in California carried them over not only to Hubble but also to the entertainment and digital imaging industries, including George Lucas's Industrial Light and Magic. One of them eventually developed the ubiquitous imaging processing software Photoshop. Our world has not been the same since.

Even though the majority of the telescope's observing time is allocated through a competitive peer review process, scientists at the Space Telescope Science Institute on the Johns Hopkins University campus who are involved in managing the process predict that the most likely projects will fall into two categories: exoplanet detection and atmospheric analysis, and scrutiny of the deepest reaches of the optical universe. Starting with the legacy Deep Field in 1995, orchestrated by a committee of peer scientists using Director Robert Williams's discretionary time, Hubble was devoted to duplicate the effort in the southern sky in 1998. It then extended the probe in 2004 with the Ultra Deep Field and in 2012 with the eXtreme Deep Field, a pencil beam survey centered on data taken between 2003 and 2004. In what has become something of a tradition, each of these repeat efforts was enhanced by more powerful detectors in cameras inserted during servicing missions.

Those missions have ended, but not the tradition. As we note in Moment 25, Hubble is now engaged with the other Great Observatories to create a series of "frontier fields," using its most powerful imaging instruments combined with nature's own gravitational lenses. Hubble has already started peering into these presently blank fields, collecting data that computers then reconstitute into images of these unimaginably distant objects at the beginning of time. Following a century-old tradition of probing "selected areas" of the sky to build up a general picture, astronomers selected six regions over the sky known to contain massive clusters of galaxies. What will they find within these dark fields? Stay tuned!

MACS J0416.1–2403 is one of six massive galaxy clusters that have been selected as Hubble's Frontier Fields to probe the deep universe through gravitational lensing. The lensing of galaxies more distant than this cluster has been imaged by ACS to map out the mass distribution in the cluster itself, and conversely will help to better understand the character of these hugely distant objects.

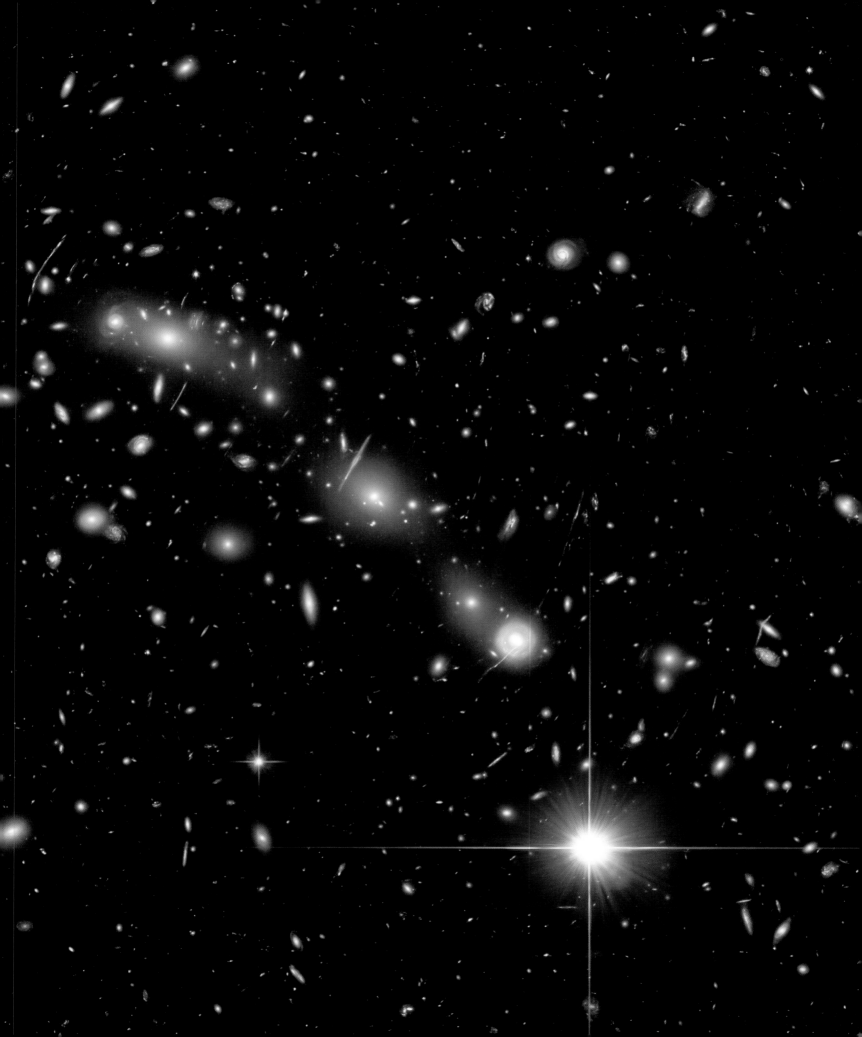

NOTES

PART 1

MOMENT 01

22 *"to uncover new phenomena"* Lyman Spitzer "Astronomical Advantages of an Extra-terrestrial Observatory," RAND report, 1946, reprinted with commentary in *Astronomy Quarterly* 7 (1990): 131–42.

MOMENT 02

35 *"resolved [in]" "mysterious ellipti-cal"* STScl, "Hubble Space Telescope Resolves Gaseous Ring Around Supernova," press release, August 29, 1990, http://hubblesite.org/news center/archive/releases/1990/1990/07/.

35 *"Whenever you look at things"* Robert Sanders, "Red giant star Betelgeuse mysteriously shrinking," UC Berkeley press release, June 9, 2009, http://berkeley.edu/news/media/releases/2009/06/09_betelim .shtml.

35 *"The Hubble observations" . . . "Who would have guessed?"* Robert Kirshner, quoted in STScl, "NASA's Hubble Telescope Celebrates SN 1987A's 20th Anniversary," press release, February 22, 2007, http://hubblesite.org/newscenter/archive/releases/2007/10/full/.

MOMENT 03

40 *"we might still perhaps"* Rev. John Michell, "On the Means of Discovering the Distance, Magnitude, etc., of the Fixed Stars," *Philosophical Transactions of the Royal Society of London* 74, no. 35 (1783): 465–77.

41 *"It looks like a 'duck'"* Tod R. Lauer quoted in STScl, "NASA's Hubble Space Telescope Probes the Compact Nucleus of Galaxy M87," press release, January 16, 1992, http://hubblesite.org/newscenter/archive/releases/1992/01/text/.

41 *"just totally unexpected"* Holland Ford quoted in STScl "Hubble Confirms Existence of Massive Black Hole at Heart of Active Galaxy," press release, January 16, 1994, http://hubblesite.org/newscenter/archive/releases/1994/23/text/.

41 *"Everyone in the room"* Holland Ford and Zlatan I. Tsventanov, "Black Holes in the Hearts of Galaxies," *Sky & Telescope* (June 1996): 28–33.

MOMENT 04

45 *"We are getting great science"* Steve Maran, quoted in Jim Detjen, "Scientists Close to Age of Universe: The Size of a Supernova Sighted in 1987 May Be the Key to the Mystery," *The Inquirer*, January 17, 1991, http://articles.philly.com/1991-01-17/news/25819973_1_nino-panagia-stephen-maran-astronomers.

46 *"There were surprises."* John Trauger, personal communication to David DeVorkin, May 18, 2014.

PART 2

MOMENT 05

52 *"Do you have any champagne in the refrigerator?"* Edgar B. Herwick III, "Rescuing The Hubble Telescope," *WGBH News*, April 25, 2014, http://wgbhnews.org/post/rescuing-hubble-telescope.

52 *"even skeptics were convinced"* Edward Weiler, quoted in John Noble Wilford, "NASA Pronounces Space Telescope Cured," *New York Times*, January 19, 1994, http://www.nytimes.com/1994/01/14/us/nasa-pronounces-space-telescope-cured.html.

52 *"She is tough, she is determined"* Jennifer Steinhauer, "Senator Amplifies Her Voice to Referee Fiscal Showdown," *New York Times*, August 5, 2013, http://www.nytimes.com/2013/08/06/us/politics/senator-amplifies-her-voice-to-referee-fiscal-showdown.html?pagewanted=all&_r=0.

52 *"the resources then to take advan-tage"* Departments of Veterans Affairs and Housing and Urban Development and Independent Agencies Appropriations for Fiscal Year 1994: Hearings Before a Subcommittee of the Committee on Appropriations, U.S. Senate, Vol. 2., 103rd Cong. 406–407.

53 *"How long do we put up with these technoturkeys?"* J. Craig Crawford, "Double Whammy Hits Nasa Congress Jumps To Blame Dreams Far Beyond Reality," *Orlando Sentinel*, June 30, 1990, http://articles.orlandosentinel.com/1990-06-30/news/9006300395_1_hubble-space-telescope-nasa-shuttle-program.

53 *"as perfect as engineers can achieve."* John Noble Wilford, "NASA Pronounces Space Telescope Cured," *New York Times*, January 14, 1994, http://www.nytimes.com/1994/01/14/us/nasa-pronounces-space-telescope-cured.html.

53 *"We knew white dwarfs must exist"* John Noble Wilford, "Hubble Telescope Chalks Up Discovery About Aging Stars," *New York Times*, January, 15, 1994, http://www.nytimes.com/1994/01/15/us/hubble-telescope-chalks-up-discovery-about-aging-stars.html.

MOMENT 06

57 *"it is indeed a unique object"* D. H. Levy, "Of Bonding and Discovery," chap. 1 in *Shoemaker by Levy: The Man Who Made an Impact* (Princeton University Press, 2000), 13.

58 *"a certain device by means of which"* Albert Van Helden, "The Invention of the Telescope," *Transactions of the American Philosophical Society* 67, no. 4 (1977): 1–67.

59 *"In my dreams we couldn't have gotten any better!"* STScl, "Hubble Astronomers Watch First Impact of Comet P/Shoemaker-Levy 9 with Jupiter," image release, July 17, 1994, http://hubblesite.org/newscenter/archive/releases/1994/1994/29/image/a/.

MOMENT 07

63 *"It was stunning"* Associated Press, "From Cosmic Joke to Historic Eye in Space," *Arlington (IL) Daily Herald*, May 11, 2009, 8.

65 *"I was stunned"* Edward Weiler, email message to David DeVorkin, June 5, 2014.

65 *"My jaw dropped"* Ray Villard, quoted in Elizabeth Kessler, *Picturing the Cosmos: Hubble Space Telescope Images and the Astronomical Sublime* (Minneapolis: University of Minnesota Press, 2012), 106.

67 *"appeals not only to the senses but also to reason"* Kessler, *Picturing the Cosmos*, 102.

67 *"resonated across religion and popular science"* Kessler, *Picturing the Cosmos*, 99.

MOMENT 08

71 *"Look again at that dot"* Carl Sagan, quoted in Rebecca J. Rosen, "An Early Draft of Carl Sagan's Famous 'Pale Blue Dot' Quote," *The Atlantic*, February 3, 2014, http://www.theatlantic.com/technology/archive/2014/02/an-early-draft-of-carl-sagans-famous-pale-blue-dot-quote/283516/.

71 *"The variety of galaxies"* STScl, "Hubble's Deepest View of the Universe Unveils Bewildering Galaxies across Billions of Years," press release, July 15, 1996, http://hubblesite.org/newcenter/archive/releases/1996/01/text/.

71 *"We felt ourselves"* James Hutton, quoted in M. Playfair, "Biographical Account of the late Dr. James Hutton," *Transactions of the Royal Society of Edinburgh* 5 pt III (1803), 72.

72 *"Eventually we reach the dim boundary"* Edwin Hubble, *The Realm of the Nebulae* (New Haven: Yale University Press 1936; rep Dover, 1958), 202.

72 *"drinking from a fire hose"* Eric Richards, quoted in Gretchen Vogel, "Mining the Deep Field," *Science* 274 (1996): 2006–7.

MOMENT 09

80 *"Each has its advantages, but none is perfect."* Wendy Freedman, "The Expansion Rate and Size of the Universe," *Scientific American* (1998): 92–97.

81 *"We live in a special time"* George H. Jacoby, quoted by John Noble Wilford, "Finding on Universe's Age Poses New Cosmic Puzzle," *New York Times*, October 27, 1994, http://www.nytimes.com/1994/10/27/us/finding-on-universe-s-age-poses-new-cosmic-puzzle.html.

PART 3

MOMENT 10

86 *"to assess the ubiquity"* Don Figer et al., "Two New Wolf-Rayet Stars and a Luminous Blue Variable Star in the Quintuplet (AFGL 2004) Near the Galactic Center," *Astrophysical Journal* 447 (1995): L29–L32.

MOMENT 11

91 *"vastly better than you"* Charles Robert O'Dell, interview by Robert Smith, May 21, 1985, transcript, Center for History of Physics, American Institute of Physics, College Park, MD.

92 *"We have found numerous"* C. R. O'Dell, Zheng Wen, and Xihai Hu, "Discovery of New Objects in the Orion Nebula on HST Images: Shocks, Compact Sources, and Protoplanetary Disks," *Astrophysical Journal* 410 (1993): 696–700.

93 *"Even given its impaired performance"* Jeff Hester et al., "Ionization Fronts and Shocked Flows: The Structure of the Orion Nebula at 0.1 Arcsec," *Astrophysical Journal* 369L (1991): L75–L78.

95 *"that planet formation is a hazardous process"* National Space Development Agency of Japan, "Hubble Captures Galactic Episode of Survivor," press release, April 26, 2001, http://www.spaceref.com/news/viewpr.html?pid=4650.

MOMENT 12

103 *"This has taken four years"* STScI, "New Hubble Maps of Pluto Show Surface Changes," press release, July 15, 1996, http://hubblesite.org/news center/archive/releases/2010/06/full/.

103 *"complete the reconnaissance of the solar system"* Michael J. Neufield, "First Mission to Pluto: Policy, Politics, Science, and Technology in the Origins of New Horizons," *Historical Studies in the Natural Sciences* 44, no. 3 (2014): 234–76.

PART 4

MOMENT 13

109 *"When I found that my calculations"* "Einstein Revealed," *NOVA*, PBS, episode #2311, aired September 9, 1997, transcript.

109 *"fictitious double stars"* Orest Chwolson, "Über eine mögliche Form fiktiver Doppelsterne [Regarding a possible form of fictitious double stars]," *Astronomical Notes* 221 (1924): 329.

109 *"It is of little value"* Einstein to J. McKeen Cattell, 18 December 1936, quoted in Jürgen Renn and Tilman Sauer, "Eclipses of the Stars: Mandl, Einstein, and the Early History of Gravitational Lensing." Preprint 160 (2000), Max-Planck-Institut Für Wissenschaftsgeschichte, http://www.mpiwg-berlin.mpg.de/Preprints/P160.PDF.

MOMENT 14

116 *"physical nature of this dark matter"* Sidney van den Bergh, "Cosmology: In Search of a New Paradigm," *Journal of the Royal Astronomical Society of Canada* 84 (1990): 275–80.

MOMENT 15

125 *"a heart-stopping moment"* Dennis Overbye, "One Last Ride to the Hubble," *New York Times*, December 4, 2007, http://www.nytimes.com/2007/12/04/science/space/04hubb.html?pagewanted=all&_r=0.

125 *"To be the Hubble repairman is really just unbelievable."* Dennis Overbye, "Last Voyage for the Keeper of the Hubble," *New York Times*, April 13, 2009, http://www.nytimes.com/2009/04/14/science/space/14prof.html?pagewanted=all.

MOMENT 16

132 *"An observer on another planet"* Paul Willard Merrill, "Cosmic Chemistry," *Astronomical Society of the Pacific Leaflets* 2, 57 (1933), 25.

135 *"nearest, brightest, and highest"* Carl Grillmair et al., "A Spitzer/IRS Legacy Reference Spectrum for Exoplanet HD 189733b," Spitzer Proposal ID #40504, http://adsabs.harvard.edu/abs/2007sptz.prop40504G.

135 *"the first clear spectral signature"* Mark R. Swain et al., "The Presence of Methane in the Atmosphere of an Extrasolar Planet," *Nature* 452 (2008): 329–31.

MOMENT 17

140 *"Starlight is falling"* George Ellery Hale, "The Possibilities of Large Telescopes," *Harper's Magazine* 156 (April 1928): 640.

141 *"bump in the night"* STScI, "Hubble Celebrates Its 19th Anniversary With a 'Fountain of Youth,' " press release, April 21, 2009, http://hubblesite.org/newscenter/archive/releases/2009/2009/18/results/100/.

141 *"a fitting accomplishment"* Hashima Hasan and Denise A. Smith, "IYA2009 NASA Programs: Midyear Status," *Science Education and Outreach: Forging a Path to the Future*. ASP Conference Series, Vol. 431 (2010): 41–46.

MOMENT 18

144 *"hit by a two-by-four"* Dennis Overbye, "Last Voyage for the Keeper of the Hubble."

144 *"We will build new ships"* White House, "President Bush Announces New Vision for Space Exploration Program," press release, January 14, 2004, http://history.nasa.gov/Bush%20SEP.htm

147 *"by one man in a back room"* Guy Gugliotta, "Hubble Hubbub Eclipses Rocket Science," *Seattle Times*, March 23, 2004, http://seattletimes.com/html/nation world/2001885729_hubble23.html.

147 *"The public and Congress"* Editorial, "Keep Hubble Functioning," *Denver Post*, March 22, 2014, B-07.

147 *"Our confidence is growing"* Howard McCurdy, *Space and the American Imagination*, 2nd ed. (Baltimore: John Hopkins University, 2011), 263.

147 *"I am fully confident"* Geoff Brumfiel, "NASA Approves Hubble Repair," *Nature News*, October 31, 2006, doi:10.1038/news061030-5.

148 *"arguably the most important"* Dennis Overbye, "As Tasks at Hubble End, No Tears, but It Was Close," *New York Times*, May 18, 2009. http://www.nytimes.com/2009/05/19/science/space/19hubble.html

PART 5

MOMENT 20

163 *"When a supernova explodes"* Robert Kirshner to David DeVorkin and Robert Smith, November 30, 2014.

164 *"was a total surprise. And nobody"* Adam Riess, quoted by Jeff Kanipe, *Chasing Hubble's Shadows* (New York: Hill & Wang, 2006), 95.

MOMENT 21

171 *"our best tool to explore"* Deming to DeVorkin, May 4, 2014.

172 *"because it's one of the hottest"* Drake Deming, personal communication to David DeVorkin, May 4, 2014.

172 *"is an extremely precise observation"* STScI, "NASA's Hubble Makes One Millionth Science Observation," press release, July 5, 2011, http://hubblesite.org/newscenter/archive/releases/miscellaneous/2011/22/full/.

MOMENT 22

178 *"emission from shells of orbiting particles"* D. E. Brackman et al., "IRAS Observations of Nearby Main Sequence Stars and Modeling of Excess Infrared Emission," *Advances in Space Research* 6, no. 7 (1986): 43–46.

181 *"unexpected characteristics"* P. Kalas et al., "HST/STIS Imaging of Fomalhaut" *Proceedings of the International Astronomical Union* 8, Symposium S299 (2013): 204–207.

MOMENT 24

193–194 *"spew its venom"* Sara J. Schechner, *Comets, Popular Culture, and the Birth of Modern Cosmology* (New Haven: Princeton University Press, 1999), 58.

196 *"It's hard to believe we are looking at an asteroid."* STScI, "NASA's Hubble Sees Asteroid Spout Six Comet-like Tails," press release, November 7, 2013, http://hubblesite.org/news center/archive/releases/2013/52/full/

MOMENT 25

202 *"a zoo of oddball galaxies"* STScI, "Hubble's Deepest View Ever of the Universe Unveils Earliest Galaxies," press release, March 9, 2004, http://hubblesite.org/newscenter/archive/releases/2004/07/text/.

202 *"think big"* Daniel Goldin, The American Astronomical Society (speech, San Antonio, CA, January 1996). Quoted in R. Albrecht, "From the Hubble Space Telescope to the Next Generation Space Telescope," *Reviews in Modern Astronomy 11: Stars and Galaxies* (1998), 332.

205 *"expect a housefly to instruct us as to the theory of the planets"* G. H. Darwin, "Cosmical Evolution," *The Observatory*, 38 (1905), 405.

ACKNOWLEDGMENTS

National Geographic Books and the Smithsonian Institution give special thanks to Zoltan G. Levay, senior image processing specialist at the Space Telescope Science Institute (STScI), for providing the best available images. We also thank Ray Villard and his staff at STScI's Office of Public Outreach for their helpful insights in response to our inquiries, and, most gratefully, for their continuing support of NASA's and the European Space Agency's marvelous websites. We have also depended upon staff expertise at both the National Air and Space Museum and the National Geographic Society. At NASM, Trish Graboske provided legal and financial management, and Kate Carroll provided full project management, facilitating the solution of many editorial and artwork issues that arose during the course of the work. Her energy and expertise were critical to the success of this project. The authors also benefited from the curatorial staff of the National Air and Space Museum, as well as Edward J. Weiler, former associate administrator for science at NASA and longtime Hubble protector. At the National Geographic Society, the authors thank Charles Kogod and Susan Blair for photo research and editing, Marty Ittner for design and layout, and Barbara Payne and Susan Tyler Hitchcock for editing and project management. Finally, both David DeVorkin and Robert Smith are very grateful to the many astronomers, engineers, and managers who have discussed Hubble and its history with us over the years.

ABOUT THE AUTHORS

David H. DeVorkin is senior curator for the history of astronomy and the space sciences at the National Air and Space Museum, Smithsonian Institution, in Washington, D.C. Among many exhibit projects, he most recently curated "Repairing Hubble," featuring the WFPC2 and COSTAR that were returned from the Hubble Space Telescope's last servicing mission. This is his 16th book, the third with co-author Robert Smith.

Robert W. Smith is a professor of history at the University of Alberta and former staff member at the National Air and Space Museum, Smithsonian Institution, in Washington, D.C. His books include the award-winning *The Space Telescope: A Study of NASA, Science, Technology and Politics* and *The Expanding Universe.* He has closely followed Hubble's history for more than 30 years.

DeVorkin and Smith are the authors of National Geographic's *Hubble: Imaging Space and Time* (2008).

Foreword writer **Robert P. Kirshner** is the Clowes Professor of Science at Harvard University. His work with Hubble includes the observing program to study Supernova 1987A. He administered the HST observing program for the High-Z Team: This contributed to the discovery of cosmic acceleration using supernova explosions. He now leads an HST program to measure the history of cosmic expansion more accurately using infrared observations of supernovae to infer the properties of dark energy.

ACRONYMS AND ABBREVIATIONS

ACS	Advanced Camera for Surveys
ACS/WFC	Advanced Camera for Surveys/Wide Field Channel
CANDELS	Cosmic Assembly Near-Infrared Deep Extragalactic Legacy Survey
CCD	charge-coupled device
Chandra ACIS	Chandra X-Ray Observatory Advanced CCD Imaging Spectrometer
COS	Cosmic Origins Spectrograph
COSMOS	Cosmic Evolution Survey
COSTAR	Corrective Optics Space Telescope Axial Replacement
EGG	evaporating gaseous globule
ESA	European Space Agency
ESO	European Southern Observatory
EVA	extravehicular activity
FGS	Fine Guidance Sensor
FOC	Faint Object Camera
FOS	Faint Object Spectrograph
GHRS	Goddard High Resolution Spectrograph
GOODS	Great Observatories Origins Deep Survey
HST	Hubble Space Telescope
HUDF	Hubble Ultra Deep Field
IRAC	Infrared Array Camera
IRAS	Infrared Astronomical Satellite
IYA	International Year of Astronomy
IUE	International Ultraviolet Explorer
JPL	Jet Propulsion Laboratory
KBO	Kuiper belt object
M	Messier
MOC	Mars Orbiter Camera
NASA	National Aeronautics and Space Administration
NGC	New General Catalog
NICMOS	Near Infrared Camera and Multi-Object Spectrometer
PIG	partially ionized globule
SM	Servicing Mission [1, 2, 3a, 3b, 4, 5]
STIS	Space Telescope Imaging Spectrograph
STScI	Space Telescope Science Institute
VLA	Very Large Array
VLT	Very Large Telescope
WFC3	Wide Field Camera 3
WFPC	Wide Field Planetary Camera
WFPC2	Wide Field Planetary Camera 2
XDF	eXtreme Deep Field

ILLLUSTRATIONS CREDITS

Cover: NASA, ESA, CXC and the University of Potsdam, JPL-Caltech, and STScI.
Back cover: (LE), NASA, ESA, and the Hubble Heritage Team (STScI/AURA); (CTR), NASA, ESA, SAO, CXC, JPL-Caltech, and STScI; (RT), NASA, ESA, and M. Livio and the Hubble 20th Anniversary Team (STScI).
Author photos: (UP) NASM Photographer Carolyn Russo; (CTR) Elly Smith; (LO) Lynn Barry Hetherington.

Front: 2-3, NASA, ESA, the Hubble Heritage Team (STScI/AURA), and R. Gendler (for the Hubble Heritage Team); 3, NASA; 4-5, NASA, ESA, and J. Maíz Apellániz (Instituto de Astrofísica de Andalucía, Spain); 6-7, NASA, ESA, and the Hubble Heritage Team (STScI/AURA); 8-9, NASA, ESA, and The Hubble Heritage Team (STScI/AURA); 10, NASA, ESA, and the Hubble SM4 ERO Team; 13, NASA, ESA, and the Hubble Heritage Team (STScI/AURA); 14, NASA, ESA, and the Hubble SM4 ERO Team; 16-17, NASA, ESA, and F. Paresce (INAF-IASF, Bologna, Italy), R. O'Connell (University of Virginia, Charlottesville), and the Wide Field Camera 3 Science Oversight Committee; 18-19, NASA, ESA, CXC, JPL-Caltech, J. Hester and A. Loll (Arizona State Univ.), R. Gehrz (Univ. Minn.), and STScI; 18-19, ESA/Hubble, NASA, HST Frontier Fields.

PART 01: 20-21, NASA; 23, NASA/ESA; 26, NASA; 27, Photo by Al Fenn/The LIFE Picture Collection/Getty Images; 28-29, NASA, ESA, the Hubble Heritage Team (STScI/AURA)-ESA/Hubble Collaboration and A. Evans (University of Virginia, Charlottesville/NRAO/Stony Brook University); 30 (UPLE), NASA, P. Challis, R. Kirshner (Harvard-Smithsonian Center for Astrophysics) and B. Sugerman (STScI); 30 (UP CTR), NASA, P. Challis, R. Kirshner (Harvard-Smithsonian Center for Astrophysics) and B. Sugerman (STScI); 30 (UPRT), NASA, P. Challis, R. Kirshner (Harvard-Smithsonian Center for Astrophysics) and B. Sugerman (STScI); 30 (CTR LE), NASA, P. Challis, R. Kirshner (Harvard-Smithsonian Center for Astrophysics) and B. Sugerman (STScI); 30 (CTR), NASA, P. Challis, R. Kirshner (Harvard-Smithsonian Center for Astrophysics) and B. Sugerman (STScI); 30 (CTR RT), NASA, P. Challis, R. Kirshner (Harvard-Smithsonian Center for Astrophysics) and B. Sugerman (STScI); 30 (LOLE), NASA, P. Challis, R. Kirshner (Harvard-Smithsonian Center for Astrophysics) and B. Sugerman (STScI); 30 (LORT), NASA, P. Challis, R. Kirshner (Harvard-Smithsonian Center for Astrophysics) and B. Sugerman (STScI); 32-33, Composite: X-ray image: NASA/CXC/ASU/J. Hester et al. Optical image: NASA/HST/ASU/J. Hester et al.; 34, NASA, ESA, J. Hester and A. Loll (Arizona State University); 36, NASA, ESA, and A. Nota (STScI/ESA); 37, NASA, ESA, and M. Livio and the Hubble 20th Anniversary Team (STScI); 38, NASA/JPL-Caltech; 41, Holland Ford, Space Telescope Science Institute/Johns Hopkins University; Richard Harms, Applied Research Corp.; Zlatan Tsvetanov, Arthur Davidsen, and Gerard Kriss at Johns Hopkins; Ralph Bohlin and George Hartig at Space Telescope Science Institute; Linda Dressel and Ajay K. Kochhar at Applied Research Corp. in Landover, Md.; and Bruce Margon from the University of Washington in Seattle.; NASA; 42-43, NASA and the Hubble Heritage Team (STScI/AURA); 44, NASA; 46, NASA; 47, NASA.

PART 02: 48-9, NASA, ESA, and the Hubble Heritage Team (STScI/AURA); 50, NASA; 52, Robert Giroux/AFP/Getty Images; 53 (LE), NASA; 53 (RT), NASA; 54-55, NASA, ESA, D. Lennon and E. Sabbi (ESA/STScI), J. Anderson, S. E. de Mink, R. van der Marel, T. Sohn, and N. Walborn (STScI), N. Bastian (Excellence Cluster, Munich), L. Bedin (INAF, Padua), E. Bressert (ESO), P. Crowther (University of Sheffield), A. de Koter (University of Amsterdam), C. Evans (UKATC/STFC, Edinburgh), A. Herrero (IAC, Tenerife), N. Langer (AifA, Bonn), I. Platais (JHU), and H. Sana (University of Amsterdam); 56, Hubble Space Telescope Comet Team and NASA; 58, Hubble Space Telescope Comet Team; 59, H. Weaver (JHU), T. Smith (STScI), NASA; 60, NASA, ESA, C. Heymans (University of British Columbia, Vancouver), M. Gray (University of Nottingham, U.K.), M. Barden (Innsbruck), the STAGES collaboration, C. Wolf (Oxford University, U.K.), K. Meisenheimer (Max-Planck Institute for Astronomy, Heidelberg), and the COMBO-17 collaboration; 61, NASA, ESA and the Hubble SM4 ERO Team; 62, NASA, ESA, STScI, J. Hester and P. Scowen (Arizona State University); 64, The Hubble Heritage Team (AURA/STScI/NASA); 65, NASA, ESA, and the Hubble Heritage Team STScI/AURA); 66 (UP), NASA, ESA, STScI, J. Hester and P. Scowen (Arizona State University); 66 (LO), NASA, ESA, STScI, J. Hester and P. Scowen (Arizona State University); 68-9, NASA, ESA, CXC, C. Ma, H. Ebeling, and E. Barrett (University of Hawaii/IfA), et al., and STScI; 70, R. Williams (STScI), the Hubble Deep Field Team and NASA; 73, Dr. Clifford E. Ford; 74-75, NASA; 76, NASA, ESA, and the Hubble Heritage Team (STScI/AURA); 77, NASA, ESA, and the Hubble SM4 ERO Team; 79, NASA, ESA, and A. Nota (STScI); 80, Margaret Bourke-White/Time Life Pictures/Getty Images; 81 (LE), NASA, ESA, A. Riess (STScI/JHU), L. Macri (Texas A&M University), and the Hubble Heritage Team (STScI/AURA); 81 (RT), Illustration credit: NASA, ESA, and L. Frattare (STScI)/Science credit: NASA, ESA, A. Riess (STScI/JHU), and L. Macri (Texas A&M University).

PART 03: 82-83, Credit for Hubble image: NASA, ESA, N. Smith (University of California, Berkeley), and the Hubble Heritage Team (STScI/AURA)/Credit for CTIO Image: N. Smith (University of California, Berkeley) and NOAO/AURA/NSF; 85, NASA, ESA and Jesús Maíz Apellániz (Instituto de Astrofísica de Andalucía, Spain); 86, Don F. Figer (UCLA) and NASA; 88-89, NASA, ESA, and the Hubble Heritage Team (STScI/AURA)-ESA/Hubble Collaboration; 90, NASA, ESA, M. Robberto (Space Telescope Science Institute/ESA) and the Hubble Space Telescope

ILLUSTRATIONS CREDITS (CONTINUED)

Orion Treasury Project Team; 92 (LE), C. R. O'Dell (Rice University) and NASA; 92 (RT), Neil Brake; 93 (LE), NASA, ESA, J. Bally (University of Colorado, Boulder), H. Throop (Southwest Research Institute, Boulder), and C. R. O'Dell (Vanderbilt University); 93 (RT), NASA, ESA, J. Bally (University of Colorado, Boulder), H. Throop (Southwest Research Institute, Boulder), and C. R. O'Dell (Vanderbilt University); 94-95, Masahiro Miyasaka; 96-97, NASA, ESA, and the Hubble Heritage Team (STScI/AURA); 99, NASA, J. Bell (Cornell U.) and M. Wolff (SSI); NASA, J. Bell (Cornell University), and M. Wolff (SSI); 100, NASA, ESA, and the Hubble Heritage Team (STScI/AURA). Acknowledgment: M. Wong (STScI/UC Berkeley) and C. Go (Philippines); 102, NASA, ESA, H. Weaver (JHU/APL), A. Stern (SwRI), and the HST Pluto Companion Search Team; 103, NASA, ESA, and M. Buie (Southwest Research Institute).

PART 04: 104-105, NASA, ESA, S. Baum and C. O'Dea (RIT), R. Perley and W. Cotton (NRAO/AUI/NSF), and the Hubble Heritage Team (STScI/AURA); 107, NASA, ESA, Richard Ellis (Caltech), and Jean-Paul Kneib (Observatoire Midi-Pyrenees, France); 108, ESA, NASA, K. Sharon (Tel Aviv University), and E. Ofek (Caltech); 109 (UP), AP Photo; 109 (LO), NASA, ESA, and STScI; 110-111, NASA, ESA, and the SLACS Survey team: A. Bolton (Harvard/ Smithsonian), S. Burles (MIT), L. Koopmans (Kapteyn), T. Treu (UCSB), and L. Moustakas (JPL/Caltech); 112-113, NASA, ESA, and the Hubble Heritage Team (STScI/AURA)-Hubble/Europe Collaboration; 114, NASA, ESA, ESO, CXC, and D. Coe (STScI)/J. Merten (Heidelberg/Bologna); 116-117, Image courtesy of NRAO/AUI and NRAO; 119, NASA, ESA, CFHT, CXO, M. J. Jee (University of California, Davis), and A. Mahdavi (San Francisco State University); 120-121, NASA, ESA, and the Hubble Heritage Team (STScI/AURA); 123, NASA, ESA, and M. Livio (STScI); 124, NASA, ESA, and the Hubble Heritage Team (STScI/AURA); 125, Jean-Pierre Jans/New York Times; 126-127, NASA, ESA, and Z. Levay (STScI); 127, NASA; 128-129, ESA/Hubble & NASA; 131, NASA, ESA, M. Kornmesser; 132-133, NASA, ESA, and the Digitized Sky Survey 2. Acknowledgment: Davide De Martin (ESA/Hubble); 134, NASA/ESA; 136-137, NASA, ESA, and the Hubble Heritage Team (STScI/AURA)-ESA/Hubble Collaboration; 138, NASA, ESA, M. Livio, and the Hubble Heritage Team (STScI/AURA); 140, TWAN/Babak Tafreshi/Courtesy IYA2009; 141, NASA, ESA, and the Hubble Heritage Team (STScI/AURA); 142-143, NASA/JPL-Caltech/ESA/CXC/STScI; 145, NASA; 146, NASA, ESA, and the Hubble SM4 ERO Team; 148, NASA; 149, NASA.

PART 05: 150-151, NASA, ESA, and J. Lotz, M. Mountain, A. Koekemoer, and the HFF Team (STScI); 153, NASA, ESA, R. O'Connell (University of Virginia), F. Paresce (National Institute for Astrophysics, Bologna, Italy), E. Young (Universities Space Research Association/Ames Research Center), the Wide Field Camera 3 Science Oversight Committee, and the Hubble Heritage Team (STScI/AURA); 154-155, NASA, ESA, E. Sabbi (STScI); 156, NASA, ESA, and F. Paresce (INAF-IASF, Bologna, Italy), R. O'Connell (University of Virginia, Charlottesville), the Wide Field Camera 3 Science Oversight Committee, and the Hubble Heritage Team (STScI/AURA); 157, R. Gendler, D. Martinez-Delgado (ARI-ZAH, Universität Heidelberg) D. Malin (AAO), NAOJ, ESO, HLA-Assembly and Processing: Robert Gendler; 158-159, NASA, the Hubble Heritage Team, and A. Riess (STScI); 161, NASA, ESA, the Hubble Heritage Team (STScI/AURA), and NASA/CXC/SAO/J. Hughes; 162, NASA/ESA, CXO and P. Ruiz-Lapuente (University of Barcelona); 164, ESA/Hubble & NASA; 165, Engraving from Camille Flammarion's Astronomie populaire (1880); 166, NASA, ESA, T. Megeath (University of Toledo), and M. Robberto (STScI); 167, NASA, ESA, and the Hubble Heritage Team (STScI/AURA); 168, NASA, ESA, and G. Bacon (STScI); 171 (UP), 171 (LO), NASA Ames; 172-173, NASA, ESA, and R. Thompson (CSC/STScI); 174-175, NASA, ESA, S. Beckwith (STScI), and the Hubble Heritage Team (STScI/AURA); 176, ESA, NASA, and L. Calcada (ESO for STScI); 179 (UPLE), ALMA (ESO/NAOJ/NRAO). Visible light image: The NASA/ESA Hubble Space Telescope; 179 (UPRT), ESA/Herschel/PACS/DEBRIS consortium; 179 (LO), NASA, ESA, and P. Kalas (University of California, Berkeley, and SETI Institute); 180, "De Sterrennacht"/"The Starry Night" by Vincent Van Gogh/Images: NASA/ESA Hubble Space Telescope/Arrangement: Alex H. Parker; 181, A. Fujii, NASA, ESA, and Z. Levay (STScI); 182-183, NASA and the Hubble Heritage Team (AURA/STScI); 184, NASA and the Hubble Heritage Team (STScI/AURA); 187, NASA and the Hubble Heritage Team (STScI/AURA); 188, USAF photo; 188-189, NASA, ESA, Andrew Fruchter (STScI), and the GRB Optical Studies with HST (GOSH) collaboration; 190-191, NASA, ESA, C. R. O'Dell (Vanderbilt University), M. Meixner and P. McCullough (STScI); 192, NASA, ESA, and the Hubble Heritage Team (STScI/AURA); 195, NASA, ESA, and J.-Y. Li (Planetary Science Institute); 196-197, NASA, ESA, PSI, JHU/APL, STScI/AURA; 198-199, Hubble Component Credit: NASA, ESA, and Q. D. Wang (University of Massachusetts, Amherst)/Spitzer Component Credit: NASA, Jet Propulsion Laboratory, and S. Stolovy (Spitzer Science Center/Caltech); 200, NASA, ESA, R. Ellis (Caltech), and the UDF 2012 Team; 202, NASA/MSFC/David Higginbotham; 203, NASA, ESA, SAO, CXC, JPL-Caltech, and STScI; 204 (UPLE), ESA; 204 (UP CTR), NASA, ESA, K. Kuntz (JHU), F. Bresolin (University of Hawaii), J. Trauger (Jet Propulsion Lab), J. Mould (NOAO), Y.-H. Chu (University of Illinois, Urbana), and STScI; 204 (UPRT), NASA/JPL-Caltech/R. Hurt (SSC); 204 (LO), NASA, ESA, CXC, SSC, and STScI; 205 (LE), NASA, Jet Propulsion Lab/Caltech, and K. Gordon (STScI); 205 (CTR), NASA/CXC/NGST; 205 (RT), NASA, CXC, and K. Kuntz (JHU); 206-207, NASA, ESA, and Andy Fabian (University of Cambridge, U.K.).

Epilogue: 209, NASA and E. Karkoschka (University of Arizona); 210-211, ESA/Hubble, NASA, HST Frontier Fields.

INDEX

THE HUBBLE COSMOS

DAVID H. DEVORKIN AND ROBERT W. SMITH

In Association with the Smithsonian National Air and Space Museum

Published by the National Geographic Society

Gary E. Knell, *President and Chief Executive Officer*
John M. Fahey, *Chairman of the Board*
Declan Moore, *Chief Media Officer*
Chris Johns, *Chief Content Officer*

Prepared by the Book Division

Hector Sierra, *Senior Vice President and General Manager*
Lisa Thomas, *Senior Vice President and Editorial Director*
Jonathan Halling, *Creative Director*
Marianne Koszorus, *Design Director*
Susan Tyler Hitchcock, *Senior Editor*
R. Gary Colbert, *Production Director*
Jennifer A. Thornton, *Director of Managing Editorial*
Susan S. Blair, *Director of Photography*
Meredith C. Wilcox, *Director, Administration and Rights Clearance*

Staff for This Book

Barbara Payne, *Text Editor*
Marty Ittner, *Art Director*
Charles Kogod, *Illustrations Editor*
Sam Serebin, *Design Consultant*
Katherine Carroll, *Editorial Assistant*
Marshall Kiker, *Associate Managing Editor*
Judith Klein, *Senior Production Editor*
Lisa A. Walker, *Production Manager*
Galen Young, *Rights Clearance Specialist*
Katie Olsen, *Design Production Specialist*
Nicole Miller, *Design Production Assistant*
Bobby Barr, *Manager, Production Services*
John Chow, *Imaging*

National Geographic Partners
1145 17th Street NW
Washington, DC 20036-4688 USA

Become a member of National Geographic and activate your benefits today at natgeo.com/jointoday.

For information about special discounts for bulk purchases, please contact National Geographic Books Special Sales: specialsales@natgeo.com

For rights or permissions inquiries, please contact National Geographic Books Subsidiary Rights: bookrights@natgeo.com

Library of Congress Cataloging-in-Publication Data
DeVorkin, David H., 1944-
 The Hubble cosmos : 25 years of new vistas in space / David DeVorkin and Robert W. Smith ; in association with the Smithsonian National Air and Space Museum.
 pages cm
 Includes bibliographical references and index.
 ISBN 978-1-4262-1557-5 (hardcover : alk. paper) -- ISBN 978-1-4262-1558-2 (hardcover (deluxe) : alk. paper)
 1. Hubble Space Telescope (Spacecraft) 2. Orbiting astronomical observatories. 3. Outer space--Exploration. I. Smith, Robert W. (Robert William), 1952- II. National Air and Space Museum. III. Title.
 QB500.268.D47 2015
 522'.1919--dc23
 2015002139

Printed in China

17/RRDS/3